# COSTUME OF THE WESTERN WORLD

## Pictorial Guide and Glossary

### DOREEN YARWOOD

*Illustrated by the author*

## LUTTERWORTH PRESS
Guildford and London

# CONTENTS

# COSTUME OF THE WESTERN WORLD

## Pictorial Guide and Glossary

Fully illustrated throughout by the author with fluent and detailed drawings, and with 24 pages of full colour, this indispensable guide to costume presents its information in concise, easy-reference form.

The introduction traces the development of costume in western Europe and North America from the early Middle Ages to the present day. Complemented by colour illustrations, it shows how this supremely visual art reflects the events of history and the changing social climate of each period and place.

A wealth of monochrome drawings expands the glossary of terms which follows, to make a lucid, practical and satisfying book.

First published in Great Britain 1980

Copyright © 1980 by Doreen Yarwood

ISBN 0 7188 2405 9 (hardback)
ISBN 0 7188 2478 4 (paperback)

Filmset in 12/12 Bembo (Introduction) and
10/10 Bembo (Glossary of Terms)
Printed in Hong Kong
by Colorcraft Ltd

# INTRODUCTION

Costume is one of the arts of mankind, a visual art and probably the one which most accurately and vividly depicts the character and social structure of any human society at a given age and region of the world. The history of costume mirrors the outstanding events, discoveries, internecine struggles and technical achievements of the human race and a study of it cannot be divorced from an understanding of the relevant background history.

It follows then that fashion in costume is closely related to the other visual arts particularly architecture, interior decoration and the design of furniture. A typical instance is seen in the high-backed chairs, settees and bedsteads of the 1690s and the towering fontange head-dresses and periwigs of the same date. Motifs used in wall decoration appear also in fabric design: rococo is a classic example of this.

An instant reaction to the question 'Why do we wear clothes?' might be 'For warmth and modesty.' But this is only a small part of the answer. Climate is, naturally, an important factor in determining a type of costume and in the later centuries BC and the early centuries AD mankind in northern Europe took to wearing tunics and trousers while, south of the Alps, the classical world wore draped garments with bare legs and arms. This is, again, only a partial truth, for in Persia and India, both warm areas, trousers (albeit of thinner fabrics) were also customary while in primitive societies in equatorial regions, a loin-cloth for men and necklaces for women were regarded as adequate for modesty.

Man differs from the animal in that he does not cover himself solely for warmth, to simulate the animal's hide or fur. He has other needs, essential instincts of the human being, which he expresses in the clothes he wears and these display his creed, his personality, his status. In civil dress, with which this book is solely concerned, the principal factors which influence attire include religion, social and political status, sexuality and the human desire for change and to imitate social superiors.

In the West the Christian religion has influenced dress with regard to the decent covering of the human body, particularly the limbs. This has applied more to women's dress than men's but, in certain instances (see glossary QUAKER DRESS and PURITAN DRESS), a restraint was imposed on the choice of clothes worn by both sexes, frowning upon frivolity, lavishness and pride.

Over the ages, in most societies, the rulers and the aristocracy, the wealthy and the important, have adopted clothes to signify their position. As the lower social classes copied such fashions, the leaders of society found new styles. Sumptuary laws were passed to try to maintain the leaders' supremacy (see glossary SUMPTUARY LAWS).

The erotic characteristic is fundamental to the history of dress. Examples are many of garments, both men's and women's, which demonstrate the essential human need of the male to impress and attract the female, and vice versa. In the west there were the excessively décolleté necklines of the 16th and 18th centuries, the accenting of male genitals and form of the legs in the tightly-fitting hose of the later Middle Ages, the artificially-slenderised, corseted feminine bodies of the 16th, 18th and 19th centuries, the form-revealing, gossamer-thin dresses of the French Directoire and the English Regency and, in our own century, the mini-skirts of the girls and the hipster pants of the young male.

In two separate sections this book sets out to present in concise, easy-reference form, information about costume. The first part briefly traces the development of costume in the west—in Britain, western Europe and north America—to show how the social and political structures, the wars and power struggles, the historical events and technological developments have shaped the fashions of the last thousand years. The centres of influence have always followed the areas of power and wealth and the successive costume modes over the years illustrate the changes as such spheres of influence moved from Venice to Burgundy, Spain to France, England to America. Colour drawings illustrate in each section the characteristic dress of men, women and children. The second, larger, section is a glossary of terms, the majority illustrated by drawings set side by side with the text entries, which were in use for articles of costume worn in the west during this thousand years.

## 1. THE EARLY MIDDLE AGES: 1000–1340

In these years people wore loose, full garments, not tailored to the body but held in place only by an encircling belt, the pin of a brooch or by lacing. The draped apparel derived from the classical dress of Greece and Rome which, by AD 1000, had been adapted by northern and western Europe to the climatic variations so that, north of the Alps and the Pyrenees, garments had acquired sleeves and legs were covered. In the countries which were nearer to and traded with the Byzantine Empire, its capital in Istanbul, an oriental richness appeared in the dress. In Italy, for instance, fabrics and embroideries were sumptuous and colours more brilliant. The influence of north Africa could be seen in Spanish costume where the Moors introduced caftan-like coats and colourful trousers.

The Norman Conquest of England in 1066 led to a more sophisticated cut and style than the simple garments which had been worn before this. A unique source material for the second half of the 11th century is the Bayeux Tapestry (1066–77). Embroidered in coloured wool on a strip of linen about 77 yards (70 metres) long and 20 inches (50 cm) wide, it tells in great detail the story of the Conquest and depicts the dress of noblemen and kings, soldiers and peasants.

During the 11th and 12th centuries the chief masculine body garment was an overtunic called a bliaud (see BLIAUD). When worn by the nobility this was of brightly-coloured wool or linen and was decoratively bordered at neck, sleeves and hem. It was a full, loose garment, generally girded by an ornamented leather belt. The round neckline was slit in front to facilitate donning. Bodice, skirt and sleeves were cut in one piece. For ordinary wear the bliaud reached to knee or mid-calf, for important occasions the nobility wore it ankle-length. Women also wore a similarly-styled but longer bliaud. Under the bliaud both sexes wore a white or light-coloured undertunic, the chainse (see CHAINSE). The masculine version was a little longer than the bliaud, the feminine one reached the ground. Underwear developed slowly but, by the 12th century, wealthy members of the community had adopted a shirt or shift which had long sleeves and was knee-length. Braies, which were like loose breeches, and stockings, called chausses or hose, accompanied it (see BRAIES, HOSE).

Out-of-doors, long mantles or shorter cloaks, with or without

attached hoods, were worn by both sexes. Cords or brooches served as fastenings.

13th-century dress for men and women was characterized by extreme simplicity. Until about 1340 loose garments were often worn ungirded and were allowed to fall in graceful folds from neck to hem. They were plain, almost unornamented but made of heavy, sumptuous fabrics. The surcoat was introduced. Deriving from the tabard, it was at first a loose, sleeveless garment with large armholes, worn threequarter-length over the bliaud; later in the century it developed sleeves. Dagged edges and parti-colouring were beginning to make their appearance by the later 13th century.

Materials available for making clothes were limited when the period began, being mainly wool, linen and furs. The Crusades of the 11th to 13th centuries made a great difference to the quality and variety of fabrics available in western Europe. International contacts increased and trade routes for textiles were extended. By 1200 beautiful silks and cottons were being imported from the east and fine materials were being manufactured in France, Flanders and Italy especially. Good-quality woollen cloth was made in England and decorative leatherwork came from Spain and Germany. The nobility of Europe was wearing costly velvets, silks and fine wools, beautifully embroidered with coloured silks and gold thread. Crusaders also brought back from their travels what had hitherto been regarded as rare luxury costume accessories: embroidered and appliquéd leather and silk footwear, purses, girdles, gloves and handkerchiefs.

Men usually wore their hair fairly short in the 11th century but much longer in the 12th. Beards and moustaches were general, especially with the long hair. 13th-century hairstyles were neat, often in a bob or with a long horizontal curl at the back. Women's hair was always long. It was plaited or bound and was left hanging at the sides or back or, as in the 13th century, was arranged in a chignon or coiled over the ears (see CHIGNON). Hair was often confined in a decorative net or caul attached to a fillet encircling the brow (see CAUL).

The most usual masculine head-covering was a hood attached to a shoulder cape. A linen cap—the coif—could be worn under this and was in use indoors as well as out. Felt or wool caps were alternatives to the hood. Women wore the veil or couvrechef in

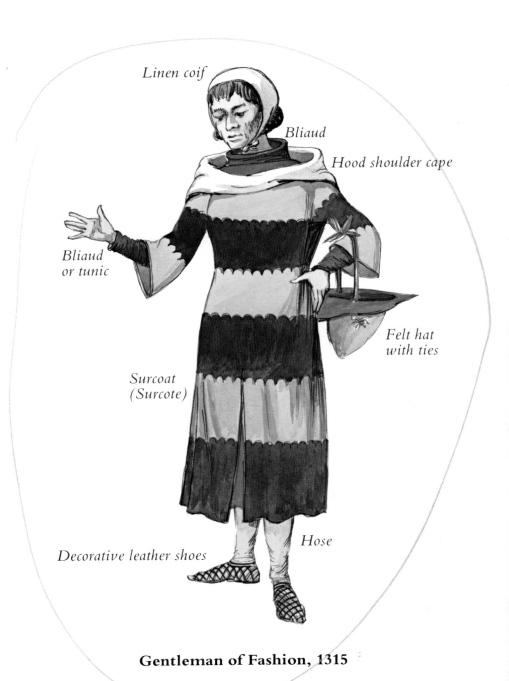

Linen coif

Bliaud

Hood shoulder cape

Bliaud or tunic

Surcoat (Surcote)

Felt hat with ties

Decorative leather shoes

Hose

**Gentleman of Fashion, 1315**

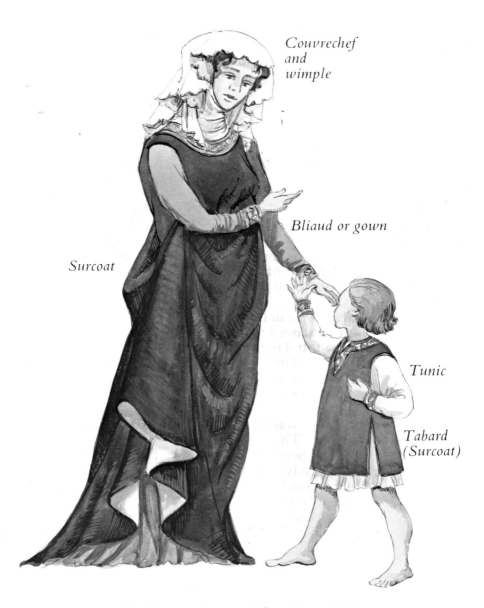

Couvrechef
and
wimple

Bliaud or gown

Surcoat

Tunic

Tabard
(Surcoat)

**Noblewoman and her Son, 1290**

varied forms during these years. By the 12th century the wimple was beginning to accompany the couvrechef and an alternative was provided a century later by the barbette. Different types of caul could be worn with these designs so giving to each lady a wide personal choice of chaste and elegant head-dresses (see BARBETTE, COIF, COUVRECHEF, WIMPLE).

## 2. THE LATER MIDDLE AGES: 1340–1465

It was in the decade 1340–50 that a profound change occurred in European costume and the foundations were laid of modern dress. The draped loose garments were replaced by ones cut and shaped to fit and display both masculine and feminine figures.

No single event was responsible for the change. It resulted from natural evolution and that it happened at this time was partly due to a new-found ability to tailor clothes more accurately, partly because of the availability of fabrics which lent themselves in texture and patterning to such shaping, and partly because the designs were inspired by the exciting ideas stemming from the stirrings of the Renaissance in Italy. With the doctrine of Humanism and consequent enhanced value of things secular, the human body became a vital symbol in man's search for the aesthetic ideal. It was studied and glorified in literature and the visual arts. Fashion as such an art, and one in which all could participate, became a prime exponent. In the design of clothes the human figure could be displayed and idealised.

Another development was that costume design became more national, even regional. The style of loose, long garments had transcended frontiers: it became European. Now national characteristics reasserted themselves. Climate, wealth, differing political and social structures, availability of materials, all contributed towards expressing in dress the personality of a nation. In some countries, notably England, where the hold of the feudal system was being weakened, a nation was being forged and dress illustrated this. In contrast Italy, advanced artistically but backward politically, was divided into city states, many wealthy and all competitive. As a result the styles worn by fashionable Venetians differed not a little from those of Florence.

There was more than one centre of fashion influence in these

years. Apart from Italy—Venice in particular, where wealth and extensive trade with Mediterranean lands and the Orient stimulated new ideas and design—the dominant influence on western European dress was Burgundy. Originating in the eastern part of Germany, the Burgundians had settled in Gaul under the later Roman Empire. After 1360 the Dukes of Burgundy had been successful in expanding the limits of their realm to include Flanders, Lorraine and parts of France.

Characteristic of dress at this time were the sumptuous fabrics from which it was made. Silk, satin, taffeta, velvet were imported all over Europe, chiefly from Italy, also from Spain. Flanders, Germany and England produced fine linens and woollens. Fashionable colours were brilliant and embroideries were rich. Because homes were draughty and often cheerless, furs were widely incorporated into clothing. They were used as decorative trimming but, above all, as linings to gowns, tunics, cloaks and even hose. Attempts were constantly made to restrict to the nobility the wearing of rare, imported and costly furs by means of sumptuary laws. Indeed such laws were passed to try to regulate the wearing of all expensive fabrics and means of decoration but these were rarely completely successful (see SUMPTUARY LAWS).

Characteristic also were the decorative forms of the time. Large motifs were used in patterning, notably geometrical, floral and heraldic in inspiration, and these were displayed to advantage on the fitting clothes. All garments could be parti-coloured, especially the hose, and counterchange design was prevalent everywhere (see COUNTERCHANGE, PARTI-COLOURING). From about 1360 until well into the 15th century the fashion for cutting the edges of a garment into various shapes was at its height. Apart from the hose, no garment escaped this treatment, which was called 'dagges'. The shoulder cape, hood, tunic hem and the wide sleeves of the houppelande were particular targets for dagging (see DAGGES).

The chief masculine body garment of the 14th century, known over the years by various names (see COTEHARDIE, DOUBLET, PALTOCK, POURPOINT), was made in four vertical sections cut to fit the torso, seamed at sides and back and buttoned down the centre front. Hip-length by 1360, the tunic became much shorter as the century progressed. At first a heavy, leather and metal belt was worn just above the hem; this was replaced later by a waist-belt.

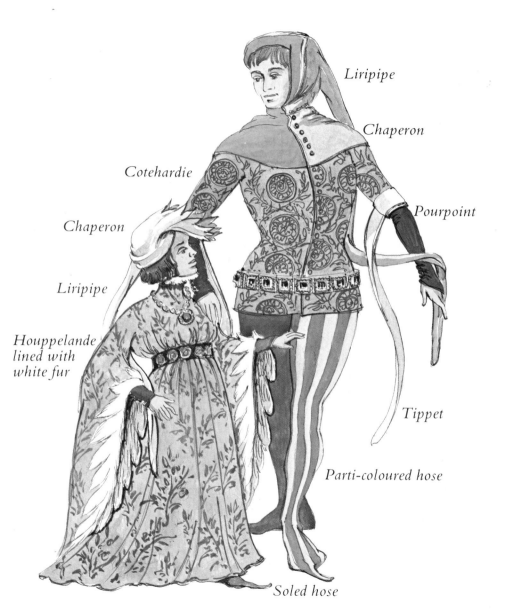

Liripipe

Chaperon

Cotehardie

Chaperon

Pourpoint

Liripipe

Houppelande
lined with
white fur

Tippet

Parti-coloured hose

Soled hose

**Gentleman 1360: Boy 1390–5**

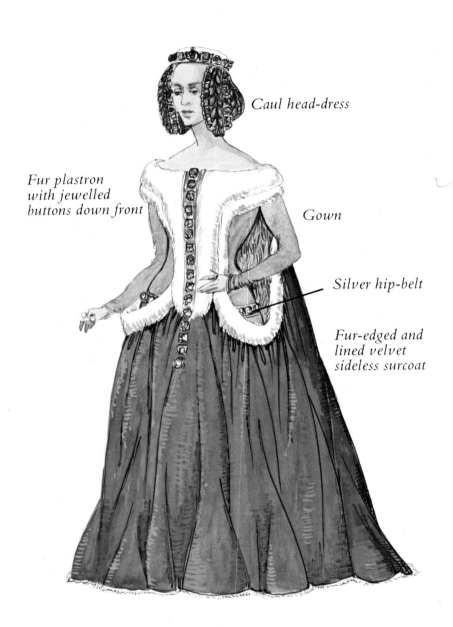

Caul head-dress

Fur plastron
with jewelled
buttons down front

Gown

Silver hip-belt

Fur-edged and
lined velvet
sideless surcoat

**Noblewoman, 1390–1410**

The fitting sleeves finished at the elbow where long tippets streamed out from a cuff (see TIPPET). Under the tunic was another, similar garment which was often padded (see GAMBESON, GIPON). In the 15th century padding was introduced into the outer tunic which was then pleated vertically from shoulder to hem. ·

Tailored to the leg, parti-coloured and striped to draw attention to the masculine form and laced to the undertunic, the hose was the predominant and most characteristic feature of masculine dress of the later Middle Ages. As the tunic became shorter, so the importance of the hose increased. Padding was incorporated in places where a male leg lacked substance (see COD-PIECE, HOSE, POINTS). Indoors, shoes became almost superfluous as the hose were soled. Pattens were donned for street-wear, boots for riding and travelling. Exaggeratedly long toes were fashionable from the later 14th century (see PATTEN, POULAINE).

Cloaks of various styles were put on out-of-doors but the introduction of the houppelande in the 1360s made this less necessary. This was a new garment, very full and long and donned over the tunic and hose. 14th-century versions had a high neckline, a decorative waist-belt and a skirt often slit to the knee. Excessively wide sleeves were ornamented by dagges (see HOUPPELANDE). ·

Masculine hairstyles varied a great deal during these years. The bowl cut was an unattractive style of the early 15th century; it was followed by bushier styles. Most men were clean-shaven (see BOWL CUT). The hood was the usual head-covering. With liripipe attached, the design and method of wearing evolved slowly to reach the formalised chaperon by the 1440s (see CHAPERON, LIRIPIPE). Tall sugarloaf hats were becoming modish in the Burgundian Court of the 1450s (see SUGARLOAF HAT).

Apart from the full-skirted gowns which swept the floor, there were many similarities between women's and men's dress. The cut of the body part of a lady's gown resembled that of the fitting masculine tunic, a similar hip-belt was worn and fabrics, patterns and ornamentation were almost identical. Sleeves were dagged, garments were parti-coloured, motifs were counterchanged and fur was widely used as a trimming and lining. Women wore the houppelande with a high-waisted decorative belt confining the fullness of the material.

One difference between masculine and feminine dress was that

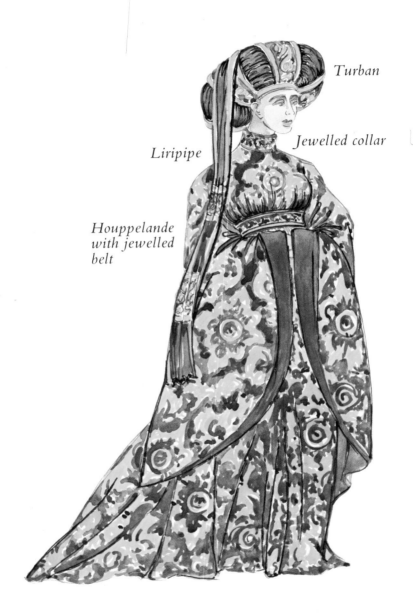

Turban

Jewelled collar

Liripipe

Houppelande
with jewelled
belt

**Lady in Houppelande, 1450**

whereas men had abandoned the 13th-century surcoat, with women it evolved into the sideless surcoat worn on top of the fitted gown. After 1350 the armholes, which were generally fur-edged, had become very large so that the front of the bodice was reduced to a narrow fur plastron (see SIDELESS SURCOAT).

During the 14th century women wore their long hair confined in cauls over the ears and these could be accompanied by a wimple or barbette. 15th-century head-dresses were of incredible diversity of design. It seemed as though the individuality and personality which men displayed in their parti-coloured hose was expressed by women in their head-dresses. Four chief types were to be seen almost contemporaneously: the turban, the heart-shaped, the horned and the steeple head-dress. In all cases the hair was confined and concealed; eyebrow hairs and those at temple and nape were plucked out. Flowing or wired diaphanous veils as well as liripipes were attached to most head-dresses (see HEART-SHAPED HEAD-DRESS, HENNIN, STEEPLE HEAD-DRESS, TURBAN).

## 3. THE SPREAD OF THE RENAISSANCE: 1465–1540

The design and ornamentation of costume was now being influenced by a complex pattern of events and movements. From Italy, Portugal and Spain, in particular, sailors were embarking upon voyages of exploration to the east and, across the Atlantic Ocean, to the far west. The successful journeys resulted in the discovery of lands and peoples from which new fabrics, jewels and riches were acquired which were then introduced into Europe and were incorporated into the dress of the leaders of fashion.

In Europe itself powerful groupings of peoples and nations were emerging. Dominant kingdoms then influenced style in dress according to the ideas and customs of their race. The Holy Roman Empire still maintained its influence in central Europe, the Ottoman Empire was extending its boundaries westwards and, in the west, England, France and Spain had achieved or were moving towards nationhood.

The dress style of the peoples north of the Alps was diverging from that of those who lived in southern, sunnier lands. This was not only a question of temperature. The two contemporary

movements of significance, the Renaissance and the Reformation, were exerting pressures upon the peoples within their orbit and, to a large extent, the former was most effective with southern, Latin peoples while the latter influenced primarily the northern lands. The Italian-born Renaissance, with its Humanist outlook and idealisation of the human body, was expressed in colourful, elegant dress in natural body line, made from sumptuous materials. Reformation leaders encouraged their peoples to eschew display and coquetry, richness of dress and brilliant colours. Influential chiefly in Germany, Holland, Switzerland, Scandinavia and England, the trend was towards a body more encumbered with clothes, its form obscured by fabric and bombast and in colours more sombre.

Since human nature differed only marginally between northern and southern lands, the sartorial picture was not as clearly defined as this. All peoples wished to wear clothes which were attractive and costly, colours which were gay and fashions which were up-to-date. Dress was the visible expression of wealth and rank, the status symbol of its day, and those in positions of power and importance dressed in a luxurious manner wherever they lived. Sumptuary laws were passed ever more frequently in an attempt to preserve this status but people continued to copy the fashions and ostentatiousness of their peers so the aristocracy was forced to search for new modes and ornamentation in order to preserve their distinction (see SUMPTUARY LAWS). The differences between regions and social classes, however, remained. The Reformation curbed some of the excesses of dress in northern Europe and the Renaissance encouraged the stylistic enhancement of the human figure in the south.

These factors can be clearly seen in a study of the fashions of the years 1465–1540. The centre of influence passed successively from Burgundy to Italy and then to northern Europe, focused on Germany and England.

The sumptuous, luxurious dress of the Burgundian Court continued to dominate European fashion until the defeat of the Duke of Burgundy at Nancy in 1477. Costly fabrics were richly ornamented with jewelled embroideries in large motif designs. Garments were lined and trimmed with fur. Young men wore tightly-fitting, parti-coloured hose, the toes extravagantly

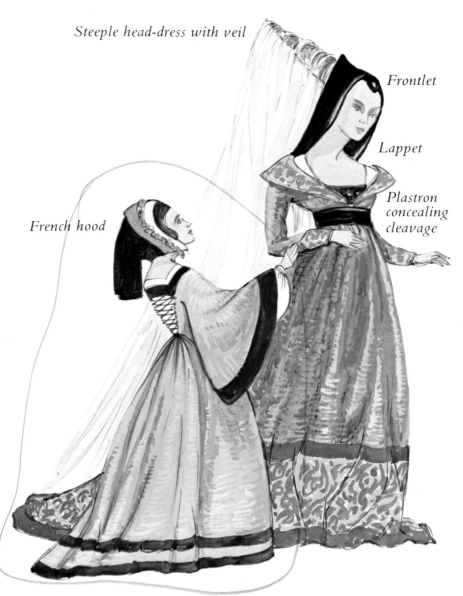

Steeple head-dress with veil

Frontlet

Lappet

Plastron concealing cleavage

French hood

**Burgundian Dress: Girl 1520, Lady 1475**

extended, abbreviated tunics, and tall hats perched rakishly over bushy or flowing long hair (see HOSE, SUGARLOAF HAT). Alternatively, voluminous, ground-length gowns with padded sleeves were held or belted round the body. Ladies' dresses were very long, extending to a train, and the material was generally held up with the hand to display the equally rich but contrasting under-skirt. The bodice was fitting and décolleté, its neckline often fur-edged and plunging to the belted high waistline at centre front and back, where a decorative plastron was inserted for modesty's sake (see PLASTRON). Of the rich variety of extravagant head-dresses, the veiled turban and steeple head-dress, especially, lent a dramatic finish to the costume (see STEEPLE HEAD-DRESS, TURBAN).

After 1480 Italian dress design dominated the European scene. Italians, especially Venetians and Florentines, were then the best-dressed, most elegant and best-mannered peoples of Europe. The wealth of the city states and the superb standard of the Renaissance arts were reflected in costume. Italian fabrics were prized and exported all over Europe. Magnificent brocaded silks, damask, velvet and gold and silver cloth were made and embroidered in oriental and western designs. Craftsmanship in jewellery was of the highest quality. Accessories were becoming more important and cosmetics were widely used and carried on the person for on-the-spot repairs.

Dress styles were elegant, colours gay, and the human figure was displayed and accentuated. Not for the Italians was the distorted, bombastic figure of the north; this was too hot for the Mediterranean climate and it concealed the beauty of the natural form. Men wore fitted, striped and parti-coloured hose and abbreviated, figure-hugging tunics. Their long, flowing hair was capped by jaunty, be-feathered hats. Women were dressed in high-waisted, full-skirted gowns with trains and covered their hair only by jewelled caps or dainty turbans; they displayed the beauty of their long hair and did not conceal it under extravagant head-dresses.

By 1520 the accent was centred on the dress of northern Europe, of Germany, Switzerland and England. Aptly defined by some historians as the 'era of puffs and slashes', the costume was padded at sleeve, shoulder and chest and most garments were cut into embroidered and jewelled slashes to display the clothes underneath

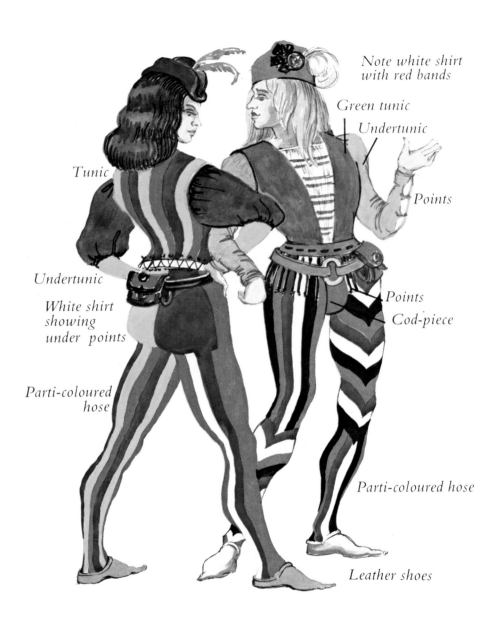

Note white shirt
with red bands

Green tunic

Undertunic

Tunic

Points

Undertunic

White shirt
showing
under points

Points

Cod-piece

Parti-coloured
hose

Parti-coloured hose

Leather shoes

**Young Men of Fashion in Renaissance Italy, 1490–5**

(see LANDSKNECHT, SLASHED GARMENTS). By the 1530s costume was rich indeed. Superb fabrics were used, heavily ornamented, jewelled and embroidered. For men the square silhouette was fashionable, created by the chamarre, the padded, heavy outer gown with immense collar, worn over doublet, jerkin and knee-length skirt (see CHAMARRE). This square form was even extended to the footwear (see EARED SHOE). The cod-piece, designed as a natural convenient covering for the male genitals with the Burgundian and Italian hose, developed in Germany and England into a padded monstrosity, its purpose doubtful and serving only to accent the wearer's masculinity and to provide a useful storage compartment for handkerchief and money.

In women's dress also the natural figure line was obscured and distorted, this time not by bombast but by the Spanish framework underskirt. This, the vertugado, had been introduced in Spain in 1470 but it was during the 16th century that the fashion swept through Europe (see FARTHINGALE, VERTUGADO). The farthingale, as it was termed in England, was adopted by western Europe from the late 1520s. It was a cone-shaped underskirt, circular in section and maintained in form by reinforcing bands. This fashion for the creaseless skirt lent itself to patterns with large motifs which were admirably displayed upon both over- and underskirts. A rigid, fitting corset was the necessary accompaniment to the farthingale, in order to create a slender, long waist. The gown of this time had a wide, square neckline with full, padded and slashed sleeves. In contrast with Renaissance Italy, northern European women of the years 1520–40 concealed their hair under a dark velvet hood which framed the face with one or more metal, jewelled bands in gable or horseshoe shape (see BILIMENT, FRENCH HOOD, GABLE HOOD).

Children were dressed, as they had been for centuries, in miniature versions of adult costume. Prior to the 1520s this had not been too unsuitable but padding, corsetry and farthingale skirts forced the immature bodies into a confinement which seriously restricted their growth and movement. This confinement began at birth with swaddling (see SWADDLING), after which both sexes were dressed in skirts until about the age of five when little boys were 'breeched' and wore adult-style male fashions.

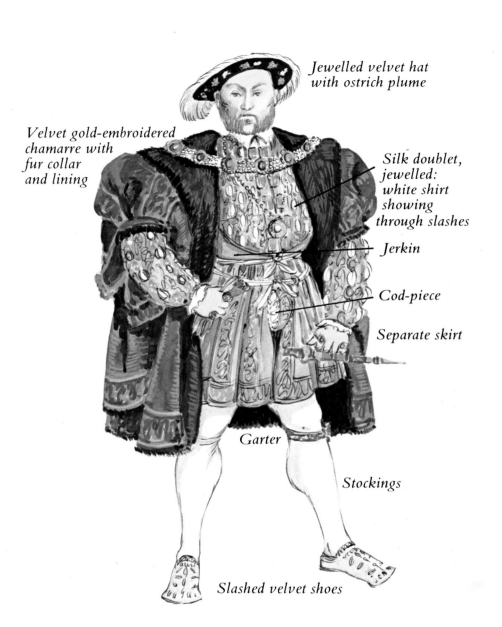

Jewelled velvet hat
with ostrich plume

Velvet gold-embroidered
chamarre with
fur collar
and lining

Silk doublet,
jewelled:
white shirt
showing
through slashes

Jerkin

Cod-piece

Separate skirt

Garter

Stockings

Slashed velvet shoes

**Henry VIII of England, 1538–9**

# 4. THE SPANISH INFLUENCE: 1540–1620

The colonisation of the New World brought great wealth and power to Spain. In north and south America the vast resources in metals, primarily gold, and jewels were being exploited and this lucrative trade was for some time controlled from the Iberian Peninsula. When Charles of Spain, later to be the Emperor Charles V, succeeded to the Spanish throne in 1516 he ruled over an immense empire with possessions in Africa, America and even Asia. He set up a colonial administration in the New World and his son Philip II developed this into a comprehensive system. It was not until after the defeat of the Armada sent against England in 1588 that the Spanish Empire and Spanish power began to decline.

It was Spain, therefore, which dominated the costume of these years and it was a time when fashionable dress reached its zenith of richness and luxury. In the succeeding centuries costume has been superbly elegant and sumptuous but never has the 16th century been surpassed for its embroidered and bejewelled luxury fabrics made into beautifully cut and shaped garments set off by lace-edged ruffs and collars which adorned the perfumed and powdered figures: this was an age of glittering splendour. Apart from the riches brought in from the New World, it was a reflection of the higher standard of living being enjoyed by larger numbers of people in western Europe and the ability of specialist trades and craftsmen to produce the beautiful fabrics, to decorate, tailor and fit them to a high standard of perfection.

Paradoxically, Spanish dress was characterised by its austere elegance. Although Spain introduced the chief innovations in 16th-century dress—the ruff, the farthingale, the cape, the corset—it was not in Spain that the designs of these features were carried to excess to become over-elaborate and extravagant in size and decoration. The more extreme forms of such garments were to be found in English, German, Dutch and French dress.

In Spain black was the dominant colour for normal wear, bright colours were for festive and important occasions. Garments were made from heavy, rich materials such as velvet and satin and these were ornamented by white or black silk and gold or silver thread incorporated with pearls and jewels. The Moorish inheritance was apparent in the beauty of the textiles, the richness of the embroideries in motifs and jewel encrustation and the heavy

ornamental girdles, neckchains and buttons. The all-pervading power and control of the Roman Catholic Church and the formal ceremonial of the Spanish Court were also reflected in constriction of the whaleboned and bombasted costume. The ensembles were beautiful and elegant but hardly comfortable to wear. Women, in particular, encased in farthingale and corset, were obliged to advance in a stately, dignified way, their walk a gliding progression rather than a natural movement. The Spanish introduced padding less than other nations; the Spanish ideal figure was elegantly slim and both men and women were corseted when necessary to achieve this.

The square-shaped masculine silhouette of the 1530s gradually disappeared and from about 1550 the Spanish doublet and jerkin accentuated a slim waistline which was pointed in front and finished with narrow basques (see BASQUE, DOUBLET, JERKIN). Sleeves were fitted and long or ended at the shoulder in picadils (see PICADIL). The neckline became higher and by the 1540s the elegant white shirt underneath was trimmed by a collar or ruffle. As time passed this style developed into the separate, larger ruff so characteristic of 16th-century dress (see RUFF). The garments were still decoratively slashed but the cuts were smaller and arranged in a pattern.

Spanish hose were now designed in two parts. The upper section, the trunk hose, was full and paned; below were fitted stockings (see CANIONS, NETHERSTOCKS, PANES, TRUNK HOSE). The exaggeratedly prominent cod-piece remained in fashion for much of the century.

Capes and cloaks had long been traditional wear in Spain but now they became high fashion everywhere. Tremendously varied in size, style, material and decoration, they could be worn in a multiplicity of ways, slung round one shoulder or both, hung by the fastening cords or just draped over the arm. Some styles had collars, others none. Fabrics were luxurious and linings contrasted in colour, decoration and material.

Hairstyles were neat, small moustaches and pointed beards were fashionable. The soft, tall, be-plumed hats were worn at a jaunty angle. Square-toed footwear was replaced by normal shapes. Perfumed gloves and handkerchiefs became important accessories.

The dress of Spanish women was also characterised by tasteful,

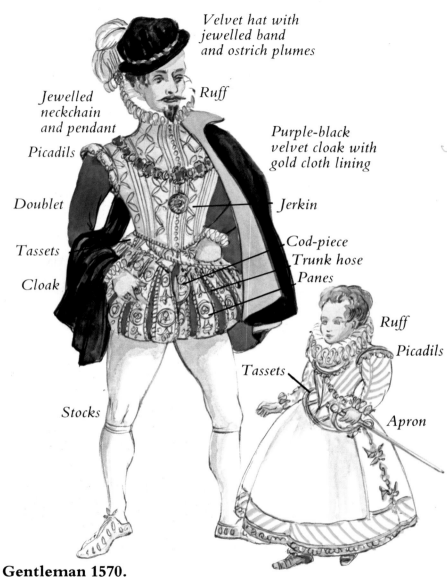

Velvet hat with
jewelled band
and ostrich plumes

Ruff

Jewelled
neckchain
and pendant

Picadils

Purple-black
velvet cloak with
gold cloth lining

Doublet

Jerkin

Tassets

Cod-piece
Trunk hose
Panes

Cloak

Ruff

Picadils

Tassets

Stocks

Apron

**Gentleman 1570.**
**Boy 3 years old in skirts: gold–embroidered**
**white satin dress, 1605**

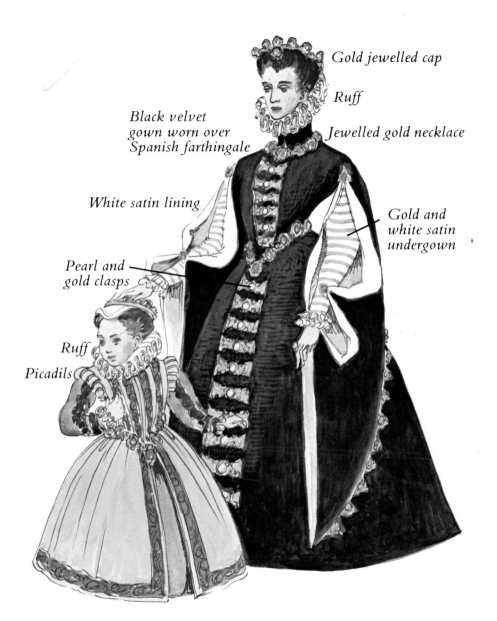

Gold jewelled cap

Ruff

Jewelled gold necklace

Black velvet
gown worn over
Spanish farthingale

White satin lining

Gold and
white satin
undergown

Pearl and
gold clasps

Ruff

Picadils

**Little Girl and Mother in Spanish Dress, 1570**

slim elegance. But while the masculine silhouette had been confined and assisted by whalebone in the doublet seams, the feminine figure was encased much more rigidly. Under the fitting bodice was worn the linen corset shaped to flatten and raise the breasts and so create the slim-waisted, concave-cone shape of the upper part of the body. This shape was maintained by strips of whalebone, horn or wood in the corset seams and the garment was laced up the centre front or back. The form of the lower part of the figure continued to be determined by the farthingale so a gown worn on top was mainly a creaseless cone shape (see FARTHINGALE).

Spanish gowns were generally high-necked and surmounted by small embroidered or lace-edged ruffs. The bodice and skirt front were decorated by a row of jewelled buttons or clasps and a heavy girdle encircled the waist. Sleeves were often in two parts, the inner one long and fitting, the detachable outer sleeve draped and clasped or hanging behind the arm.

Spanish ladies, like the Italians, preferred to wear their hair dressed loosely or braided and enclosed attractively in a jewelled cap. They carried feather fans or folding ones of perfumed leather or vellum. Nearly all ladies painted their faces and used a variety of preparations, some medically dangerous, for their teeth, complexions and hair. Perfumes were generously applied.

During these years other nations followed the Spanish style of dress but, especially between 1580 and 1620, adapted these designs to a more extreme and extravagant form. In France, the reign of Henry III (1574–89) was noted for the effeminacy and degeneracy of men's fashions. Sleeves were excessively padded, trunk hose abbreviated, whalebone and corsets constricted the waist and the doublet front was padded to the peasecod-belly shape. Other countries also adopted this strange fashion for an artificial paunch (see PEASECOD-BELLY). In northern Europe in general, the ruffs reached immense 'cartwheel' proportions. In Holland these were plain but in England ruffs and standing collars were magnificently decorated with lace and embroidery while a butterfly-wing veil could frame the back of the head. Paradoxically, while Italy and Spain retained the circular ruff and high neckline, it was in colder northern Europe that the extremely décolleté bodices with open ruffs became fashionable (see BUTTERFLY-WING VEIL, CARTWHEEL RUFF, COLLET MONTÉ, COLLET ROTONDE).

While the Spanish kept to the cone-shaped farthingale, northern Europe adapated this, first with the bum roll, then into the wheel or drum French design (see BUM ROLL, FARTHINGALE). This was accompanied by a more extreme form of corset, reaching lower down the figure and giving a slenderer, longer, excessively pointed waistline. These more extravagant forms of dress were also more elaborately ornamented with lace and jewelled embroideries so that, in court and formal dress, the whole costume from wig and head-dress to the shoes was so enriched.

## 5. BAROQUE ELEGANCE: 1620–1700

17th-century dress contrasted markedly with that of the 16th. After 1620, as Spanish power and influence waned, European fashions displayed a freer, more natural line; the rigid confinement of whalebone and bombast was relaxed. The clothes worn by the wealthy and influential were still made from beautiful fabrics —silk, satin, velvet and, especially, lace—colours were gay and varied but the encrustation of jewelled embroideries was eschewed in favour of a more restrained use of jewellery and decoration. The beauty of the fabrics could be discerned.

In Spain itself the hierarchic dress of the court became more extreme and this had a widespread influence upon Spanish fashionable dress. Women wore even larger farthingales and rigid corsetry dictated the whole silhouette. Men also retained their corseted, skirted doublets and bombasted trunk hose. Spanish fashion entered the doldrums, lagging far behind the new modes of the rest of western Europe. Italy also clung, though less tenaciously, to these older concepts, but elsewhere fashions were modelled upon the more comfortable attire being adopted by the Dutch.

By the 1620s Holland, emerging into freedom from Spanish domination, extended her trade dramatically and became wealthy and influential. Her costume was characterised by simplicity of line and richness of material. In northern Protestant areas, such as Scandinavia and Germany, this mode was closely followed. Elsewhere, in England and France, for example, a slimmer, more sophisticated version was adopted but, everywhere, clothes were looser and simpler, giving freedom to the natural shape of the human body.

The 'Cavalier' style of the years 1620–50 has been aptly described as the 'age of long locks, lace and leather'*. In men's dress this is vividly portrayed in the paintings by such artists as Frans Hals and Sir Anthony Van Dyck. By 1630 the elegant, swashbuckling costume was established. For the rest of the century man was a veritable peacock, proudly strutting beside his more quietly-dressed womenfolk. The natural hair was grown as long as possible, a be-ribboned lovelock straying coyly over one shoulder on top of the exquisite lace-edged falling band, which had now replaced the starched ruff. A soft, wide-brimmed hat with its coloured, sweeping ostrich plumes was set at a jaunty angle on the head. The natural waistline of the doublet was finished by ribbon points, its skirt divided into large tassets (see BASQUE, TASSET). Trunk hose had become elegant breeches finished at the knee with lace and ribbons. Lace boot hose foamed inside the tops of the soft leather boots. The picture was completed by a cloak slung nonchalantly around the shoulder, gauntleted leather gloves, a lace-edged handkerchief and a cane (see BOOT HOSE, BUCKET-TOP BOOTS, FALLING BAND, LOVELOCK). The influence of military dress worn during the Thirty Years War (1618–48) could be seen in the popularity of the buff coat, adopted for civil dress and worn on top of the doublet, then held in place by a broad sash tied round the waist (see BUFF COAT). The buff coat was particularly suited for wear in the American Colonies (see section 6).

Women's long dresses were high-waisted but not constricted. Sleeves were generally full and, for the first time for centuries, were only threequarter-length, finished by lace or lace-edged cuffs to match the falling band. For both sexes personal linen of shirt or chemise was of fine, white material, silk if possible and lace-trimmed. Lace, as a decorative medium, had replaced the jewelled embroideries of the 16th century. Women's dresses were often unpatterned, the quality of the material being the chief characteristic of the gown rather than its ornamentation. The coiffure was dressed with a curly forehead fringe and plaits coiled in a circlet high on the crown. Ringlets hung at the sides over the ears. Pearl ropes were widely used as hair decoration and for necklaces.

A plainer, more sober version of these fashions was adopted by

*Historic Costume by Kelly and Schwabe, (Putnam, 1976)

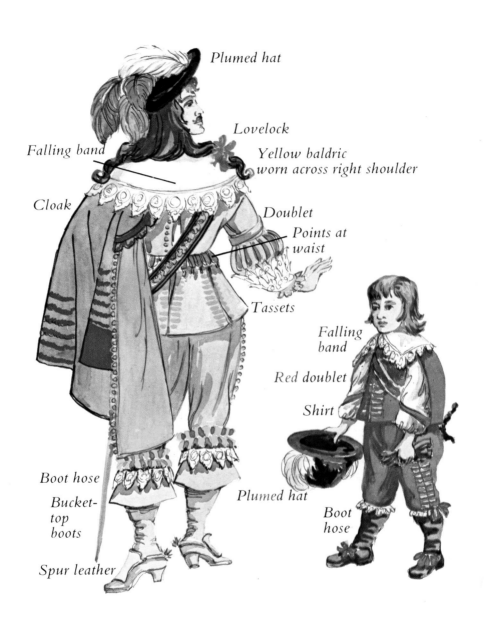

Plumed hat

Lovelock

Falling band

Yellow baldric
worn across right shoulder

Cloak

Doublet

Points at
waist

Tassets

Falling
band

Red doublet

Shirt

Boot hose

Bucket-
top
boots

Plumed hat

Boot
hose

Spur leather

**Cavalier Dress, 1635–6**

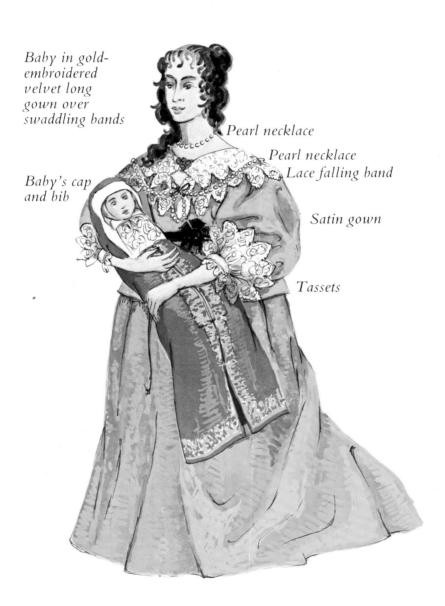

Baby in gold-
embroidered
velvet long
gown over
swaddling bands

Pearl necklace

Pearl necklace
Lace falling band

Baby's cap
and bib

Satin gown

Tassets

**Fashionable Dress, 1634**

the Puritans from the 1620s on and especially in Cromwell's England of the 1650s. This denuding the costume of its fripperies and graces was markedly reflected in the Puritan dress of the American Colonies (see PURITAN DRESS and section 6).

The *Grand Règne* of Louis XIV of France lasted from 1643–1715. During this time the king established France as a great European power and, from about 1660, France became the arbiter of European fashion, a position which remained unchallenged for nearly 300 years. The mode was set in Paris and the rest of Europe followed suit, basing its designs on the fashion dolls sent out each month from the French capital (see FASHION DOLL).

In men's dress there were two distinct modes. The first, spanning the years 1650–70, was a transitional phase which saw the final, somewhat decadent version of the garments which had been established in the later Middle Ages: the doublet, breeches and cloak. In mid-17th century this was an effeminate costume, displaying yards of ribbon and lace which almost obscured the line of the dress. The petticoat breeches (see RHINEGRAVES) looked like a be-ribboned skirt, the jacket was so abbreviated that the lace-trimmed shirt was visible at sleeve and waist, while a lace cravat hung as a folded bib over the chest. The Cavalier long locks of natural hair gradually made way for the full-bottomed periwig (see PERIWIG). Boots were clearly unsuitable with petticoat breeches so red-heeled shoes with ribbon ties replaced them. Men carried be-ribboned canes and fur muffs.

This fashion for decorating the costume with ribbons stemmed from the French determination to become self-sufficient in textile manufacture. To achieve this the government had passed sumptuary laws to curtail the importation of foreign (chiefly Italian) lace and brocaded silks. France then established a lace industry with the assistance of a group of Venetian lace-makers who taught the French craftsmen. The French-made ribbons became an important decorative medium.

Men's fashions of the last three decades of the 17th century changed completely. The basis of modern dress, a coat, a waistcoat (veste) and knee-breeches was evolved. This was a French innovation which began with the justaucorps, a short-sleeved coat, and developed into the 18th-century *habit à la française* (see HABIT, JUSTAUCORPS). The coat was collarless because the vast periwig

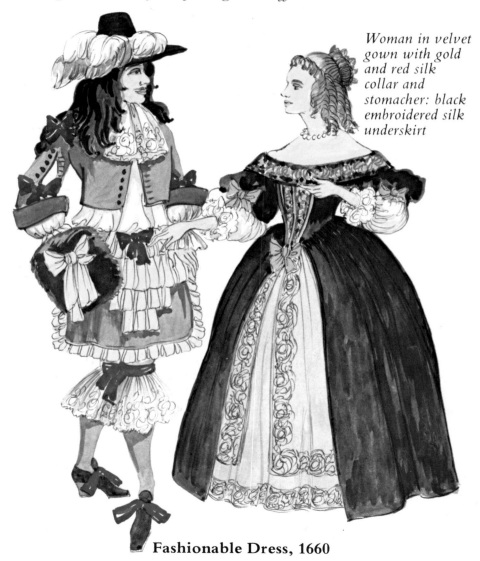

Man in silk jacket and petticoat
breeches (rhinegraves) with satin ribbon loops:
lace-edged cravat and falls: periwig and muff

Woman in velvet
gown with gold
and red silk
collar and
stomacher: black
embroidered silk
underskirt

**Fashionable Dress, 1660**

cascaded in curls over the shoulders. Sleeves ended in huge cuffs below which the shirt was visible, finished with delicate ruffles. The cravat lace foamed at the throat. The knee-length coat was generally only fastened at the waist though the decorative buttons and fastenings extended from neck to hem. A waist sash was often tied on top. The veste or waistcoat was a little shorter and had long, fitting sleeves. Because of the periwig, men began to carry their hats under the arm, the first time for centuries that these had not been worn indoors and out.

Women's dress changed more slowly and less dramatically. Yet, over the years, there was a gradual return to slenderer waists, corseting and fuller skirts held out by more petticoats. The tight bodice was boned to give a concave form under the breasts and was open in front faced by a stomacher which was often decorated by ribbon bows (see ÉCHELLE, STOMACHER). Sleeves became shorter, ending at the elbow in a cuff while lace ruffles drooped below. The neckline was low and wide. The full skirt was often open in front to display a rich underskirt; it was looped back with ribbons, then fell in folds to a train behind.

In the last decade of the century costume was accentuated in height, this echoing a similar trait in furniture design. Men's periwigs rose to a peak of waves and curls on either side of a centre parting; the fontange head-dress became fashionable for women (see FONTANGE). By this time also, while men's dress had become plainer and less effeminate, women's was acquiring more ornamentation and feminality. Ribbon loops, bows and lace decorated the whole gown. Petticoats were no longer adequate to support the weight of the bell-shaped skirt and a waist bolster or bustle was needed for this, presaging the hoop skirt of the 18th century.

### 6. COLONIAL NORTH AMERICA: 1600–1776
In the 17th century North America was colonised from northern and western Europe. The dress worn by the people of each area reflected that of their country of origin but was also influenced by the climate of the part of America to which they had come. For instance, the Spaniards who were the earliest settlers, came to Florida in 1565. Here, as in their later settlements in Texas and

California, the climate was similar to that of their own country so they were able to dress much as they had in Spain. It was never the policy of 16th-century Spain to make their colonies self-supporting and all the needs of the colonists had to be met from the mother country. In contrast, further north in New England, the winters were harsh so that, while styles of clothes worn were similar to those of northern Europe, there was a much greater use of furs, hides and skins in order to keep warm.

From the beginning the settlers set great store by preserving class distinctions. Sumptuary laws were passed in many areas more to maintain this differential than because of religious beliefs. The men and women of wealth whose breeding and education had marked them in Europe for positions of importance were expected to maintain this status even more carefully in this new land in order to set a standard for future generations to follow. It was believed that everyone should dress according to his station and that to be attired soberly and well in the latest fashion was providing an example which upheld the moral tone of the community. Protocol in dress was a visible expression of the determination of these early communities to maintain the highest standards of behaviour and culture.

For many the early years were hard. Colonists, apart from those of wealth and substance, made their own clothes. They cultivated flax and cotton and, in suitable areas, silk. They raised sheep for wool and learned to dress and tan skins. Everyday clothes were plain, simple versions of the fashions back home. Best clothes were kept for Sundays and holidays. They lasted so styles changed slowly.

Virginia, named for Queen Elizabeth I after its discovery in the 16th century, was the first English settlement in America; Jamestown was built as a fortified village in 1607 by the first colonists. By the 1620s women and children joined their menfolk and communities were established. The cultivation of tobacco had been introduced in 1612 and a flourishing industry was built up here, in Delaware and the Carolinas, by means of the labour of thousands of negro slaves. Many of the early English planters were Cavaliers of substance and their numbers were reinforced after the execution of Charles I. These men and their families sent to England for their fashionable clothes and, in years of good crop yield, would spend

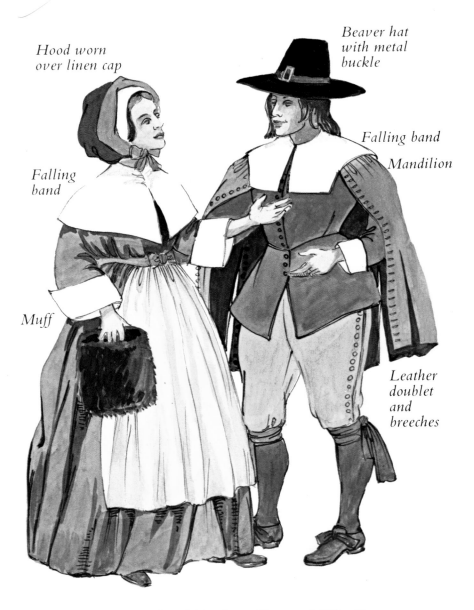

Hood worn
over linen cap

Beaver hat
with metal
buckle

Falling band

Mandilion

Falling
band

Muff

Leather
doublet
and
breeches

**New England Puritan Dress, 1630–40**

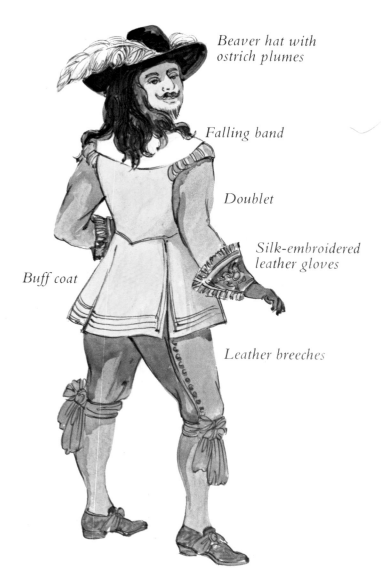

Beaver hat with
ostrich plumes

Falling band

Doublet

Silk-embroidered
leather gloves

Buff coat

Leather breeches

**Military Influence on Civil Dress, 1655**

lavishly on their London charge accounts. Tobacco was of such vital importance to the community that it became a currency and prices for garments and fabrics were quoted in pounds of tobacco. Clothes for children and servants were made in America from imported materials but the planter and his wife wore only English manufactured garments.

Soon after the building of Jamestown the English were settling in New England, where they went on to found colonies in Massachusetts, Connecticut, Rhode Island, New Hampshire and Maine. The first settlement was just south of Boston, landfall of the small ship *Mayflower* which carried the first separatists, the Pilgrim Fathers, who nostalgically named their settlement Plymouth after their Devon port of embarkation. These pilgrims suffered great hardships in a rigorous climate very different from the warmth of Virginia where they had expected to land. Also they were mainly artisans, ordinary men and women who had few possessions or substance, and the land too was poor.

The next wave of settlers, the Puritans of the Massachusetts Bay Company, derived from people of higher social class. Many were wealthy professional men and landed gentry. They settled in Salem and, later, in Boston, and others followed to move further afield so that by the 1630s settlements were well established. There was for a long time a contrast in dress between these peoples and those from Plymouth. Most were of Puritan faith and believed in dressing soberly and with dignity but those with greater wealth followed more closely the fashions of the English Cavaliers, wearing rich fabrics, only limiting excessive ornamentation and maintaining a restrained colour scheme. The Plymouth Settlers abstained from the use of richer fabrics and could not afford to import clothes from England.

In the early years the essential for most people was durable, warm clothes. Leather, linen and heavy wool were used for most garments in this inhospitable climate while much of the work was laborious and done in the open air. Men and women were warmly clad in a simple manner, based upon the styles current in the England which they had left. As time passed and industries were established and harvests were good, a higher standard of comfort and prosperity was enjoyed by the settlers. By the 1650s more and more people were sending to England for their clothes and for rich

fabrics from which to make them. The heavier furs, skins, wools which they had manufactured themselves were retained for the attire of the less well-to-do.

Sumptuary laws had been passed from the 1630s to endeavour to restrain richness in dress and efforts were redoubled in the 1650s, attempting to curb extravagance and limit spending on foreign imports to a certain proportion of income. But this was very much one law for the rich and one for the poor: the wealthier classes had no difficulty in obtaining velvet and lace, silk and embroidered fabrics.

Many Puritans believed sincerely in the rightness of adopting a plainer mode of dress and Church ministers encouraged their flock to eschew lace and gold embroideries, long hair and painted faces. The so-called 'sadd' colours were recommended. These were softer, quieter shades such as browns, greys, greens. The extensive use of leather and skins lent a golden-brown tone to the costume. Brighter touches were introduced, reds and blues for the hood and cloak lining (see MANDILION, MONMOUTH CAP, PURITAN DRESS).

Dutch settlements were also founded in the 1620s, New Netherland and New Amsterdam (later New York), for example. Unlike the Spaniards, the Dutch were encouraged by their government to settle and establish themselves. Assisted by grants and land they profited by their industry and tolerance. They mixed harmoniously with those from other countries, creating a wealthy community. They passed no sumptuary laws nor imposed restrictions on dress for reasons of religious dogma. Their attire was of high quality, not ostentatious but fashionable and elegant as it had been in Holland (see section 5 and CHAMARRE).

French colonists were assisted by their government with clothing, provisions and equipment to found a settlement on the lower reaches of the Mississippi river. The area was named Louisiana after Louis XIV. The chief city, New Orleans, was founded in 1717. The early French settlers wore a mixture of garments brought from France, ones made and woven by themselves, and skins and moccasins acquired by bartering with the Indians.

The Americans of the 18th century dressed well and fashionably. Differences between the attire of one area and another were no longer characterised by the European country from which the colonist had emigrated. Americans followed the current mode set

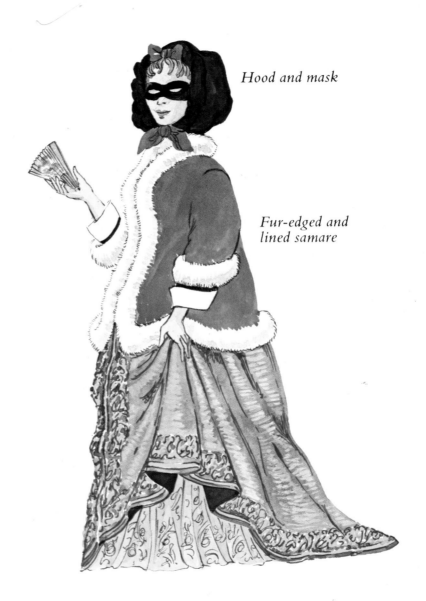

Hood and mask

Fur-edged and
lined samare

**Dutch Influence on Colonial Dress, 1660–5**

in western Europe. The differences which arose were between city dwellers and those from rural areas, and also between those living in the north and those from the south.

The well-to-do inhabitants of cities such as Boston, Philadelphia and New York dressed most fashionably. Prosperity was general and people could afford to import luxurious fabrics and finely-made garments from Paris or London. As in Europe, the opening up of the East India trade made available beautiful oriental stuffs from India and China. Men and women in America took a keen interest in dressing elegantly and expensively in the very latest mode. In the first half of the century the preference was for English fashions, after this the desire was for Parisian dress about which more and more information, including fashion dolls, was now reaching America. Even Quakers, recommended as always to dress with dignity and decorum, wore rich fabrics and indulged the latest fashion though they refrained from hooped skirts and high wigs. The 1750s and 1760s in Europe were years of great richness of fabrics and extremities of styles; Americans followed every whim and frivolity.

In rural areas many people continued to make their own clothes from homespun and woven fabrics. Wool, linen and muslin were in general use with silk reserved for Sundays. The wealthier members of rural society bought from abroad or copied designs at home but their fashions tended to be a little out of date.

In the southern states summer temperatures were unsuited to the fashions of the day. Heavy wigs, boned, heavily-embroidered coats and hooped skirts worn over layers of petticoats were not to be endured except for very formal occasions. People lived on plantations which were considerable distances from one another and a journey had to be made to visit a milliner or haberdasher. They dressed more informally in negligée dresses and banyans, caps replacing the heavy wigs. The materials were rich and the garments fine but much less formal and fashionable than those of the town-dwellers of the north.

The Revolution affected the American attitude to dress. During the years of struggle and war, restrictions were placed on the importation of goods of foreign manufacture. Home-produced materials were used for the making of garments and the luxuries of jewellery, embroideries and ornamentation were eschewed. A

simplicity and plainness of costume, out of tune with the current European fashions, resulted. After the Declaration of Independence and the end of the war, the majority of Americans did not return to buying their clothes from England. Paris became and remained the chief source of fashion for America (see BANYAN, NEGLIGEE, QUAKER DRESS, ROQUELAURE CLOAK, SHOEPACK, SKIMMER, WAGON BONNET).

## 7. ROCOCO AND NEO-CLASSICISM: THE 18TH CENTURY

England and France were the major European powers in this century and, although England was in command at sea and, in consequence, of immense influence as a trading and colonising nation, France retained her cultural supremacy. French was spoken by the aristocracy of Europe; its leaders of culture followed French customs and, naturally, French fashions. It was in France that the trades and professions essential to *la mode* were built up—millinery, dressmaking, tailoring, haberdashery, wigmaking. In these France led the world.

Changes in society were beginning to affect styles of dress. In western Europe everywhere the middle classes were establishing themselves and rapidly increasing their numbers. They challenged the dictum, accepted for centuries, that high fashion and richness of dress was a prerogative of the wealthy ruling class. It was now not only the aristocracy who paraded themselves in the latest modes, popularised by fashion dolls and the new fashion journals (see FASHION DOLL, FASHION JOURNAL). The richness of fabrics used and the quality of the ornamentation varied according to the wealth of the wearer but the styles worn were similar.

Coincident with these beginnings of egalitarianism was a slow change in the position of women in society. Their importance was increasing and so was their influence. In costume this was reflected in a gradual alteration and exchange of the relative positions held by masculine and feminine fashions. For centuries man had, as in Nature, been the more gloriously apparelled sex, a fact most clearly evidenced in the later Middle Ages and the 17th century. Gradually, after 1700, men began to take second place in this context. Masculine garments were made in darker, duller colours,

ornamentation was restrained, fabrics became less luxurious and extravagant modes in coiffure, footwear, neckwear were curbed. Men continued to dress elegantly but it was the women who appeared richly radiant. This movement advanced during the 18th and 19th centuries; at first almost imperceptibly but, gathering momentum by the 1770s, culminated in the Victorian male attired in black and grey, relieved only by a touch of white at collar and cuff.

18th-century textiles were varied and luxurious. Following French fashion, exquisitely painted, embroidered and printed silks and satins, taffetas and velvets were worn until the 1770s. Men's garments were embroidered with gold thread and coloured silks round the edges, buttonholes and pockets, ladies' were elaborately ornamented by quantities of lace, ribbon and ruching. Pioneered primarily by British inventions, the Industrial Revolution was beginning to contribute a greater quantity of fine fabrics to an expanding market in Europe. New mechanical processes were being adopted for use in weaving, spinning and knitting which led to the setting up of new textile centres and factories which, in turn, made possible a lowering of prices and consequent availability of the materials to a greater proportion of the population.

In the later decades of the century cotton became a competitor to the silks, satins and velvets which had been favourites as fashion fabrics for so long. Since the 17th century Indian cottons had been prized for their attractive designs and as a status symbol and the quantity available had increased enormously with British trading in India (see INDIENNES) but it was the infamous 'triangular trade' in which Britain and America played a leading role which established the fabric at the top of the fashion league by the end of the century. British merchants sailed to Africa to exchange their manufactured goods—arms, hardwear, jewellery—and spirits with the chieftains there for African labour. The ships then carried the slaves to America where they were sold to work on the plantations. On the third leg of the journey the ships returned to England laden with the raw cotton required for Lancashire's cotton textile industry. Costume design was ripe for change by 1775–80 and simpler styles were being adopted but the availability of cotton in quantity accelerated this process and helped to define its form.

By 1700 the *habit à la française* had everywhere become accepted

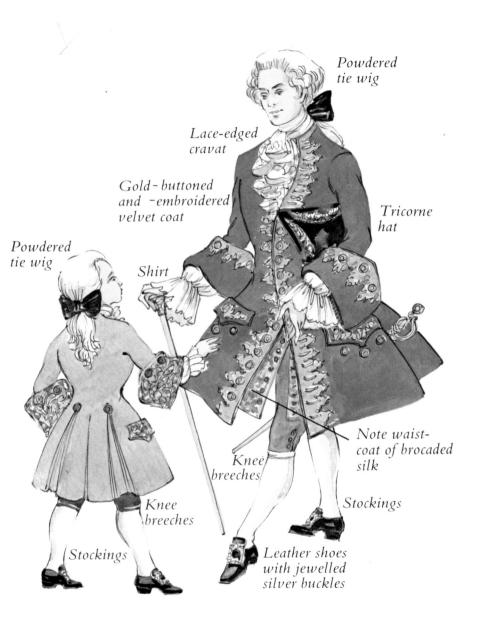

Powdered
tie wig

Lace-edged
cravat

Gold-buttoned
and -embroidered
velvet coat

Tricorne
hat

Powdered
tie wig

Shirt

Note waist-
coat of brocaded
silk

Knee
breeches

Stockings

Knee
breeches

Stockings

Leather shoes
with jewelled
silver buckles

**Fashionable Dress, 1735–50**

wear for a gentleman (see HABIT). The coat, waistcoat and knee-breeches were worn until the end of the century (see SANSCULOTTES, however), with alteration in cut being slow but continuous. The trend was away from bright-coloured rich fabrics, heavily embroidered and decorated with passementerie, and flared coat skirts, whaleboned in the seams to maintain their shape, towards a quieter, less ornamented ensemble, slimmer in cut, evincing a dignified elegance.

Wigs were worn until the 1780s, powdered for much of the time, the sides arranged in pigeon's wings or buckled and the queue finished in a variety of ways (see ADONIS, BAG, BOB, BUCKLED, CAMPAIGNE, CUT, HEDGEHOG, MAJOR, PERIWIG, PIG-TAIL, RAMILLIE, SCRATCH and TIE WIG). The tricorne hat was only superseded by the bicorne and the tall hat in the final decades (see BICORNE, COCK, KEVENHÜLLER HAT, TRICORNE).

Men still carried canes, wore gloves and possessed lace-edged handkerchiefs but their most characteristic accessory of the 18th century was the beautifully-made snuff box. Watches were still costly. Late in the century they could be seen worn in pairs as fobs below the waistcoat (see FAUSSE MONTRE).

The corset and the hoop skirt dominated the silhouette of feminine dress for most of the 18th century. The form was an artificial one though elegant and feminine (see HOOP). There were four principal phases in ladies' fashions. In the early years of the century the baroque boldness and formality of Louis XIV's court was still apparent but this was replaced in the years 1725–50 by the rococo gentleness of the time of Louis XV. Motifs of shells, flowers and ribbons predominated in dainty designs on silk dresses which were graceful and distinctive. These were the years of the sack gown and the *robe à la française* with its long box pleats (see ROBE BATTANTE, ROBE À LA FRANÇAISE, SACK GOWN, WATTEAU PLEATS).

The third phase, of the years 1750–75, was the age of extreme, accentuated fashions characterised by the vast, over-decorated coiffures, so elaborately and carefully created that they were 'opened up' only too infrequently, by the enormous caps and calashes which covered them, by the excruciatingly tight-laced corsets, the over-ornamented ruffles and flounces festooned over the hoop skirts, the high louis heels, the heavy-handed application

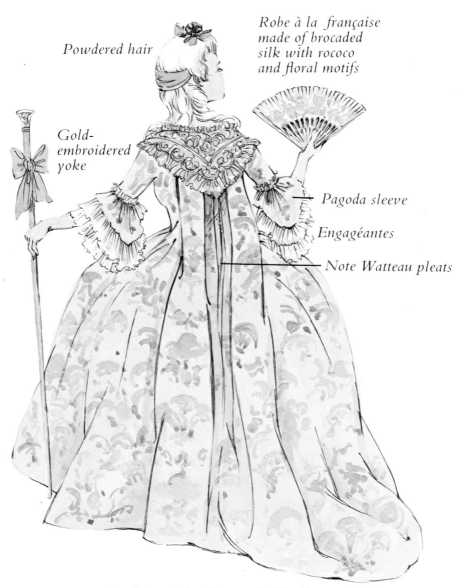

Powdered hair

Robe à la française
made of brocaded
silk with rococo
and floral motifs

Gold-
embroidered
yoke

Pagoda sleeve

Engageántes

Note Watteau pleats

**Fashionable Dress, 1750–60**

of dangerous cosmetics and the coquetry of the fan and *'mouche'* (see BAIGNEUSE, BEAUTY PATCHES, CALASH, DORMEUSE, FRENCH HEEL, MOB CAP).

By the 1770s reaction was setting in. In England a simpler gown without hoop petticoat and with a higher, less restricted waist had become fashionable. The fullness of the long skirt was drawn towards the back where a bustle helped to support the material. A soft fichu at the neck accentuated the high breastline in the modish 'pouter pigeon' effect. These softer, elegant designs became popular in Europe generally and, by 1780, 'anglomania' had finally spread to France (see BUFFONT, BUSTLE, FICHU, ROBE À L'ANGLAISE).

In western costume the chief effect of the French Revolution was to accelerate the move towards the natural form wearing a minimum of clothing. The ideals of the Revolution were translated in dress into a revival of classical themes. Ladies dressed their hair in Greek chignon styles bound with ribbons or in windswept 'Titus' cuts. They wore loose, draped gowns in white or light colours, the idea based upon classical statuary. In northern Europe women shivered in a minimum of underwear and tried to offset this with long, warm stoles decorated with Greek fret pattern borders (see TITUS CUT, TUNIC DRESS).

During the 17th century and much of the 18th the custom of dressing children as miniature versions of their parents had continued but from the 1770s an interesting divergence from this occurred. Not only were children dressed in clothes more suited to their age but the styles and types of garments worn, especially those for boys, set a precedent which was followed by adults some years later. Baby boys were still dressed in petticoats and dresses but, from the 1770s, after the age of five, the young boy was put into a frilled shirt and ankle-length trousers which were usually buttoned to the shirt (see SKELETON SUIT). Girls also were dressed in simple, unrestrictive dresses made from practical, lightweight fabrics, a freer style of wear which, like the boys' trousers, antedated a similar trend in adult dress by a decade or more.

## 8. INTERNATIONAL FASHIONS: THE 19TH CENTURY

A decline in the national influence on fashionable dress design had been taking place since the later 17th century. By the early 1800s it

was negligible; the feminine wardrobe was based upon the Parisian modes while London set the tone for men's tailoring. Local and national characteristics still moulded peasant costume and even that of the bourgeoisie where variations were myriad but the fashionable world was international.

French dominance of what was *chic* for women was absolute during the 19th century. The designs of garments and accessories found their way all over Europe and to the USA by means of fashion plates and journals. During this century there was a tremendous increase in the number of publications; at first they came mainly from England and France, but after the 1850s nearly all European countries published one or more. The Americans also entered this field and produced some world-famous journals (see FASHION JOURNAL).

Early in the century the English gentleman became established as the best-dressed and best-mannered in Europe. The noted elegants of the years 1800–30, imperturbable, ironic, graceful, were models for aristocratic bearing and behaviour. Best known of these dandies, George (Beau) Brummell, patronised by the Prince Regent, acquired a reputation for infallibility in his dress and mien which were carefully imitated all over Europe. In the Victorian era the Prince of Wales (later Edward VII) enacted a similar role, though in a different age and manner. His Royal Highness' influence on gentlemen's fashions of the last forty years of the century was considerable, notably in America, where his visit in 1860 was a great success.

The 1850s, 1860s and 1870s were decades of prosperity and luxury. Despite wars and upheavals Europe's upper classes dressed in the latest fashions made from quality materials. The styles of the two sexes contrasted vividly, each acting as a foil to the other, the men in extremely formal, stereotyped and sombre attire, the ladies dressed in a kaleidoscope of fashions, wearing through the years styles which varied from classical shifts to crinolines, from bustles to the hour-glass modes of the *fin de siècle*.

At the same time the population was increasing at a hitherto undreamt-of rate. The middle classes were expanding fast and sharing in the general prosperity. They too aspired to dress in the latest fashions and adequate availability of fabrics and even ready-to-wear garments was made possible by the technical achieve-

ments of this century, which were bringing a marked advance in mechanisation for textile production, dressmaking and marketing. Among the many important inventions which were developed were the jacquard loom to weave patterned textiles and the sewing machine which relieved the drudgery of handstitching endured for long hours by seamstresses. Indeed, it is doubtful if the immense crinoline skirts with their lavish ornamentation would have enjoyed such widespread popularity but for the invention of the sewing machine (see READY-MADE CLOTHES).

In France *haute couture*, under the direction of famous couturiers from Charles Frederick Worth onwards, had taken over the design and production of ladies' fashions and became world-famous. Live mannequins displayed the designs to wealthy clients and foreign buyers who spread the fashion throughout the west. These modes percolated through to the ready-to-wear market so that the general public could wear their, probably simpler, version. As each fashion reached this level the couturiers created a new one for their clients. Improvements in communications and transport led to the designs becoming familiarised more quickly and so to new fashions following one another at shorter intervals (see HAUTE COUTURE).

In the final three decades of the century clothes for both sexes were being designed for a greater variety of activities and occasions than before, for sport, for holidays, for the seaside. Costumes were made for tennis, bicycling, bathing, riding, mountain walking and many other pastimes. In this century the attire for some of these pursuits was, at the least, unsuitable but gradually greater comfort and informality were catered for.

By 1800 men's dress had become stereotyped. The cut and form evolved slowly; there was no marked or sudden change. Rules of etiquette strictly defined the dress to be worn by different social classes and for particular occasions or times of day.

The tail coat in its several guises was *de rigueur* for much of the 19th century. In the early decades it was waisted (corsets worn where necessary) and chest and hips were padded to accentuate this. After 1840 the line was straighter and more natural (see CUTAWAY, FROCK, MORNING, NEWMARKET and TAIL COAT). The tail coat was accompanied by a waistcoat and, at first, pantaloons strapped under the instep or, later, fuller trousers (see PANTALOONS).

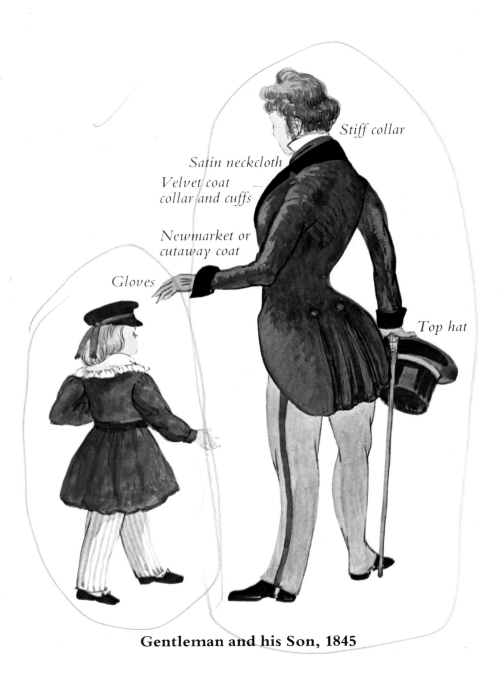

Stiff collar

Satin neckcloth

Velvet coat collar and cuffs

Newmarket or cutaway coat

Gloves

Top hat

**Gentleman and his Son, 1845**

In the middle decades of the century men's dress lost its colour; black, shades of grey and white were the uniform. Other shades began to reappear with the introduction of the three-piece suit in the 1870s. Worn at this time only for very informal occasions, loose-fitting and not well tailored, the suit was made from darkish tweeds. It was only in the years 1885–90 that the well-cut lounge suit became normal day wear, though even then not for city use.

The top hat was to the 19th century what the tricorne had been to the 18th. Alternatives for informal wear came in from the 1860s with the bowler, boater and homburg (see glossary). For further details of men's dress see BURNSIDES, CARRICK, CHESTERFIELD, CHITTERLINGS, DEERSTALKER, HESSIAN BOOT, INVERNESS, KNICKERBOCKERS, NORFOLK JACKET, PICCADILLY WEEPERS, REDINGOTE, SPATS, WELLINGTON BOOT.

In marked contrast women's styles of dress changed frequently, the form, colour, ornamentation and fabrics becoming increasingly varied as the century progressed. In the first twenty years women wore little underwear or corsetry, gowns were diaphanous and draped, the fabric falling from a high waistline just under the breasts to a train at the rear. Shawls, stoles, overtunics and pelisses helped to maintain warmth. The Romantic Age of the 1830s brought back more colour, showed a natural-level, emphasised waistline, fuller, shorter skirts, leg-of-mutton sleeves and complex coiffures enclosed in large hats and bonnets (see LEG-OF-MUTTON SLEEVE, PELISSE, TUNIC DRESS).

From 1835–40 began the process of slenderising the waist with the aid of whalebone and steel and adding more and more petticoats till the crinoline era was reached. The zenith of the style came when the cage-crinoline made the fashion available to everyone in the years 1856–65 (see CRINOLINE). Slowly the crinoline shape metamorphosed into the bustle which, in turn, changed form, first crescendo, then diminuendo in the 1870s, with a near repeat in the 1880s (see BUSTLE). Colours were strong and vivid, ornamentation was lavish and varied. Clothes were restrictive, weighing women down under multi-layers and damaging their health with tight-lacing. The styles, though hardly comfortable, were feminine and elegant but difficult to wear for the not-so-slim.

Attempts were made to influence dress towards a less restrictive

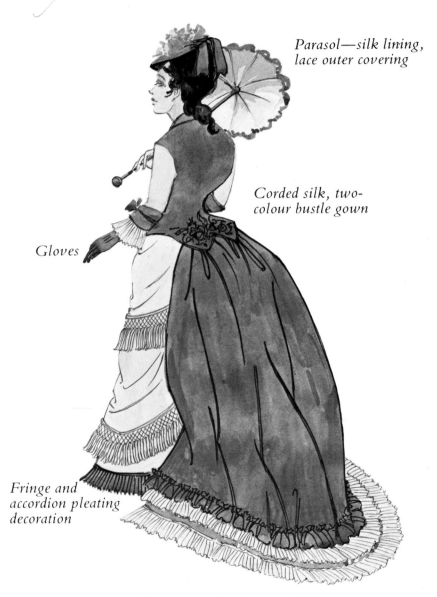

*Parasol—silk lining, lace outer covering*

*Corded silk, two-colour bustle gown*

*Gloves*

*Fringe and accordion pleating decoration*

**Promenade Dress, 1875**

line (see BLOOMERS) and, in the 1880s and 1890s, clothes were designed for sports and holiday wear which made a small concession to comfort and suitability (see RATIONALS) but, until the end of the century, elegance and corsetry went hand in hand for everyday modes.

The freer, more liberal concepts of dress suitable for children, which had been apparent in the designs of the later 18th century, lasted until the 1830s. After this clothes for children, as for adults, moved again towards restriction. In the mid-century boys' clothes tended towards the effeminate and they were kept in skirts as long as possible. From about 1860 there was more variety and sailor suits, knickerbocker suits, Norfolk jackets and blazers were available (see BLAZER, NORFOLK JACKET, SAILOR SUIT). It was the girls who suffered most, especially in the second half of the century when their clothes were closely patterned on those of their mothers. Tight-lacing, draped, be-flounced skirts worn over layers of petticoats and altogether far too many clothes were piled upon these unfortunate children.

## 9. THE YEARS 1900 TO 1945

More than in any previous age the rapidly varying fashions of the 20th century have mirrored the life of our times. The cataclysmic changes imposed on the structure of society by two world wars are clearly indicated in the styles of succeeding decades. Life before and after these upheavals was different and, in each case, there could be no return to the manner of living which had pertained before. The primarily urban society replaced an agricultural one, the emancipation of women led to their employment outside the home, national wealth was redistributed and privilege eroded. These changes would, no doubt, have come about in due course of time but each great war acted as a catalyst and accelerated the process.

With alterations in society's structure, the consequent needs, desires and expectations of its people were met in no small degree by the development of a new technology which brought as many benefits to the world of fashion as to the general mode of living. As elsewhere in life many qualities of beauty and peace, characteristic of the past, were lost; in their place came comfort and convenience and, for women at least, time to lead a fuller, more varied life.

The history of 20th-century costume is more complex than that of any preceding age. There are clothes for different functions, activities, ages and seasons. As decade succeeded decade new fashions were introduced at ever-shortening intervals. Mass production and marketing gradually brought fashion to everyone. In this confused picture there is discernible, in the first forty-five years of the century, a steady evolution of dress which passed through five principal stages. The first of these was typified in England by the Edwardian age and represents in Europe and America also the final contribution from the old world. The mode was an elaborate continuation of those of the late 19th century. A leisured class was still able to spend infinite time and money on dress and to change ensembles several times a day in accordance with the rules of etiquette for each occasion.

Until 1909–10 men were still to be seen in top hat and frock or morning coat, in lounge suit or Norfolk jacket, depending on the place and pursuit, while in the evening 'white tie and tails' was *de rigueur* in the presence of ladies. The ideal fashionable figure for women, achieved by an intractably-boned corset and the addition of padding or flounces where nature had been ungenerous, was for a full, forward-thrusting bosom, a tiny waist and generous backward-slanting hips. The whole costume, from over-decorated picture hats surmounting pompadour coiffures to ruffled petticoat sweeper hems protecting elegant trained gowns, was intensely feminine. It was frilled and flounced, beautifully decorated with lace and embroidery and quite impracticable for any purpose except to be ornamental and attractive (see POMPADOUR, SWEEPERS, TEA GOWN).

In the second decade a kaleidoscope of designs succeeded one another, reflecting a restlessness in the feminine mood of the day. In French *haute couture* Paul Poiret produced extravagant, luxurious creations, orientally exotic, made from exquisite fabrics in brilliant colours. Derived from past high-waisted Empire modes combined with eastern themes he designed sultana trouser creations worn with oriental turbans, harem skirts, kimonos and enveloping be-furred capes. Poiret was designing for the new woman of 1909–14—but not a liberated woman. His women were no longer shackled by rigidly-boned corsetry but he hobbled them with skirts so tight from knee to ankle that they could hardly walk.

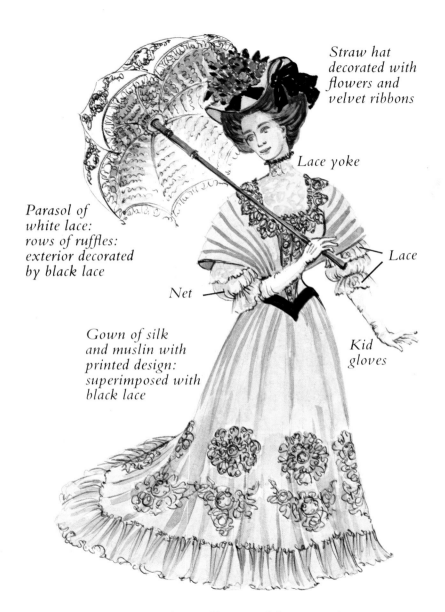

Straw hat decorated with flowers and velvet ribbons

Lace yoke

Parasol of white lace: rows of ruffles: exterior decorated by black lace

Lace

Net

Gown of silk and muslin with printed design: superimposed with black lace

Kid gloves

**Edwardian Fashion, 1904**

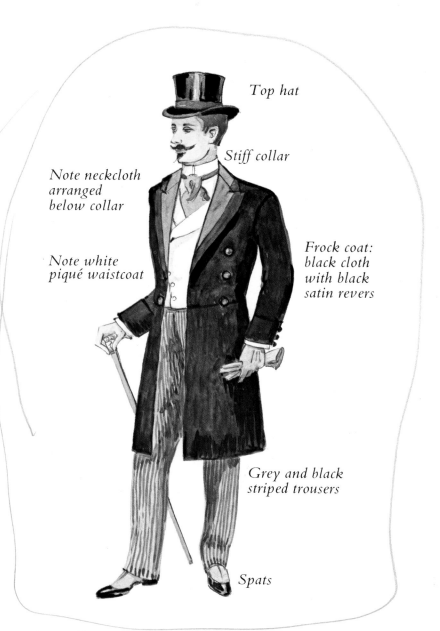

Top hat

Stiff collar

Note neckcloth
arranged
below collar

Note white
piqué waistcoat

Frock coat:
black cloth
with black
satin revers

Grey and black
striped trousers

Spats

**Edwardian Gentleman in Formal Dress, 1906**

In fashion at a more average level the full-bosomed, wasp-waisted, generous-hipped Edwardian figure was also 'out'. Corsets were worn but they were long and straight and not over-restrictive. Women wore fewer layers of underwear, petticoats were plainer and the brassière replaced the bust bodice. This softer, abbreviated design, which was an innovation in that it indicated a separation of the breasts instead of compressing them, came from America in 1913.

By 1910 a few women had begun to challenge the accepted view of their status. Some became suffragettes, some were earning a living and so independence. This was reflected in dress, in the blouse and skirt or suit which replaced the tea gown. Skirts still reached the ground but they were stripped of frills and flounces.

It was the war which accelerated the pace of these changes. Some women, a minority, wore uniform but many did war work. The absurdity of wearing hobble or lampshade skirts in a munitions factory or an office was patent. Women's growing emancipation was expressed in a skirt hem 8 inches (20·3 cm) above the ground, displaying the ankle for the first time. Hats became small, hair-styles neat, and shoes were comfortable (see HAREM, HOBBLE and LAMPSHADE SKIRT).

The post-war years of the 1920s brought great changes to dress design and habits. Men's fashions advanced slowly and hesitat-ingly towards a greater variety in colour, fabrics and types of garments. The trend was to greater informality so that the lounge suit became the city wear and sports jacket and flannels casual attire. Oxford bags for a time replaced the slim trouser line and turn-ups were general. Sports jacket and plus fours were the twen-ties' version of the Norfolk jacket and knickerbockers. They were accompanied by a knitted pullover instead of a waistcoat. Water-repellent fabrics were now of good quality and most men posses-sed a raincoat (see OXFORD BAGS, PLUS FOURS, TRENCH COAT).

The revolution in feminine dress which occurred in the 1920s has been highlighted and somewhat exaggerated. Skirts did not rise above the knee nor were they mere tight tubes. The more extreme styles of the years 1925–7 worn by the fashionable young had a sexless appearance and were only suited to a slim, boyish figure. Nevertheless, the effect on women of the complete change brought about by a freedom from ground–length skirts, layers of

petticoats, unyielding corset cages and unmanageably long hair cannot be over-estimated.

All this was a reflection of the new freedoms opening up for women to choose careers, to study at university, to enter the professions. For a while it went to their heads. In demanding freedom to do as men did—smoking, free love, freedom of attire—many women assumed that to work successfully in a man's world they must appear masculine or, at least, unfeminine. For ten years women tried to hide the attributes of femininity which they had hitherto, in different ways and in different ages, accentuated: breasts, sloping shoulders, small waist, spreading hips, long hair.

The fashionable figure of the 1920s was slim and straight. A 'flattener' brassière partially concealed the swelling breasts. The natural waistline was ignored and the sash or belt encircled the hips. Necklines were plain and many dresses sleeveless. The hemline was the most variable characteristic, though it was the same for all garments, coats, suits and dresses whether for day or evening wear. In 1921–2 it was ankle-length; it was raised slowly to its shortest level, covering the knee, in 1927; then it descended in 1929–30. In the years 1927–9 designers tried to lower the line and introduce variety by adding longer, floating panels of draped fabric at sides and back.

Not the least revolutionary change was in the feminine coiffure. Many women had the hair cut short to a bob and then, in the mid-twenties, to a shingle. The marcel wave gave easier control and slightly longer styles reappeared by 1928 but few women returned to long hair. The deep-crowned hat, cloche or wide-brimmed, was fashionably pulled down to eyebrow level.

With shorter skirts stockings became more important. Flesh-tones were worn in silk, lisle or wool. Shoes and boots had high, curved heels (see CLOCHE HAT, ETON CROP, MARCEL WAVE, SHINGLE).

The fashionable figure of the 1930s was still slim but no longer boyish; femininity had returned. The waistline was at its natural level, accentuated by belt and shaping, the breasts were no longer flattened but defined in a brassière which, by 1937, was beginning to be an uplift bra. Skirts were longer with hems about 8 inches (20·3 cm) from the ground, and were pleated or gored. The material was often bias cut to ensure a clinging fit and a draped effect. There were now two lengths, one for day-time and another,

ground-length, for evening. These evening gowns were fashion-
ably backless with halter necklines or, by 1938–9, strapless with
boned bodices (see BIAS CUT, HALTER NECKLINE, UPLIFT BRA).

While men were clean-shaven and opted for a 'short back and
sides', women grew their hair a little longer now and had it
'permed', set in careful firm waves and curls. They wore hats in a
wide variety of styles. Costume jewellery became fashionable and
ladies carried cosmetics for running repairs, especially a powder
compact (flapjack) and lipstick. (See PERMANENT WAVING.)

War-time styles were influenced by the high proportion of the
population in uniform. The square box silhouette with padded
shoulders and knee-length skirt lasted until 1946. In Europe these
were years of austerity and clothing coupons. With utility designs
fashion changed little.

For both sexes there was by 1930 a greater choice of fashions for
differing needs and occasions. Beach wear, swim wear, holiday
wear, clothes for walking, cycling, sports in general, parties,
dances and for work: all were available. The Americans were now
exerting a stronger influence on fashion, not yet in the design of
clothes, which still came from Paris and London, but in mass-
production methods, marketing and publicity and, above all, in
technological advance, which was beginning to bring great
changes to fabrics, fastenings and the types of clothes worn.

The American way of life in the 1930s and 1940s, oriented
towards centrally-heated, air-conditioned buildings and transport
by private motor car, was far in advance of the European one.
From America came informality of dress and more easy-care
clothing. The American cosmetics industry was big business with
leading names such as Helena Rubinstein, Elizabeth Arden, Yard-
ley, Max Factor and Pond.

Research had been pursued since the 1880s in France to perfect an
artificial textile. Artificial or 'art' silk, as it was known, became an
important costume material in the 1920s. In 1924 the name 'rayon'
was coined in America for this synthetic fabric made from a
cellulose base. Nylon was developed in the USA by Du Pont over
the years 1927–38, a research project costing over 27 million
dollars, and the fibre was made experimentally into stockings in
1937. Articles made from it went on sale in the USA in 1940.

The development of Lastex (extrusion of liquid latex into fine

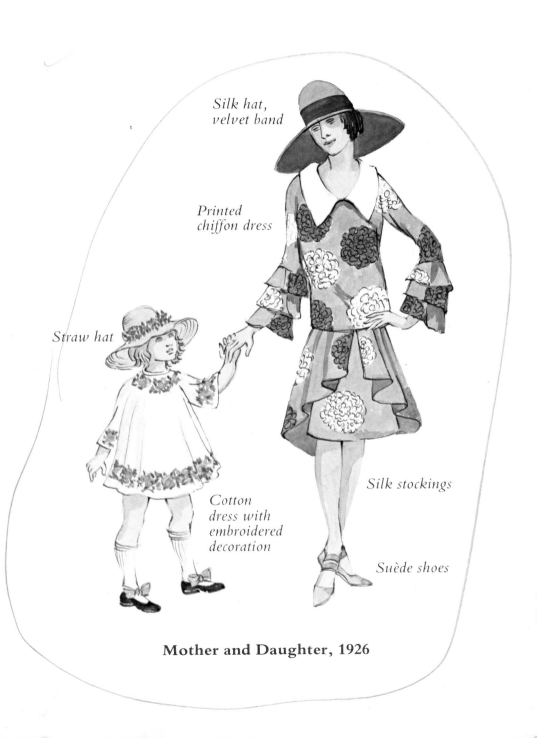

Silk hat,
velvet band

Printed
chiffon dress

Straw hat

Cotton
dress with
embroidered
decoration

Silk stockings

Suède shoes

**Mother and Daughter, 1926**

elastic threads) by Dunlop in the early 1930s was a major break-through for corsetry. Together with the zip fastener (zipper), the resulting two-way stretch roll-on and pantie girdle made boned corsets a thing of the past for all women except the stout and middle-aged.

## 10. THE MODERN WORLD: 1945–1980

It is very much more difficult to discern a logical pattern in the styles of dress in these years than in the first half of the century. Fashions have changed much more quickly and the pace of change has accelerated as time has passed. For both sexes the development of a wide variety of synthetic fabrics which have incorporated easy-care techniques has led to new possibilities in fashion, in texture and patterns. Also, for both sexes, the trend has continued towards casual types of clothes, with formality reserved more and more for specific occasions. From the later 1960s onwards the emphasis has been on personal choice or, in contemporary par-lance, 'doing one's own thing'. The rigid rules of etiquette which, until about 1920, governed what might or might not be worn for certain functions or at particular times of day, have disappeared. It is now left to the individual to wear what suits and pleases him or her whatever the occasion. At the same time fashion has been brought to everyone by the department store and the latest designs are available at a varying level of cost. The more one pays the better the quality but the design may be similar at different prices.

But whereas for women revivals follow one another at speed and only occasionally has something original been designed, for men the clothes of the years 1945–80 are related to the styles of earlier times and have presented a logical evolution from them. There are two factors here: the availability of easy-care materials and the alterations in cut and line. The introduction of man-made fibres with associated qualities of crease-resistance, permanent pleating, pre-shrinking and other characteristics has brought within the range of the average man lightweight, non-iron sum-mer suits, a variety of shirt or casual tops, rainwear and gay holiday clothes which have immensely widened his wardrobe possibilities. Worsted and tweed are still used for men's suiting but many fabrics are now mixtures, incorporating man-made fibres to add durabil-

ity and easy-care properties. Weaves, patterns and colours show far more variety than ever before.

In cut and line men's clothes have also changed more quickly than previously. Since 1945 there have been the very narrow, cuffless trouser, the hipster line, the bell bottoms with return of cuffs, the waisted jacket, the fuller design, the car coat and many others. But, as in women's dress, if a man wishes to retain a certain line, he may and provision is made for him. Casualness is the keynote but, in evening wear, the options are considerable. Richly-toned velvet jackets, cummerbunds and decorative shirts with appropriate ties are part of the scene which encourages a man to develop his own personality in what he wears.

In women's fashions revivals have followed one another faster and faster so that, by the late 1970s, we have reached a situation where a woman in her late fifties is now being invited to wear once again the designs which she adopted in her twenties and thirties.

Apart from these revivals certain innovations and presentations stand out from these years. For example, Dior's New Look of 1947 which, although retrospective in a number of ways, provided a psychological 'lift' to women at a time when it was sorely needed. All the politicians had to offer after six years of war and austerity was yet more austerity. Dior gave women femininity and a new hope (see NEW LOOK). It did not last because such feminine clothes were no longer practical for women who were now combining two jobs, at home and at work, but for many years the feminine line prevailed, at least for party wear.

The most original fashion concept of these years was the mini-skirt. Very much a young person's style of 1965, it attained such heights of popularity that it seemed, even in the early 1970s, that its public would never let it die. The mini-skirt started at a level a little above the knee. It climbed higher and still higher to become a micro-skirt, barely covering a girl's seat. A necessary accompaniment was nylon tights. Stockings were, thenceforth, 'out' and so were girdles and suspenders. By 1970 hot pants followed but never achieved a following since they were merely short shorts, totally impracticable for office wear and suited to only a few female bottoms. Similarly unisex clothes were restricted to *aficionados* (see HOT PANTS, MINI-SKIRT, UNISEX).

The fashion for the maxi-skirt, not only as a long skirt or dress

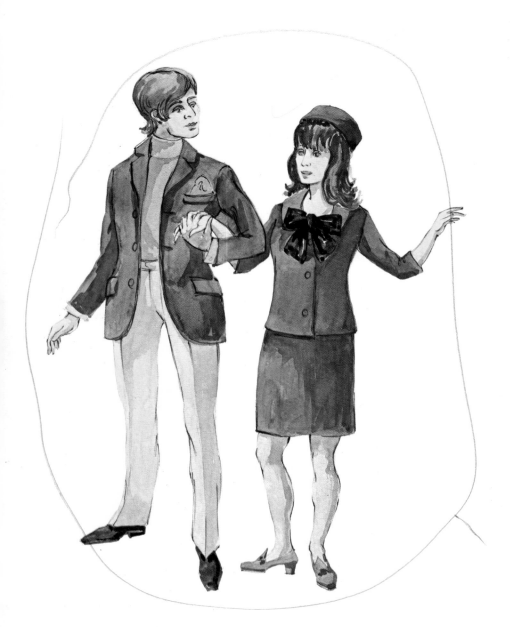

The Modern World: 1967

for evening wear, but for day coats and dresses was, like the mini-skirt, hot pants and unisex clothes, characteristic of the importance now accorded to designing for the young. The tendency to 'cash-in' on this market had been growing since 1945. The trend could be seen in many forms—gramophone records, transistor radios, soft drinks packaging. Advertising was directed more and more towards this potentially profitable market. In the 1960s a complete wardrobe for teenage boys and girls was evolved, unsuitable and almost unwearable for adults: in this lay part of its attraction. Clothes were tight-fitting and informal. The basic designs, especially blue jeans, uniform of the young for so many years, came from the USA (though, for a decade, London's Carnaby Street was a Mecca for the young of the western world). Boys and girls tended to dress alike. For centuries, when very young, they had done so but, before boys had been dressed in skirts like their sisters. Now girls dressed like their brothers.

From the 1950s onwards the supremacy of French *haute couture* was being eroded. When, with the fall of Paris in 1940, the flow of designs to the USA was halted, the Americans began to develop their own couture. Mainbocher returned to America, other designers followed and, in post-war years, new ideas began to emerge from the American continent. At the same time other European countries began to build up their couture. Italy became an important centre for shoes (see STILETTO HEEL), for silk blouses and dresses (Turin) and for knitwear and textiles. Spain, Ireland and Switzerland followed.

The sophisticated technology which, in the last fifty years, has brought to fashion a complex range of synthetic textiles with safety and easy-care properties, has largely been the result of research and development in the USA. European countries have contributed many new ideas and laboratory research but only America had the financial resources and population with power of purchase to sponsor much of the work. Apart from the production of nylon (see section 9), there have followed polyester and acrylic fibres, elastane, metallic yarns, synthetic furs and finishing processes of great importance which we now take for granted. These include crease, flame and mildew resistance, water-repellence, pre-shrinking, moth-proofing, permanent pleating and bonded fabrics.

Dress with
accordion-
pleated
bustle skirt
1880

# GLOSSARY OF TERMS

**ACCIAMARRA:** see CHAMARRE.

**ACCORDION PLEATING:** as in the bellows part of the musical instrument, the fabric is folded and pressed so that equal amounts are taken up inward and outward. Used for sleeves and skirts from the 19th century onwards.

**ADONIS WIG:** a full, flowing, white wig worn by men in the first half of the 18th century.

Gold
aglets in
black
velvet cap
1530

Aglets on
doublet
and hose
1475

**AGLET (AIGLET, AIGUILETTE):** in the later Middle Ages one garment was fastened to another (e.g., hose to doublet) by means of laces passed through eyelet holes (see POINTS). These laces were finished with decorative metal tags known as aglets, a term which was the anglicised version of the French *aiguille*, 'needle'. By the 16th century aglets were often costly, of gold or silver, chased or jewelled, and the laces were used to join together the fashionable slashes which ornamented all gar-ments—sleeves, hats, doublets, gowns (see SLASHED GARMENTS). 17th-century aglets usually finished the ribbon ties and bows which ornamented the waist-line of the masculine doublet or the feminine gown. After the mid-century this method of fastening was replaced by buttons or hooks.

**AGRAFFE:** a word deriving from the late Latin *grappa*, 'a hook'. In the early Middle Ages an agraffe was a fastening for clothing in the form of a hook attached to a ring, making a buckle. In the 18th and 19th centuries it became a jewelled metal clasp used to fasten a cloak at the throat or to ornament a turban, hat or gown.

Aigrette
1800

Aigrette
1899

**AIGRETTE (EGRET):** a tall feather plume or plumes worn vertically to ornament a lady's even-ing coiffure or her hat. Especially fashionable in the years 1785–1805 and 1885–1900. Most favoured were feathers from the egret (the white heron) and the osprey.

**ALBERT WATCH-CHAIN:** in the late 19th

century, a heavy metal chain, preferably gold, which was slung across the front of a gentleman's waistcoat. The watch, attached to one end, was slipped into a pocket on one side and at the other end was a guard (a metal rod or weight), which was concealed in a pocket on the opposite side. In the centre the chain was passed through a hole in the waistcoat.

ALBORNOZ: a hooded travelling cloak worn in 17th-century Spain. The word, and garment, were derived from the Arab burnous which had been introduced originally into the Iberian peninsula by the Moors.

ALL-IN-ONE: see CORSELETTE.

ALOHA SHIRT: a brightly-coloured, patterned shirt of Hawaiian origin popular in the USA as beach and sportswear from the 1930s onwards. Worn outside the trousers or trunks, it had short sleeves and a patch breast-pocket. Since the Second World War it has been widely adopted all over the western world.

ALPARGATA: traditional Spanish footwear worn since the years of the Moorish occupation, in the form of a sandal made of hemp or esparto grass. The term derives from the Arabic word for 'a pair' which, in Christian usage, became *el-par-korkat* and, later, *alpargate*. The sandal is still worn in the Pyrenees; it is similar to the Mediterranean rope-soled canvas shoe (see ESPADRILLE).

ANDROSMANE HAT: see KEVENHÜLLER HAT.

ANILINE DYES: in the second half of the 19th century aniline dyes were produced from coal tar. The colours obtained included some brilliant shades of purple, red, blue and green, which became very popular for clothes and furnishings: magenta, fuchsia and alizarin were typical.

ANORAK: the modern anorak is a hooded, long-sleeved, hip-length garment worn for sports such as mountain walking, skiing and sailing. It is made of lightweight, water-repellent material and may be padded for extra warmth and wind resistance. It derives from the Eskimo sealskin garment which was known as an anorak in Greenland but as a PARKA in the Aleutian Islands.

Albert watch-chain 1875

Aloha shirt

Alpargata

Anorak

Ascot tie
English
1892

Attifet
head-
dress
German
1595

Babouche

Bag-
pipe
sleeve
English
1380

Bag
sleeve
Italian
1435

AQUATIC SHIRT: an informal brightly-coloured cotton shirt, usually striped or checked, worn in the 19th century for boating and also as country and seaside wear.

ARO: the hoops of wood which were inserted at regular intervals into the Spanish farthingale skirts of the 15th and 16th centuries (see FARTHINGALE, VERTUGADO).

ASCOT TIE: masculine neckwear of the second half of the 19th century in the form of a broad scarf with a narrower neckband. It was folded and crossed over to show the flat, square ends, then was held in place at the crossing by a decorative tie-pin (see also OCTAGON TIE).

ATTIFET: a heart-shaped feminine head-dress of the 16th century which dipped to a point in the centre over the forehead and curved back in an arc on each side. The edge was usually wired to hold the form and was decorated with lace or a frill. The attifet was made of linen or silk, often embroidered and with an attached veil. Made in black it was a traditional mourning head-dress for women (see also WIDOW'S PEAK).

AUTOMOBILE TOGS: see MOTORING DRESS.

# B

BABOUCHE: a Turkish slipper worn extensively in the Moslem world. Traditionally it was a mule type of design, having no back or heel, and was generally made of coloured leather richly decorated with gold or silver.

BAGPIPE SLEEVE, BAG SLEEVE: a very full sleeve fashionable especially in the 15th century which was drawn closely into the wrist but draped in a pendant manner from the forearm, forming a large bag or pouch which was put to use as a pocket.

BAG WIG: a method of dressing the end or

queue of a man's wig in the second half of the 18th century. The queue was enclosed in a square, black silk bag drawn up with strings at the nape and finished there with a black bow. The style was especially fashionable in the years 1750–75. It was popular partly because the bag protected the coat from the wig powder and partly because of its use when concealing hair which was being grown, for many men preferred to retain their natural hair, powdering and styling it to imitate a wig.

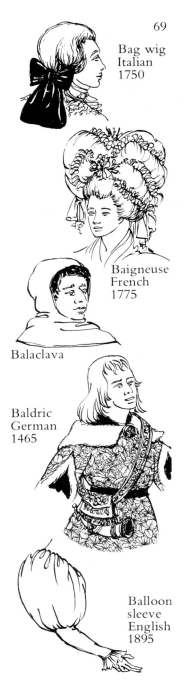

Bag wig
Italian
1750

Baigneuse
French
1775

Balaclava

Baldric
German
1465

Balloon
sleeve
English
1895

BAIGNEUSE: an extravagantly large cap, tucked, be-ribboned and flounced, worn originally (as the name suggests) by 18th-century ladies in the bath. From the 1770s it became a day-time covering to the complex and immense coiffure styles.

BALACLAVA HELMET: a knitted wool covering for the head and shoulders worn chiefly by men on active service as a protection from the cold. It was named after the site of the battle of October 25, 1854, in the Crimean War.

BALANDRANA: an early medieval long travelling cloak worn by both sexes. It had long, wide sleeves and an attached hood. A similar design was revived in the 17th century.

BALAYEUSE: see SWEEPERS.

BALDRIC (BALDRICK): a broad belt or sash made of leather or fabric, often richly ornamented, worn round the body diagonally from the shoulder to hip and in general use from about 1360 to 1700. From the baldric was suspended the sword or dagger, powder horn, pouch or bugle. The lower edge of a medieval baldric could be decorated by a row of little bells. Similar belts made of heavier, woven fabric were manufactured later for military use or hunting. Like the North American Indian version, woven in multicoloured designs, these were referred to as **bandoliers** (**bandoleers**).

BALLOON SLEEVE: a feminine style fashionable in the 1830s and again in the 1890s. It was a long sleeve, fitting on the forearm but immensely full and puffed on the upper arm and gathered into the armhole. The puff was generally stiffened and/or padded. Also known as a MELON SLEEVE.

BAND: at the beginning of the 16th century this term referred to the neckband of a man's shirt or a

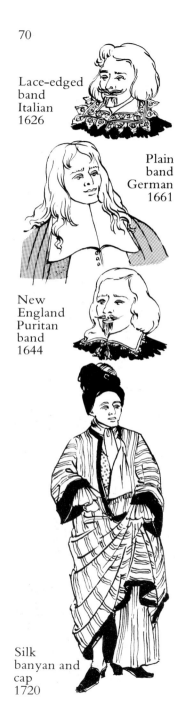

Lace-edged
band
Italian
1626

Plain
band
German
1661

New
England
Puritan
band
1644

Silk
banyan and
cap
1720

woman's chemise. Gradually the meaning altered and the word was used to describe the separate neckwear which was tied at the throat by small tasselled strings known as **band strings**. During the 16th century neckwear at first took the form of a small collar, the edges of which began to be ruffled. After the mid-century this became a ruff, at first small but, after 1570, growing steadily larger (see RUFF). In the late 16th and the 17th century the band became a large collar, either upstanding and framing the neck or falling gracefully over the shoulders (see COLLET MONTÉ, COLLET ROTONDE, FALLING BAND, GOLILLA, STANDING BAND, WHISK). In the 17th century a pair of white linen strips or tabs were attached to the neck band in front; these were termed **short bands**. Their use was perpetuated in ecclesiastical, academical and legal dress.

16th-century ruffs and 17th-century collars were generally costly and were prized possessions. They needed frequent laundering and, in the former instance, starching and were stored carefully in circular boxes designed for the purpose. These were termed **band boxes**.

BANDANNA (BANDANA): in the 18th century a large coloured silk handkerchief with rich, dark ground patterned with white or yellow spots, imported from India and used as a neckcloth. The name derives from the Hindustani *bandhnū*, which refers to a method of tie-dyeing. The lighter spots on the material were obtained by tying the fabric to prevent its receiving the dye. In the 19th century bandannas were often made of cotton and the pattern was produced by chemical means.

BANDOLIER (BANDOLEER): see BALDRIC (BALDRICK)

BANYAN (BANIAN): a long, loose coat or gown imported from India in the second half of the 17th century and worn by gentlemen as a negligé garment for relaxing at home. Called after an Indian loose gown which in turn derived from the name for a Hindu trader in the province of Gujarat. The banyan, also known as the INDIAN GOWN, became especially fashionable in the 18th century. It was made of richly patterned material, beautifully lined, and was cut with loose sleeves and a full skirt reaching to the knee or ankle. It could be held to the figure by hand or sash, be buttoned or worn loose. Gentlemen wore especially fine examples to receive visitors or even to step out-of-doors during

the daytime. In Colonial America the banyan was worn extensively in the South where, in the more informal plantation life, it was regularly seen as an outdoor garment.

BARBETTE:   a feminine head-dress of the 13th and early 14th centuries, generally made of white linen. In England, the name usually refers to a band worn under the chin and fastened on top of the head or to the hair on each side above the ears. The French more commonly use the term to describe a piece of material which is similarly fastened to the hair above the ears on each side of the face but which then falls in draped folds to cover the throat; in many instances it covers the chin also. The barbe was worn in a similar manner but its use is generally associated with mourning (see MOURNING BARBE). The wimple was formed by the marriage of a veil or couvrechef with the barbette (see COUVRE-CHEF, WIMPLE).

BARROW:   a 19th-century warm covering for a young baby. The flannel or knitted wool material was wrapped round the baby's body and was then turned back in a deep fold over its feet, making a bag. The barrow, or barrow coat, was pinned or ribbon-tied at the bottom and at the baby's neck. In modern times the barrow has been replaced by the zipped-up carry bag.

BASQUE:   an extension of the bodice of a garment slightly below the waist forming a short skirt. This was a characteristic finish to the man's doublet and jerkin of the 16th and early 17th centuries, when it was often cut into decorative tabs to adapt the material to the curve from waist to hip. The name derived from the Basque (Spanish) style of the 16th century.
   In the second half of the 19th century jackets and gowns with basque finish at the waistline were fashionable in feminine dress. In the years 1863–78 the basque was concentrated at the back and cut into tabs which rested on the crinoline and bustle draperies.

BASQUINA (BASQUINE):   a Spanish skirt worn by ladies of the 16th century in conjunction with the farthingale petticoat. The basquina (basquine is the French term) could be worn under the farthingale petticoat, in which case it was usually made of a rich, black material. As time passed it was

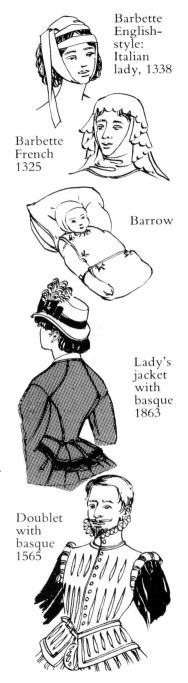

Barbette English-style: Italian lady, 1338

Barbette French 1325

Barrow

Lady's jacket with basque 1863

Doublet with basque 1565

Bateau neckline 1964

Batwing sleeve 1972

Bavolet 1864

more often seen on top of the farthingale, when it was fashioned from a heavy, luxuriously-ornamented fabric. In style it was frequently fastened down the centre front with decorative, jewelled points; alternatively, it could be worn open in an inverted V shape.

BATEAU NECKLINE: a boat-shaped line without collar, similar at back and front and extending from shoulder to shoulder.

BATIK: a Javanese word meaning wax painting which describes an ancient method of resist-dying of fabrics. The origin of the process is not certain; it is thought that it might have come from China but the source is considered more likely to have been India.

In Java the resist is made from beeswax mixed with paraffin, resin and some animal fat and this is applied to the material, usually cotton or silk, by the slender spout of a *tjanting* (a copper cup held by a handle on the opposite side) to cover the parts of the design which are to be left uncoloured. The process is repeated for each colour used.

In modern batik work in America and Europe a fine brush is generally used instead of a *tjanting* and a wider variety of fabrics is employed.

BATTS: in the 17th century, heavy, low shoes laced in front, for rural wear. Worn extensively in the American Colony of New England from the 1640s onwards.

BATWING SLEEVE: a design cut very wide at the armhole, almost to the waist, and diminishing to fit snugly at the wrist. It is a modern term and the sleeve may be set into an armhole or cut in one with the garment.

BATWING (BATSWING) TIE: a late 19th-century bow tie with ends shaped like bats' wings.

BAVOLET: the gathered 'curtain' attached to the brimless back of a lady's bonnet from about 1830 until the 1880s.

BEANIE (BEANY): see CALOTTE.

BEARD BOX: a pasteboard box put on in bed by a fashionable gentleman of the 17th century to maintain the carefully-groomed shape of his beard.

**BEAU:** the 18th-century term for a dandy, fop, exquisite: a gentleman who devoted excessive time and care to his manners and the elegance of his appearance. During the 18th century several of these dandies—Beau Feilding, Beau Nash and, best known, Beau Brummell, were famed throughout Europe for their style, distinction, imperturbability and nonchalance, establishing the high reputation of English tailoring and demeanour.

**BEAUTY PATCHES:** a fashion, which has recurred from time to time, for applying tiny shapes cut from adhesive-backed material to the face, neck, breasts and arms. Both sexes wore them in ancient Rome, and 16th-century Italy re-introduced the custom to the rest of Europe. The fashion for 'patching the face', as it was termed, was most prevalent in the 17th and 18th centuries when patches were cut from black silk, taffeta or velvet into a variety of shapes—stars, hearts, crescent moons, etc.—and were carried on the person in beautifully-made, costly **patch boxes** which contained a mirror in the lid, useful for running repairs. Seven or eight patches (called *mouches*, 'flies' by the French) might be applied to hide smallpox scars, but they also represented a silent, though expressive, language according to their shape and placing. For example, a patch on the right cheek indicated that the wearer was married, on the left that she was affianced, when set near the mouth it signalled that she was flirtatious but at the corner of the eye that she was passionate.

**BEDGOWN:** a loose negligée gown worn during the 18th century in the bedroom by both sexes. The name was also given to a loose house gown worn by women in the mornings which had elbow-length sleeves, a bodice and a long skirt open in front displaying a petticoat. This type of bedgown survived as a basis for so-called Welsh national dress in the 19th century.

**BEEHIVE BONNET, BEEHIVE HAT:** a late 18th-century hat shaped like a beehive and with a narrow brim which was adapted in the early years of the 19th century into a bonnet style, usually made of straw and tied under the chin with ribbons.

**BEEHIVE COIFFURE:** a bouffant hairstyle of the 1950s shaped like a beehive and backcombed to produce sufficient height.

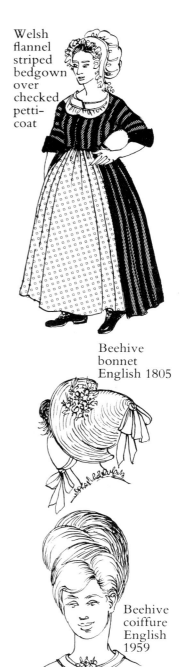

Welsh flannel striped bedgown over checked petti-coat

Beehive bonnet English 1805

Beehive coiffure English 1959

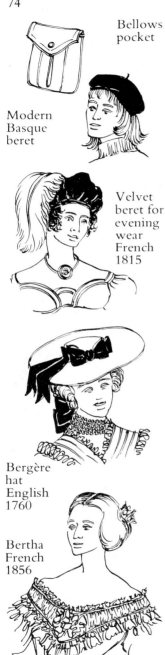

Bellows pocket

Modern Basque beret

Velvet beret for evening wear French 1815

Bergère hat English 1760

Bertha French 1856

BELLOWS POCKET: a patch pocket sewn on the exterior of a jacket or coat having vertical pleats which could expand or lie flat like a bellows; a buttoned flap held the pocket closed. Suitable for sporting or hunting coats and seen especially in late Victorian Norfolk jackets.

BERET: a very simple form of head-covering for either sex which dates from ancient times. It comprises a circular piece of felt, knitted or woollen cloth which is drawn up by a thread or leather thong to make it fit the head.

Such caps were made by the Bronze Age inhabitants of northern Europe, by the Cretans, and in ancient Greece and Rome, and the style reappeared at intervals throughout the Middle Ages as in, for instance, the biretta. The characteristic tail was sewn on last to cover the eye of the weave.

These types of cap were generally fairly fitting to the head but in later times a much fuller style became fashionable and was decorated with plumes and ribbons. An example of this was the modish beret worn by ladies in the 1820s and 1830s, especially with evening attire. Also full were the traditional Scottish coloured wool Kilmarnock cap and the tam-o'-shanter (see KILMARNOCK CAP, TAM-O'-SHANTER).

The modern beret, in use for military wear, for working men and as a recurring fashion for women, is more closely related to the Basque beret popularised by the French in the 1920s as a working cap.

BERGÈRE (SHEPHERDESS) HAT: a style fashionable from the 1730s until the end of the 18th century and revived in the 1860s. It was a straw hat with a wide, soft brim and a flat crown.

BERMUDA SHORTS: an American term and style denoting knee-length shorts worn by both sexes, especially for sport and relaxation, since the Second World War.

BERTHA: a wide collar or fall which lay on the shoulders of a gown enclosing a décolleté neckline. It was made of ribbon and layers of silk or lace ruffles. A BERTHA-PÈLERINE was similar but extended in two long ends down the centre front to the waist. This was more fashionable with evening gowns. Both styles were typical of the 1840s and 1850s.

BESPOKE:   see CUSTOM-MADE.

BETSIE:   a small ruff or collarette, which in France was called a *cherusse* (a corruption of *collarette à la Cyrus*), made of several layers of lace or lawn, worn by ladies round their throats in conjunction with the décolleté gowns of the early years of the 19th century. The English term was called after Elizabeth I of England.

BIAS:   material cut on the cross: i.e., a woven fabric cut diagonally across warp and weft threads. The purpose is to achieve a closer fit of the garment which then hugs the body. The term originated in the 15th century when this method of cutting was used for fitted hose. In more modern times it was the couturière Madeleine Vionnet who introduced, in the 1920s, a new technique of bias cutting particularly suited to her creations of draped classical gowns.

BIBI BONNET:   a style of the 1830s and 1840s, where the crown was small and continued in one line with the brim, whose sides hid the cheeks. Also known as a COTTAGE BONNET.

BICORNE:   a man's hat of the later 18th century and the early years of the 19th which had developed from the three-pointed tricorne. The bicorne had two points and was often used as a military hat as can be seen in portraits of Napoleon Bonaparte (see also TRICORNE).

BIEDERMEIER:   a term used to describe the style of interior decoration and furniture in Germany in the years 1820–45 and also employed to distinguish the dress of the time in German-speaking countries.

BIGGIN:   a cap shaped like a coif. The name derives from *béguin*, a French word which referred to the coif worn by the Béguines, a lay sisterhood initiated in the Low Countries in the 12th century.
    The term 'biggin' has been widely used over the centuries for caps shaped like coifs: e.g., a baby's bonnet, and a child's coif-like cap. The word was also used to refer to the coif worn by men under the heavy 17th- and 18th-century wigs, and a man's night-cap of the same period (see COIF).

BIKINI:   see G-STRING.

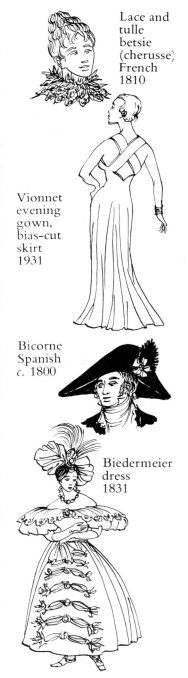

Lace and tulle betsie (cherusse) French 1810

Vionnet evening gown, bias-cut skirt 1931

Bicorne Spanish c. 1800

Biedermeier dress 1831

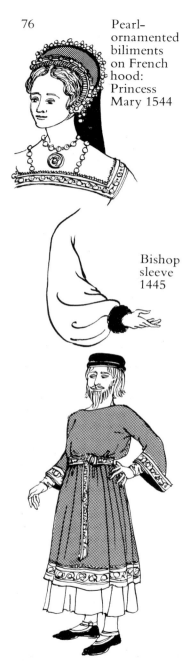

Pearl-ornamented biliments on French hood: Princess Mary 1544

Bishop sleeve 1445

Nobleman's bliaud late 11th century

**BILIMENT:** a 16th-century term for an ornamental edging of lace or jewelled metal. Applied specifically to the frontlets of the Tudor French hood, worn from the 1530s until about 1560, where the two jewelled metal biliments were generally separated by silk, satin or velvet bands (see FRENCH HOOD, FRONTLET).

**BILLYCOCK:** colloquial term for a bowler hat, thought to derive from its popularisation by William Coke of Holkham, Norfolk (see BOWLER).

**BISHOP SLEEVE:** a long, softly-draped, full sleeve gathered into a fitted band or cuff at the wrist. This was based on a bishop's rochet and was fashionable in the 19th and 20th centuries. The style was most fashionable for sheer fabrics so has been most often used for ladies' dresses and blouses.

**BLAZER:** a lightweight jacket made from brightly-coloured flannel and often striped, adopted for summer and sports wear. Used as a distinctive garment for clubs, schools, universities and regiments, when the breast-pocket generally carried the appropriate badge. The name derives from the scarlet colour of the original, university jacket, but from the 1880s it was applied to any brightly-coloured jacket.

**BLIAUD (BLIAUT):** a long, loose, belted overgown or overtunic worn by both sexes in the Middle Ages from the 11th to the early 14th century. A nobleman's bliaud was ankle- or calf-length; that of men of other classes could be shorter, generally reaching to the knee. Women's versions were ankle- or ground-length. The garment had a round neck and full sleeves and was often richly decorated, especially at hem, cuffs and neck. The word derives from the German *blialt*, 'cloth'.

**BLOOMERS:** it was in 1851 that Mrs Amelia Jenks Bloomer travelled to London and Dublin to display and publicise at mass meetings the Reform Dress (or Bloomer attire), which was an early attempt to free women from the constriction of corset and crinoline and give them something healthier and more comfortable to wear. The outfit had been designed by Elizabeth Smith Miller. When she wore it on a visit to Seneca Falls (in America), her friend Mrs Bloomer, a journalist and writer who lived there, took it up with enthusiasm.

The Reform Dress was received by many

women and nearly all men with disdain, horror and distaste. It was regarded as immodest and unfeminine and men saw the trousers, in particular, as a symbol of a future feminine intrusion into their prerogative. Yet the outfit was hardly outrageous—only, perhaps, a little absurd and ahead of its time. The idea died quickly, especially in Britain. It consisted of a jacket and knee-length skirt worn over full, Turkish-type trousers.

It was the trousers to which the word 'bloomers' was applied and this stuck, being used ever since to describe any knee-length, loose, leg garment worn by women. It reappeared in the cycling knickerbockers of the 1890s (see also RATIONALS) and again in the long, full knickers worn as underwear in the earlier 20th century by ladies; also, as a slightly derisory term, for the schoolgirls' knickers worn under the gym tunics of the inter-war years.

BOA: a long, cylindrical tippet made from feathers, fur, lace or tulle, fashionable in the first and last decades of the 19th century, revived in the 1920s and again after the Second World War. The boa was long (up to 7 or 8 feet, 2·5 metres) and ladies wound it round the neck and allowed the ends to hang to the knees. The name stems from the similarity in appearance to the South American family of serpents which kill by constriction.

BOATER: a hard straw hat fashionable as summer wear for men in the 19th century. It was so-called because, in England, it was widely used on the river. The boater had a flat, low crown decorated by ribbon and bow and a flat brim.

BOBBY PIN: an American term for a metal clip or hairpin first developed to hold the newly-shorn hair of the 1920s. The English word was KIRBI-GRIP.

BOB WIG: in the 18th century a wig for informal wear which did not possess a queue.

BODY (BODYS): an underbody stiffened by a mixture of paste between two layers of linen, made to define and control the feminine torso. This body, or 'pair of bodys' as it was known since it was made in two parts fastened up the front and back, evolved in answer to the demand for the more figure-revealing gowns of the 15th century. The term later developed into 'bodice'.

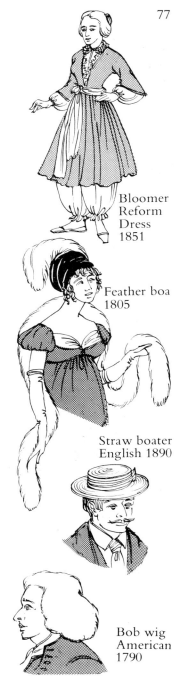

Bloomer Reform Dress 1851

Feather boa 1805

Straw boater English 1890

Bob wig American 1790

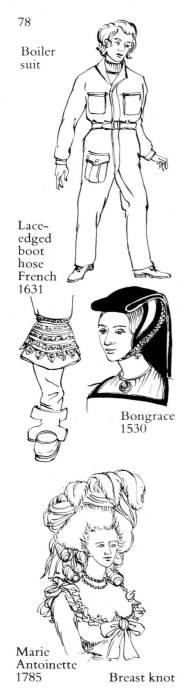

Boiler
suit

Lace-
edged
boot
hose
French
1631

Bongrace
1530

Marie
Antoinette
1785

Breast knot

BOILER SUIT: a 20th-century all-in-one work-ing garment, generally made of denim, which has a pocketed bodice, long sleeves and trousers and is belted at the waist. It is fastened from neck to crotch by buttons or a zip (see also JUMPSUIT, SIREN SUIT).

BOMBAST: a padding material which was used in the garments of the 16th and 17th centuries to distort the natural figure. Bombast could be made of cotton or wool rags, raw cotton, flax, flock, horsehair or bran.

BONDED FABRIC: laminated fabrics where, in a comparatively recent process, different fabrics are bonded back to back, giving a warmer, more dur-able material which retains its shape better in wear.

BONGRACE: in the 16th and 17th centuries a shade or curtain, extended over the front of a woman's head-dress to protect her complexion from the rays of the sun. This could be a separate item, worn with a cap or coif, in which case it was in flat, stiffened form projecting forward over the forehead and hanging unstiffened down the back of the neck, or, in mid-century, part of the French hood, when a section of the hanging portion at the back was brought forward to serve the same pur-pose.

BOOT HOSE: cloth or linen stockings worn inside boots in the 16th to 18th centuries on top of the costly silk stockings to protect them from travel stains and wear. With the elegant, open bucket-top, soft leather boots of the first half of the 17th cen-tury, the boot hose became as fine and delicate as the hose which they were protecting and were finished at the top with lace ruffles which were displayed inside the open bucket-top of the boot.

BOSOM BOTTLE: a small, slender, glass or metal bottle, sometimes covered with material to match the gown, inserted into a pocket in the top of a lady's stomacher between the breasts. This was a custom of the second half of the 18th century when the bottle contained water to keep the bosom-flowers fresh.

BOSOM (BREAST) KNOT: a fashion of the years 1750–1820 for a perfumed ribbon knot or rosette to be worn at the centre front of the gown neckline.

BOURRELET (BIRLET, BURLET): a sausage-shaped padded roll used in different parts of the costume for support or distension. In the 15th century it was seen especially as the circular roll of the chaperon, the part which was placed on the head (see CHAPERON), and was also the basis of the feminine turbans and heart-shaped head-dresses (see HEART-SHAPED HEAD-DRESS). In the 16th century it acted as a support for the ruff, also for padding in the man's doublet (see also BUM BARREL).

BOWL CUT: an unusual hairstyle for men in the years 1425–50, when the hair was cut short and combed outwards all round the head and curled under above ear level; the head was then shaved at the back up to the hairline.

BOWLER: a hard felt hat with a domed crown and narrow brim rolled up at the sides, worn by men. The bowler could be black, grey, fawn or brown, with matching ribbon. It originated in the first quarter of the 19th century. The name, in England, refers to the hatter William Bowler, though other countries used different terms for the hat (see BILLYCOCK, DERBY, MELON).

BOX PLEAT: a system of pleating where the folds are in pairs and point towards one another.

BRACELET SLEEVE: a modern style where the long sleeve extends only to about 2 inches (5 cm) above the wrist bone, so enabling a bracelet to be displayed.

BRACES: an English term for straps worn over the shoulders with a button fastening to support short or long trousers and skirts. Decorative designs in embroidered or woven braid, silk and wool are widely used in peasant and national dress but in fashionable wear braces were worn from the late 18th century onwards to support men's trousers until the 20th-century development of waist support. By the mid-19th century braces were often divided into two at the lower ends to button in four places on the trouser band at back and front. Later still, at the back, the braces were crossed over and sewn at the intersection. For terms in different countries see BRETELLES, GALLOWSES, SUSPENDERS.

BRAGUETTE: French word for cod-piece (see COD, COD-PIECE).

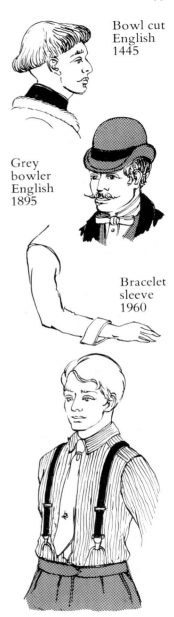

Bowl cut
English
1445

Grey
bowler
English
1895

Bracelet
sleeve
1960

Modern braces 1950

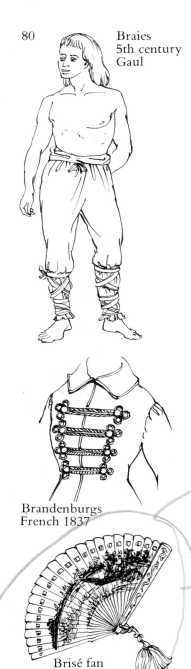

Braies
5th century
Gaul

Brandenburgs
French 1837

Brisé fan
Japanese
19th century

**BRAIES:** from the early centuries AD until the early Middle Ages, braies were a loose form of shapeless trousers which were pulled in at the waist by a draw-string. They extended to knee-level or longer and could be tucked into stockings or bound with leg wrappings. The Celts and Teutonic tribes referred to them as *bracchae*. In Norman times, about mid-12th century, the braies became an undergarment, being covered by the Norman tunic, and from this time until the 15th century, were gradually shortened while, at the same time, the hose were progressively lengthened. By the 15th century the hose had become 'tights' and the braies were underpants or briefs.

**BRANDENBURGS:** a decorative button and braid fastening where twin buttons are linked by transverse loops of cord and are ornamented by tassels. The **brandenburg** was a man's overcoat of the later 17th century which was so decorated and fastened. This type of coat fastening was traditional to the north-east Baltic area of Prussia and Poland and was adopted by the French (and so spread to the remainder of western Europe) after contact with the Brandenburg troops of Prussia. Brandenburg fastenings were in use throughout the 18th century and became especially fashionable for men's overcoats and ladies' jackets in the early decades of the 19th century, when the whole front was ornamented in this way.

**BREAST KNOT:** see BOSOM KNOT.

**BRETELLES:** French word for braces (see BRACES).

**BRISÉ FAN:** similar to a folding fan but has no mount. The blades, of wood, ivory or mother-of-pearl, are generally delicately carved, inlaid or painted; they are connected at the outer edge by a ribbon threaded through each blade and are riveted together at the handle end. The fan is so-called because of its 'broken' form of construction.

**BROGUE (BROGAN):** originally a primitive, heavy, rawhide shoe worn by both sexes in country and, especially, mountain areas of Europe until after the end of the 17th century. In Britain the shoe was indigenous to Scotland and Ireland, in particular, and was termed a 'brogue' in Scotland and a 'brogan' in Ireland. Made of a single upper piece of untanned leather held together by a tie lace, the

shoe was widely used in Colonial America. The modern brogue is a laced, flat-heeled, leather shoe, decorated by perforations and ornamental stitching (see also CARBATINE).

BUCKET-TOP BOOTS: in the first half of the 17th century, especially in the years 1625–50, when boots were high fashion for men, worn indoors and out, the soft leather, high boot with **funnel top** was characteristic. Pulled up, this funnel covered the knee for riding but, in town and indoors, the funnel was turned down, giving the wide, open bucket-top style. This top was so heavy that the soft leather sagged and creased across calf and ankle (see also BOOT HOSE).

BUCKLED WIG: one arranged in formal, horizontal, sausage curls at the sides over the ear. Fashionable from the mid-18th century, the name derives from the French *boucle*.

BUFF COAT, BUFF JERKIN: a military coat of the 16th and 17th centuries made originally of buffalo (later ox) hide. It was durable and warm and was adopted for civilian use, when it was worn over the doublet, its style varying according to date. The body part was generally fitted, cut into four pieces seamed vertically. There was often a waist seam and the hip-length skirt was cut to flare slightly. Some styles were sleeveless, ending at the shoulder with wings or epaulets. Other versions had long sleeves but of a different material. A staple garment with the 17th-century American colonists of New England.

BUFFONT (BUFFON): a mode of the 1770s and 1780s for a diaphanous scarf or kerchief of gauze, lace or linen, generally white, to be draped round the neck and shoulders of the décolleté gown bodice. The buffont was puffed out in front to give the pouter pigeon effect modish at the time. Gauze buffonts were also fashionable in New England at this period.

BUM BARREL, BUM ROLL: a padded roll or waist bolster tied on round the waist in the later 16th and the 17th century to distend the skirt silhouette. It was most often worn in lieu of a farthingale petticoat but could be an addition to and worn on top of it (see also BOURRELET, FARTHINGALE).

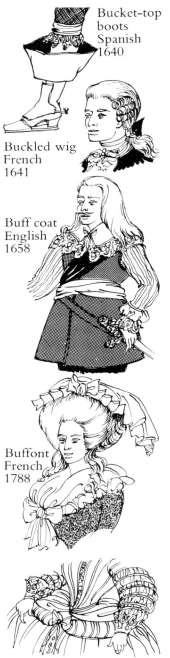

Bucket-top boots
Spanish
1640

Buckled wig
French
1641

Buff coat
English
1658

Buffont
French
1788

Bum roll, Dutch, *c.* 1610

Burnouse
1857

BURBERRY: Thomas Burberry was a country draper who began business in the 1830s making in his mill a cloth which was weatherproofed before and after weaving and which was then made up into rainwear, first for men but later for ladies also. The word is still used for a particular type of rain-coat.

BURNOUSE: a garment of the mid-19th century inspired by the Arab burnous and introduced by the French as a lady's cloak. The fashionable burnouse was hooded and generally threequarter-length. Made in a variety of fabrics, it was suitable for day or evening wear.

BURNSIDES: a style of facial whiskers fashion-able for men in the 19th century, especially in the 1860s. The hair was grown on the cheeks as very low side-whiskers, descending down the jaw-line but leaving the chin free. Burnsides were named after General Burnside.

These whiskers were also called DUN-DREARIES after Lord Dundreary, a character in a play. (See also PICCADILLY WEEPERS.)

BUSH JACKET: see SAFARI JACKET.

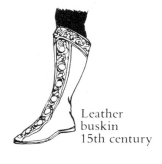

Leather
buskin
15th century

BUSKIN (BRODEQUIN): a medieval high boot reaching up as far as the knees. The design derived from the classical style of Greece and Rome and continued to be worn until the late 17th century. It was made of leather for riding and travel-ling but for indoors and court wear costly materials and soft leathers dyed in bright colours and deco-rated by embroidery were used.

BUSTLE: a term introduced in the 1830s to describe a form of padding attached round the body in order to distend the skirt at the rear just below the waist. Though this was very much a 19th-century mode and 'bustle' is still the accepted term for such a device, the fashion for concentrating the interest and draped decoration at the back of a skirt in this way has recurred a number of times over the centuries, as, for instance, in the years 1670–1715 and in the later 18th century. The material was bunched up and supported on a pad made of stuffed cork which was tied on round the waist. The term BUM ROLL seems still to have been in use in the 17th century while by the 18th it was simply called BUM or RUMP in England and *cul postiche* in French.

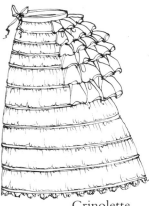

Crinolette
petticoat 1873

With the high-waisted gowns of the second decade of the 19th century, a small pad continued to be worn but, as the waistline descended to normal level and skirts became fuller, the 1830s bustle became fashionable. A much larger pad, this was taken up by women of all classes and continued to be worn, growing larger and extending round the sides also, until the petticoat and crinoline era of the 1840s to 1860s (see CRINOLINE).

It was in the 1870s and 1880s that the more extreme and elegant bustle gowns were fashionable. These were two separate and differently-silhouetted forms created by a variety of artificial bustle aids. The first mode began to develop by 1863 when the circular shape of the crinoline became flattened in front and at the sides and more pronounced at the back and, by 1867–8, full draperies were being concentrated behind. The weight of this material required special support so extra steel bands were incorporated into the crinoline at the back. This new bustle was known under its French name, the TOURNURE, and by the early 1870s could be part of the crinoline petticoat as a kind of metal cage covered in material—a **crinolette**—or it could be separate and then worn on top.

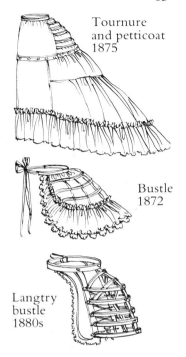

Tournure and petticoat 1875

Bustle 1872

Langtry bustle 1880s

After 1875 the fashionable line became sleeker on the hips and gradually the tournure was abandoned. In the 1880s it returned, this time in a more exaggerated form, also known as a BUSTLE or DRESS IMPROVER. It underpinned a fashionable silhouette which projected like a horizontal shelf at the back just below the waist. On to this was looped up a mass of draped folds from skirt and petticoat decorated by enormous ribbon bows and loops, lace flouncing, fringe and tassels. The new form of bustle was a separate basket of steel or whalebone attached round the waist. Soon a variety of bustles was available, from braided wire baskets to horsehair pads and even, the *pièce de résistance*, the Langtry bustle (named after Lillie Langtry), which was advertised as available to fit any lady and every dress. It was made of spring metal bands worked on a pivot which adjusted correctly as the wearer sat down or stood up. 1885 was the zenith of the bustle vogue and the fashion slowly diminished until, by 1889, it had disappeared.

BUTTERFLY CAP: a lady's cap of the second half of the 18th century made of lace, silk or cambric and worn perched on top of the head. It was

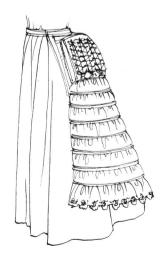

Cotton and framework bustle 1884

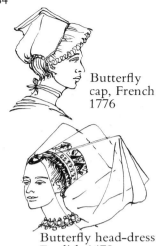

Butterfly cap, French 1776

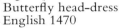

Butterfly head-dress English 1470

Butterfly-wing veil Elizabeth I 1590

Cabbage ruff 1598

wired into a butterfly shape and had a frilled front edge.

BUTTERFLY HEAD-DRESS: a feminine fashion of the third quarter of the 15th century which comprised a richly decorated cap in the shape of a tarboosh worn on the back of the head and, fixed to it, a transparent gauze veil wired into wings. The hairs on the temples and at the nape were plucked out so that no hair was visible below the head-dress.

BUTTERFLY-WING VEIL: a fashion of Elizabethan England and, particularly, of the Queen herself, for two (or sometimes four) wired circular wings framing the back of the head. These were filled with white gauze or silk and were edged with pearls or jewels. A soft, white, transparent veil then descended from the shoulders to the ground.

BYRRUS: a knee-length, heavy, travelling and hunting cloak with attached hood, worn throughout the Middle Ages.

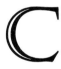

# C

CABBAGE RUFF: a ruff folded in an informal unsymmetrical manner which resembled the leaves of a cabbage. Also known as a LETTICE RUFF, a mis-spelling for lettuce.

CACHE FOLIE: an aptly named false switch of hair or small wig adopted by women in the years 1807–11 to conceal the ravages of the 'Titus cut'. These exaggeratedly-short, pseudo-classical coiffure styles had been fashionable, especially in France, at the time of the Revolution and under the Directoire and Consulate. The *cache folie* was adopted while the hair was being grown again (see TITUS CUT).

CADDIE: in the 1890s an alternative name for the hip-pocket at the rear of a man's trousers.

CADOGAN: see CATOGAN.

**CAFTAN (KAFTAN):** a long, loose robe, open in front, the prototype of the European coat. The caftan is a garment from the ancient world which originated in Asia and was widely adopted over the centuries in the Middle East, India, Persia, Mongolia, China and Asian Russia. It was introduced into Europe during the Middle Ages, firstly from the westward spread of the Mongolian Empire in the 13th century and, again, under a similar movement in the 15th century by the Ottoman Empire.

As a long coat-like robe, drawn in at the waist by a sash and having wrist-length full sleeves, the caftan has been more traditional wear in eastern Europe than in the west but, in the 1960s, it became fashionable as a decorative, informal evening gown for ladies.

**CAGE-CRINOLINE:** see CRINOLINE.

**CALASH (CALÈCHE):** a large articulated hood made of a ruched and padded silk covering to a series of whalebone or cane hoops. The calash was worn by women in the 1770s and 1780s as an outdoor protection for the immense coiffure styles of the time. The structure could be raised or lowered in a similar manner to a carriage hood and was tied under the chin with broad ribbons. The original French design was termed a THÉRÈSE, later altered to CALÈCHE, a word of Slav origin which was given to a 17th-century design of carriage with a similar folding hood. 'Calash' is the English term.

**CALOTTE:** a skull cap, of which many variants have been worn. The calotte was a medieval cap, round and brimless, worn alone or underneath another cap or hat. In the 1920s and 1930s a modern version was adopted in America called a BEANIE (BEANY). Like the traditional skull cap this had a short tail in the centre.

**CAMI-KNICKERS:** a combination feminine undergarment of knickers and chemise introduced about 1916 and especially fashionable in the 1920s and 1930s.

**CAMISOLE:** in the 19th century a short-sleeved or sleeveless underbodice worn in the early years by women as a corset cover but which, by the end of the century, was padded and be-ruffled to help to shape the figure to the fashionable silhouette. It continued as an important item of underwear, conforming to current fashion and form, during the first three decades of the 20th century.

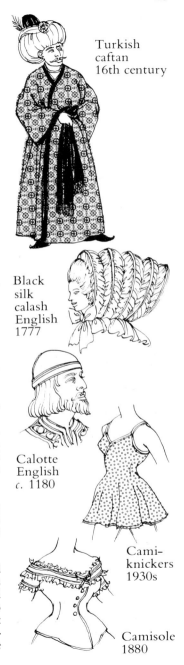

Turkish caftan 16th century

Black silk calash English 1777

Calotte English c. 1180

Cami-knickers 1930s

Camisole 1880

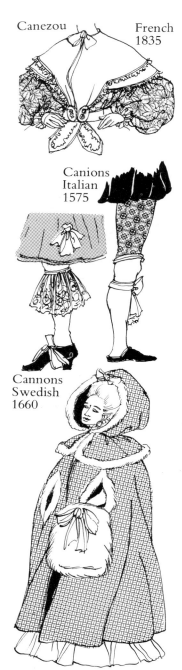

Canezou     French
1835

Canions
Italian
1575

Cannons
Swedish
1660

Capuchin USA 1780

**CAMPAIGNE WIG:** a style of the later 17th and early 18th centuries worn especially for travelling. It was a bushy style with sides puffed out, then brushed back; it had a short queue sometimes encased in black silk.

**CANEZOU:** a feminine garment fashionable in the years 1820–50. Early designs took the form of a sleeveless spencer (see SPENCER) but, from the 1830s, the canezou became a shoulder cape, often in two or three tiers, made of a thin, semi-transparent material (generally white), embroidered and lace-trimmed. Characteristic of the 1830s, when the garment was very much the mode, were long ends which hung down in front and were held in place by the waist-belt.

**CANIONS:** in the second half of the 16th century masculine hose were divided into upper and netherstocks. The upper stocks were called canions and these were a close-fitting extension of the short trunk hose, covering the thigh and reaching to below the knee; the stockings, or netherstocks, were then pulled up over them. Canions were often richly embroidered and were usually of a different material from the stockings (see NETHERSTOCKS, TRUNK HOSE).

**CANNONS:** deep linen and lace ruffles tied round the stocking just below the knee. Men wore these cannons with the petticoat breeches (rhine-graves) of the 1660s and early 1670s (see RHINE-GRAVES).

**CAPA DA PASEO:** the bullfighter's cloak worn for his ceremonial entry into the ring. The collared cloak is cut in a semicircle from rich, beautifully decorated material.

**CAPOTE:** there are two distinct meanings:
1. A bonnet of the first half of the nineteenth century with a soft, gathered crown and a stiff brim.
2. A long, full, outdoor cloak or coat of heavy fabric with a collar and sometimes, a hood. Worn in the 18th and 19th centuries by both sexes.

**CAPUCHIN:** an outdoor hood worn by ladies in the 18th century, made of silk or velvet and lined with a contrasting colour and material. The hood was attached to a deep cape and was named after the cloak of the Capuchin monks.

CAPUCHON: the early medieval hood with attached shoulder cape (see also CHAPERON).

CARACO: in the 18th century a lady's hip-length or longer jacket which varied in style—in reflection of the gown design of the day. Earlier examples were based on the sack gown (see SACK GOWN) and were fairly fitted at the waist in front but hung loose at the back: these were termed CASAQUINS. The caraco of the years 1750–75 was a shortened *robe à la française*, being closely fitted at the waist in front and hanging in deep box pleats behind (see *ROBE à la française*). By the 1780s the caraco had become a short fitted jacket with rear flared peplum; this style was also termed a JUSTE. All forms of the caraco adopted the sleeve styles characteristic of the current mode.

CARBATINE: a simple form of shoe adopted by many European peoples and of the same derivation as the Indian moccasin. It was made of a piece of rawhide (see RAWHIDE) with the hair attached, generally facing outwards. Holes were pierced all round the edge and a leather thong or sinew was threaded through. This was drawn up and tied on top of the foot, providing sole and upper in one piece of leather. The carbatine was worn in northern Europe before the coming of the Romans but continued in use for centuries afterwards, in remote areas as late as the 19th century (see also BROGUE, PAMPOOTIE). The North American Indian moccasin is more sophisticated, being decorated in a variety of ways and having an inset apron front (see MOCCASIN).

CARCAILLE: a high, decorative neckline, fashionable in the 14th century, which extended up to the chin and the ears and was characteristic of most body garments, especially the houppelande (see HOUPPELANDE).

CARCANET: a deep, ornamental, jewelled collar worn high round the throat, fashionable at periods when the neckline was décolleté as in, for instance, the first half of the 16th century and during the 17th century. Revived for wear with evening gowns during the period 1890–1910. The word derives from the French *carcan*, 'yoke', referring to the erstwhile iron punishment collar for criminals.

CARDIGAN: a knitted wool or worsted, fitted jacket, with or without sleeves and sometimes hav-

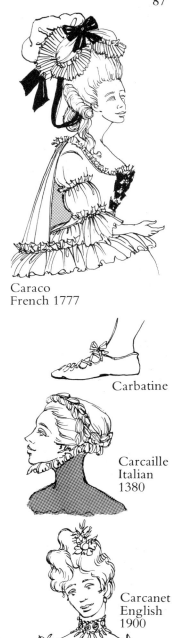

Caraco
French 1777

Carbatine

Carcaille
Italian
1380

Carcanet
English
1900

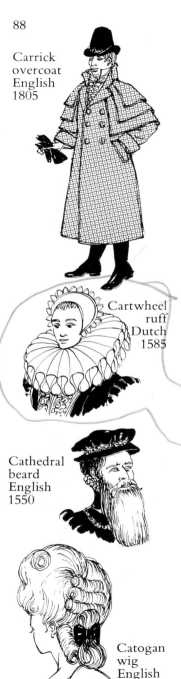

Carrick
overcoat
English
1805

Cartwheel
ruff
Dutch
1585

Cathedral
beard
English
1550

Catogan
wig
English
1777

ing a fur, braid or velvet collar, worn by men in the later 19th century. The garment was named after the Earl of Cardigan, renowned for his part in the Crimean War of 1854–56. The modern cardigan has no collar and is buttoned down the centre front.

CARDINAL: an 18th-century hooded cloak, usually made from scarlet cloth and so-called because of its resemblance to the ecclesiastical *mozzetta*.

CARMAGNOLE: derived from a workman's jacket worn in Carmagnola in northern Italy. Donned by the revolutionaries of Marseilles and, later, Paris as symbolic of proletarian dress (see SANS-CULOTTE). Adopted in 1792, worn with wide trousers, cap and sabots, by members of the newly-established People's Commune.

CARRICK (GARRICK): originally a heavy coat worn by coachmen on the box, adopted during the whole of the 19th century by men as a bad-weather, caped (in two or three tiers) overcoat used for travelling; it was long and full and was double-breasted. In the last quarter of the century a similar design was adopted for feminine wear which, in the 1890s, became useful as an automobile dust coat. In the USA the term was also used during the 19th century to refer to a cloak of similar style.

CARTWHEEL RUFF: a particularly large ruff fashionable in the last two decades of the 16th century (see RUFF, SUPPORTASSE).

CASAQUIN: see CARACO.

CASSOCK: in civil dress a knee- or three-quarter-length coat worn by men in the 16th and 17th centuries. The coat was buttoned down the centre front and the skirts were slit at the sides to facilitate riding. It was decorated by braid and stitching. In general use in Colonial America.

CATHEDRAL BEARD: a square-cut, long, broad style to be seen particularly in the 16th and 17th centuries, so-called because of its prevalence with dignitaries of the Church.

CATOGAN (CADOGAN) WIG: a style fashionable for men and women in the years 1760–90 where the queue was combed out straight, then looped upwards over a horsehair pad and tied in

position at the nape with a black ribbon bow. Alternatively, the hair could be fastened there by a comb or be contained in a net. The name is said to derive from the Earl of Cadogan but the style was also known as a CLUB WIG and, in France, as an ENGLISH QUEUE.

CAUL: a net or netted cap, worn chiefly by women through the centuries but especially in the Middle Ages. The medieval caul consisted of a silk or wool cap or coif made from coloured silk, wool or gold or silver thread and often decorated at the intersections by pearls or jewels. During the Middle Ages there were many different styles of caul, from the soft designs which accompanied a barbette or turban (see BARBETTE), to a firm, metal framework worn at the sides of the face over the ears and held in place by a metal fillet encircling the brow. These more rigid cauls, which contained the plaited hair, could be of curved box shape or formed into cylinders.

The word was also used for the net foundation of the wigs of 1670–1750. It returned to fashion in the feminine head-dress at the revival of Grecian coiffure styles in the early 19th century. 20th-century cauls were of chenille, wool or silk and, in the 1930s, were termed snoods (see SNOOD); these were often attached to the back of a hat.

CHAINSE: a long undertunic worn by men and women in the early Middle Ages under the bliaud (see BLIAUD). The garment was of white, fine linen and had long, fitted sleeves. It is not certain whether the chainse later developed into the shirt or chemise or if, at this period, it was worn over and in addition to the chemise.

CHAMARRE: the French word for a loose gown of rich material, heavily embroidered, jewelled and be-furred, which appeared in the Middle East, in particular Arabia and Persia, under various names from the early Middle Ages onwards. A sheepskin version is traditional to Spain, where it was termed *chamarra* or *zamarra*; in Sardinia a similar garment was the *acciamarra* (see also ZIMARRA).

'Chamarre' was the term used in France, when the garment was introduced into fashionable Europe about 1485–90 as a gown worn by men on top of the doublet and hose. Of ground length, it had a wide collar, often of fur, and was worn open, the edges turned back to display a rich, contrasting lining. Sleeves were wide with broad cuffs. A sash was

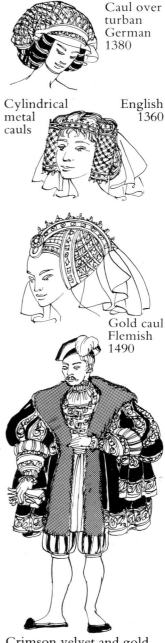

Caul over turban
German
1380

Cylindrical metal cauls

English
1360

Gold caul
Flemish
1490

Crimson velvet and gold embroidered chamarre
German 1540–5

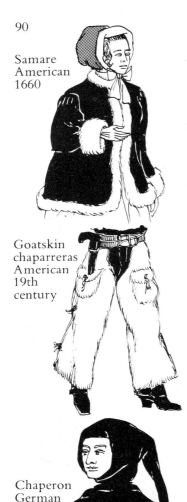

Samare
American
1660

Goatskin
chaparreras
American
19th
century

Chaperon
German
1310

Chaperon
Italian
1449

often worn round the waist. By the 1520s the chamarre was about knee-length and had padded puff sleeves, giving the characteristic square silhouette of the time. It was then very richly decorated, aptly named from the French word *chamarrer*, 'to bedeck or bedizen'. The English term was CHIMER (or CHIMERE) from the medieval word 'chimera'. Also to be found in English wardrobe inventories are 'chymer' and 'chammer'.

As SAMARE (or SAMARRE) the garment seems to have been revived as a feminine jacket of the 17th and 18th centuries. As a loose, knee-length jacket with fashionable sleeves, worn over a waistcoat and petticoat, the samarre came from Holland and became fashionable wear in the American Colonies, where it could also be worn full length.

CHAPARRERAS: cowhide or deerskin overtrousers worn by cowboys in America as protection against riding through thorny brush and scrub. This Mexican Spanish word was shortened colloquially to CHAPS.

CHAPEAU BRAS: in the 18th century men often carried their hats in their hands to avoid disarranging their wigs. By the second half of the century a folding hat was designed to be carried flat under the left arm, at first a tricorne, later a bicorne (see BICORNE, TRICORNE). In the 19th century a collapsible opera hat was designed (see GIBUS); also, in the early years, a crush bonnet for ladies.

CHAPERON: the medieval hood attached to a shoulder cape and with a point on top which became a liripipe (see LIRIPIPE). The capuchon of the early 12th century (see CAPUCHON) had developed into a chaperon by the 14th century and the liripipe tail had begun to grow. By the end of the century new ways of wearing the chaperon were being experimented with. The face opening was placed upon the head circling the skull and the folds of the shoulder cape were arranged carefully to fall at back, front or sides, while the liripipe hung loose on the other side.

By about 1420 a more formal chaperon had evolved. In order to avoid re-arranging the folds of shoulder cape material every time the head-dress was donned, the part set on the head was made into a padded roll (see BOURRELET, ROUNDLET). The shoulder cape was sewn on to one side of this and the liripipe to the other. This was a style which continued to be worn for much of the 15th century.

CHAPLET: a decorative band for the head, originally a garland of flowers or leaves but later also a jewelled circlet or a twisted, silk or velvet roll.

CHAPS: see CHAPARRERAS.

CHATELAINE: a chain or chains attached to a lady's waist-belt or girdle from which hung such domestic necessities as keys, scissors, button hook, penknife, pincushion, thimble-case or watch. A decorative idea based on the medieval châtelaine with her keys, revived in later centuries, especially the 19th.

CHAUSSES: Anglo-French term for medieval hose, used in the early Middle Ages.

CHEMISETTE: a lace-trimmed white muslin or cambric fill-in bodice to a low-necked day dress fashionable in the 19th century.

CHESTERFIELD: a classic design of masculine overcoat worn from the 1840s until the early 20th century and named after the fashionable Earl of Chesterfield. The overcoat was most often single-breasted and had a fly fastening. It was a formal, tailored coat, slightly waisted but without a waist seam. Black or plain dark cloth was the usual material with a collar of black velvet.

CHIGNON: a mass or coil of hair dressed at the back of the head and usually at the nape. The word 'chignon', derived from the French, originally denoted the nape of the neck.

CHITTERLINGS: the frills decorating the front of a gentleman's shirt, fashionable from the late 18th century until just after 1900.

CHOPINE (CHAPINEY): derived from the Turkish patten (kub-kob), an overshoe which was slipped on over the elegant footwear of the 16th and early 17th centuries to protect it from the mud and filth of the streets. The chopine usually had no back, only a front vamp, but might be laced or buttoned on top of the foot; it had high soles of cork or wood, decorated or covered with fabric. The fashion spread westwards, first to Venice, where the sole was a stilt, sometimes extending over 24 inches (60 cm) in height (see ZOCCOLO), then to the rest of Italy, Spain, southern Germany, France and Switzerland, but found little favour in northern Europe.

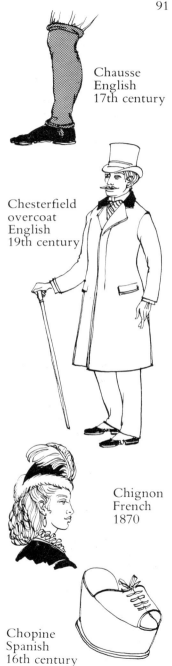

Chausse
English
17th century

Chesterfield
overcoat
English
19th century

Chignon
French
1870

Chopine
Spanish
16th century

Cloak-bag breeches
English
1624

Chopines were a subject of ridicule, especially by the dramatists (Shakespeare was no exception) and, certainly, the Venetian lady of rank, teetering along half-supported by her maidservant, amply depicted the silliness of high fashion.

CLOAK-BAG BREECHES: worn by men in the early 17th century, these were full, unpadded breeches, oval in shape and drawn in slightly just above the knee where they were ornamented with points or ribbons.

CLOCHE HAT: a style fashionable for women in the 1920s for a bell-shaped, head-hugging helmet with a narrow brim, drawn down low to the back of the head and to eye level in front.

CLOGS: shoes or overshoes worn since the Middle Ages to protect the wearer from the dirt of the street or from the conditions of work at the farm or in the factory. In most cases the thick soles were of wood or leather. The overshoes worn during the 14th to 17th centuries were much the same as pattens (see PATTEN), but the clog in the form of a shoe has also been worn for centuries in Europe as well as in the Orient.

The European working clog is carved entirely from wood and is indigenous to France and Belgium (see SABOT) and Holland (where a pair is referred to as *klompen*). In this design the clog is carved from a single block of wood and shaped to the foot. It can be left plain or, for special occasions, be decoratively carved or ornamented with fabric. The English working clog dates from the Roman occupation and has been worn by country labourers since that time. It is shaped to the foot and has a leather upper lasted and nailed to a wooden sole. With the Industrial Revolution it was adopted for factory use as a cheap, durable form of footwear, admirably suited for protecting the foot from chemicals, grease and water. The clog was worn over thick socks or, if the feet were bare, it was first lined with straw or bracken.

Cloche hat
French
1926

Black
leather,
metal and
wood clog
English

Brocade
shoe with
detachable
clog
English
1725

CLUB WIG: see CATOGAN.

COCK: from the late 17th to the early 19th century a term applied to the upward turn of the brim of a hat or cap, or to the angle of such tilt. In the 18th century the term was particularly applied to the tricorne hat (see TRICORNE) which, having a turned-up brim on three sides, became known as a

Cocked
hat
English
1780

**cocked hat**. Over the centuries a number of specific names were given to a variety of forms of turn or tilt, for example, the **Monmouth Cock** of the 1670s and 1680s named after the Duke of Monmouth, the later 18th-century **Denmark Cock** where the rear cock was lower than the front ones, and the **Dettingen Cock**, worn for much of the 18th century, where all three cocks were of equal size.

COCKERS: a rough type of knee-high boot worn by farm labourers. The term was also applied to knitted woollen stockings without feet.

COD: a bag. By the 18th century it had become a slang term for a purse.

COD-PIECE: the bag covering the fork of the medieval hose and laced to them by points. During the 15th and 16th centuries this was used more and more to contain money, also a handkerchief. In the 16th century, when worn with trunk hose, the cod-piece was fashionably padded to make it protuberant. In the 17th century the use of the cod-piece was discontinued and the term 'cod' came to be applied to the front fastening of the breeches. The French term for cod-piece was *braguette*.

COIF: a close-fitting white linen cap tied under the chin with strings, worn by both sexes from the early Middle Ages onwards as a night-cap or, during the day, under another cap or hat.

COLLARETTE: a ruched, ruffled or gathered band of lace or tulle worn round a lady's neck, generally to accompany décolleté gowns, especially in the 16th and 18th centuries.

COLLET MONTÉ: a standing collar of lace-edged lawn, or entirely of lace, wired for support to frame the back of a lady's head and worn with a décolleté gown bodice; the collar was high at the back but diminished in height towards the front. The fashion dates from the 1580s but lasted into the 1620s (see also MEDICI COLLAR).

COLLET ROTONDE: a similar and contemporary collar to the *collet monté* but encircling the neck without a break (see also WHISK).

COMBINATIONS: from the later 19th century it began to be customary to design two or more

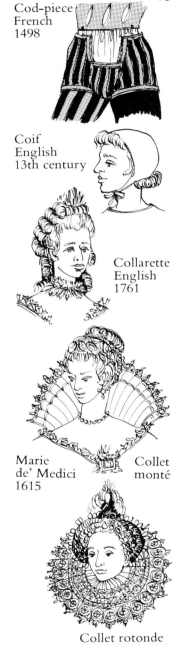

Cod-piece
French
1498

Coif
English
13th century

Collarette
English
1761

Marie
de' Medici
1615

Collet
monté

Collet rotonde
Elizabeth I 1588

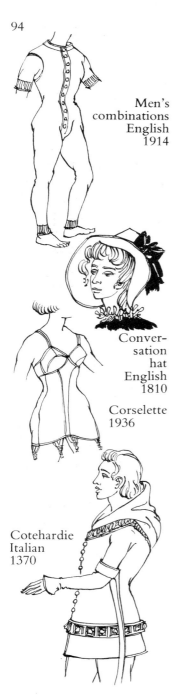

Men's combinations English 1914

Conversation hat English 1810

Corselette 1936

Cotehardie Italian 1370

undergarments in one. Before this, especially during the years 1840–70, both men and women, but especially women, had worn layer upon layer of underwear. The 'combination' garment was an attempt to reduce this number and so make the garments more comfortable to wear and easy to put on. Men's combinations, known in the USA as a UNION SUIT, combined undervest and drawers or pants. Women's underwear could be combined in a variety of ways: knickers and chemise (see CAMI-KNICKERS), bust bodice and hip belt, corset and camisole, etc. The custom continued into the 1920s and 30s, when they became 'combs'.

COMMODE:   see FONTANGE.

CONFIDENTS (CONFIDANTS):   in the lady's coiffure of the later 17th century, this was the name given to the curls near the ears.

CONTOUCHE:   a house dress or morning gown worn at home for relaxation in the 1720s.

CONVERSATION BONNET (HAT):   a design fashionable for ladies in the early 1800s, whereby one side of the brim was coyly turned back and the other pulled down to hide the cheek.

CORSELETTE:   a one-piece garment incorporating brassière and corset. As the **corsolette** this first appeared in America in 1919 and a couple of years later in Britain. This was firmly boned and laced but with the 1920s a more comfortable garment emerged, the corselette, which has continued ever since. In America more commonly referred to as a FOUNDATION GARMENT or an ALL-IN-ONE.

COTE:   old English term for the outer tunic or gown worn during the early Middle Ages by both sexes. By the 14th century it referred chiefly to the masculine tunic which later was termed a doublet or pourpoint. By the later 17th century 'cote' was becoming COAT with the modern meaning of the term (see DOUBLET, POURPOINT).

COTEHARDIE:   though the name of this garment is mentioned frequently in records from 1335 until the 15th century, its exact form is not clearly defined. It seems to have been a fitting overtunic worn by both sexes, the masculine version being about hip-length, fastened up the centre front and

having a fairly low neckline which displayed the higher line of the undertunic. The feminine cotehardie was also fitting on the torso, below which was a full, long skirt. In both cases the sleeve ended at the elbow with tippets and a decorative, metal and leather belt encircled the hips. As time passed the masculine garment became shorter.

COTTAGE BONNET: a popular bonnet, generally made of straw, seen over a long period in the 19th century from the early years until about 1870. The Victorian version had a flat-backed crown and the brim projected forward to hide the face (see also BIBI BONNET).

COUNTERCHANGE: a form of design, particularly in use in the 14th century, where the motif and its ground used in one part of a pattern are reversed in another part (see PARTI-COLOURING).

COUVRECHEF: Norman term for a veil or head-kerchief worn by women in the early Middle Ages; in England this was soon anglicised into coverchief. The square of fabric was worn in various ways; it could be tucked into the neck of the gown or could hang loose, and was often held in place by a band round the forehead (see RAYLE).

CRACOW (CRACKOW): see POULAINE.

CRAVAT: a form of neckwear worn by men. The cravat began to take the place of the falling band about 1645–50; it was then a neckcloth of white lawn, muslin or silk with fringed or lace-ornamented ends. This neckcloth was folded lengthwise and tied loosely round the throat, the ends hanging down in front. This derived from a Croatian military custom of wearing linen neck-cloths for protection; these were termed *crabate*.

During the later 17th century the cravat was tied in a bow in front with the ends arranged formally below. There were several variations on this (see STEINKIRK). In the 18th and 19th centuries the cravat was replaced by a folded stock, though the word cravat was still also used (see STOCK).

CRÊVE COEUR, HEARTBREAKER: a late 17th-century fashion, when both terms were used to describe the ringlets at the sides and nape of the neck which trembled as the lady moved her head.

CREW CUT: a masculine hairstyle of the 1940s

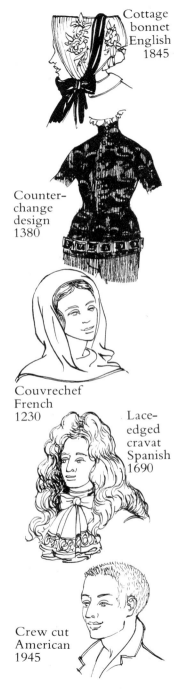

Cottage bonnet English 1845

Counter-change design 1380

Couvrechef French 1230

Lace-edged cravat Spanish 1690

Crew cut American 1945

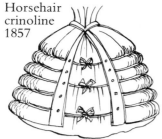

Horsehair
crinoline
1857

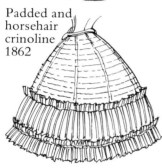

Padded and
horsehair
crinoline
1862

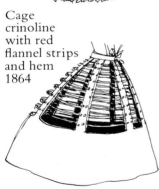

Cage
crinoline
with red
flannel strips
and hem
1864

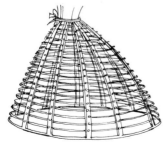

Cage crinoline
1862

and 1950s, originating in America, where the hair was trimmed very short all round the skull but up to one inch (25 mm) long on top of the head, where it stood up like a pile carpet. In the Second World War sometimes referred to as a 'G.I. cut' but the idea came earlier from American universities where it was adopted by oarsmen to keep the hair out of the eyes. A shorter version is a BUTCH CUT.

CRIARDES: an early 18th-century petticoat of linen or canvas stiffened with paste or gum which emitted a noisy rustling in movement. The French word means 'screaming', 'clamorous'; in England also called CRIERS and SCREECHERS.

CRINOLETTE: see BUSTLE.

CRINOLINE: a fabric made from horsehair mixed with cotton or linen used from the early 1840s for making stiffened petticoats which helped to support the layers of other petticoats and the full, bell-shaped skirts worn by ladies at this time. The word derives from the Latin *crinis* (French *crin*), '(horse)hair' and the Latin *linum* (French *lin*), 'flax, linen'.

By 1850, as the gown skirt became wider, stronger support was required; the crinoline petticoat was designed. It was made, like its predecessors (see FARTHINGALE, HOOP), of quilted material reinforced by circular hoops of whalebone which were inserted horizontally at intervals to maintain the shape. It was accompanied by several layers of petticoats, one of flannel and several of starched and flounced linen and muslin on top. By 1856 this weight of petticoats had become unbearable and it was with immense relief that women greeted the invention of the **Artificial Crinoline** or, as it came to be called, the **Cage Crinoline**. Soon there were a number of designs produced by different manufacturers but all were lightweight frameworks of flexible steel or whalebone hoops joined by vertical bands of tape or braid with or without a covering fabric. The numerous layers of petticoats could be abandoned and the cheapness and lightness of the framework meant that it could be worn by all classes of women.

The cage-crinoline lasted for a decade, changing its shape slowly in the 1860s towards the bustle petticoat form (see BUSTLE). A number of named crinolines were devised for different needs: e.g. for ease of sitting down, for country walking, for ball dresses. Among these were the **Cage-Américaine**

with a framework descending to the knees, the remainder being of fabric only; the **Cage-Empire** for ball dresses which had a greater number of steel hoops inset and support for a slight train; and the **Sansflectum** crinoline which was washable, its hoops covered with gutta-percha.

CROSS-BANDING: a form of simple leg-covering still customary in the early Middle Ages where the braies were bound with bands, criss-crossed round the lower leg to hold them in place and keep the leg warm (see BRAIES).

CROSS-GARTERING: a method of fastening the sash garters of the years 1565–1620 whereby the garter encircled the leg below the knee, was then crossed over at the back and brought round to tie in front above the knee.

CUBAN HEEL: a 20th-century style of heel, of medium height tapering slightly towards the ground.

CUE: alternative English spelling for queue (see QUEUE).

CUE-PERUKE: a wig with a queue (see PERIWIG).

CULOTTES: French term for breeches. The word was in use from the late 16th century onwards and applied especially to the knee-breeches of the 17th and 18th centuries (see also DIVIDED SKIRT, SANS-CULOTTE).

CUL POSTICHE: see BUSTLE.

CUMMERBUND: a wide sash worn round the waist to cover the join of shirt and trousers and so maintain the body warmth in the susceptible lumbar region. A traditional peasant garment in mountainous areas and in those with a hot climate. The word derives from the Urdu *kamar-band*, 'loin-band'. In western fashionable costume, a black pleated cummerbund was adopted with men's evening dress in the 1890s. In the 1960s revival, black or coloured velvet, silk or satin, could be worn.

CURCH: a square kerchief worn by women on the head; the word derives from the French *couvre-chef*. In the American Colonies 'curch' was used to

Cross-banding
12th century

Cross-gartering
16th century

Cuban heel
1935

Cummerbund

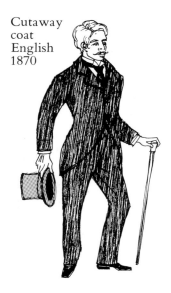

Cutaway coat English 1870

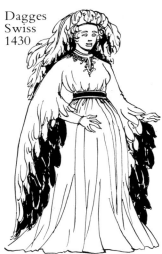

Dagges Swiss 1430

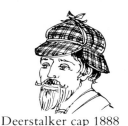

Deerstalker cap 1888

refer to a fitting cap of plain linen worn especially in New England and Pennsylvania (see COUVRECHEF).

CUSTOM-MADE: clothes made to measure and order. This is the American term; in Britain it is BESPOKE TAILORING.

CUTAWAY COAT: a man's tail coat of the 19th century. The style was introduced in the 1830s as a **Newmarket coat** and was most fashionable in the 1850s when it was termed a cutaway coat. This design was single-breasted and had a waist seam. The tails were short and rounded off (cut away) in front. Less formal than the frock coat, the cutaway was made in black or grey cloth, the edges often finished with braid. In the later 19th century the style developed into the **morning coat**, retained today for weddings, racing and formal occasions (see MORNING COAT, NEWMARKET COAT).

CUTLETS: see PICCADILLY WEEPERS.

CUT WIG: a small wig of the 18th century in use for informal wear.

CYCLAS: a rich fabric which was made in the Greek Islands of the Cyclades. The name was given to the material, also to a fitted overtunic or over-gown made from it worn by both sexes from ancient Greek and Roman times until *c.* 1400.

D

DAGGES: a method of decoration introduced in the 14th century and continuing during the 15th for cutting and finishing the edges of garments into a variety of shapes: leaf forms, scallops, tongues and simple V-snips. All garments were subjected to such treatment, which was carried to excess in the later 14th century. This cut-work, known as dag-ges or dagging, was applied to the hem of the tunic and cloak, to the shoulder cape of the hood, to the sleeve tippets and to feminine gowns.

DEERSTALKER: a masculine cap of the second half of the 19th century, generally made of tweed and having a peak fore and aft. It also possessed side

flaps which could be buttoned or tied together on the crown, then pulled down as required to make ear flaps. The deerstalker was especially fashionable in the years 1870–90 and was associated with Conan Doyle's character, Sherlock Holmes.

DENIER: the term is used in modern times to define the fibre filament of silk and synthetic materials; the higher the denier number, the thicker the filament, so the sheerest of nylon tights are classified with the lowest denier numbers. The denier was originally a tiny French coin, the name having been taken from the ancient Roman silver *denarius*. Much later, in the 19th century, the word was applied to a unit of weight used to classify the fineness of silk yarn.

DERBY: American term for bowler hat (see BOWLER).

DERBY SHOE: a lace-up tie shoe with eyelet tabs stitched on top of the vamp.

DETACHABLE GARTERS: American term for suspenders (see SUSPENDERS).

DICKEY (DICKY): in the 19th century this word was most commonly applied to a detached shirt front of finer material than the flannel shirt worn underneath. Such a device was adopted by the less well-off strata of society. The term was also given to a stiff, standing shirt collar and to a woman's underpetticoat.

DIRECTOIRE KNICKERS: a slim style of closed knickers with elastic at waist and knee which became fashionable about 1910 and were worn for many years. The name derived from the slimmer line adopted for the whole ensemble which contrasted with the Edwardian frills and flounces which had preceded it; it was deemed to reflect the simplicity of the French Directoire period in relation to the excesses of pre-Revolution dress.

DIRNDL SKIRT: an Austrian peasant style which became a popular fashion of the later 1930s and the 1940s. The skirt was very full, gathered into a tight waistband.

DIVIDED SKIRT: introduced in Britain and Europe in the early 1880s for ladies to ride bicycles more comfortably and conveniently. In the 20th-

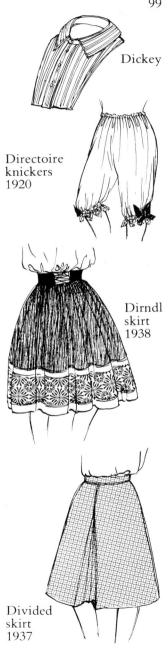

Dickey

Directoire knickers 1920

Dirndl skirt 1938

Divided skirt 1937

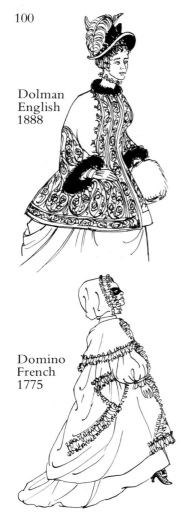

Dolman
English
1888

Domino
French
1775

Dormeuse, French, 1776

century inter-war years a divided skirt of knee- or mid-calf-length, which was in reality a pair of full shorts designed so that the division was not apparent, was in general use for sports and leisure wear. In these years the garment also became popular in America, worn especially for bicycling and known as CULOTTES. In more recent times such culottes have been designed as day-length wear and long evening wear, full enough to resemble a skirt (see also CULOTTES).

DOLMAN: an oriental, outer, masculine garment which came from Turkey and was worn in eastern Europe, especially Hungary, from the 16th to the 19th centuries. Originally the dolman was a loose, sleeved robe but under Hungarian influence it became a more fitted coat. In 19th-century western Europe it was revived as a fashion for ladies. In the 1870s and 1880s it was cut to fit over the bustle style of gown, where it hung with pendant ends down the front though it was shorter behind, resting on the bustle draperies, and had open, loose sleeves. An ankle-length, ample wrap with full sleeves was more typical of the early years of the 20th century. A similarly long but less full dolman was characteristic of the late 1880s and 1890s. This was a warm coat for winter wear, made of heavy fabrics such as velvet, plush or cashmere, often in Paisley designs. It was ornamented with fur and often lined with quilted silk. The **dolman sleeve**, typical of many such 19th-century coats, was cut with a very wide armhole and diminished towards the wrists; the term is synonymous with batwing (see BATWING SLEEVE, BUSTLE, PAISLEY SHAWL).

DOMINO: a hooded, full cloak worn with the half-face mask (see LOO MASK) at masquerades and carnivals in the 18th century; the custom originated in Venice. The domino was a long cloak often made of silk, in most instances black.

DORMEUSE: a lady's cap of the 18th century. Originally intended for night-time use, the design slowly became more elaborate and, in the second half of the century, was adopted for day wear. Often tied under the chin with wide ribbons, the dormeuse was held closely to the cheeks, edged with ruching and pleating, but it rose high on top, leaving visible the forehead and front hair. The cap was made of white lawn and lace and became larger in the 1770s, to accommodate the immense coiffure styles of the time (see also BAIGNEUSE).

DOUBLET: a close-fitting body garment worn by men from the 14th to the 17th century. Known by various names during the Middle Ages (see GIPON, PALTOCK, POURPOINT). The term 'doublet', though usual on the Continent from the 14th century, was not in general use in Britain until the later 15th century. The garment was originally quilted, i.e. of double material, and derived from the padded gambeson (see GAMBESON). The style varied with current modes during the 300 years in which it was worn. The neckline followed general trends as did the skirt, which ranged from knee-length to being a mere row of tabs at waist-level, but the garment was always fitting on the torso and waisted. In the later 16th century it was padded and boned (see PEASCOD-BELLY). Some doublet styles had wrist-length sleeves, some had none and were finished with a padded roll or tabs at the shoulder (see PICADIL) when the long shirt sleeve extended below.

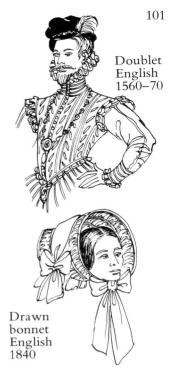

Doublet
English
1560–70

DOUILLETTE: a quilted, padded, outdoor garment in the form of a long coat or pelisse adopted by ladies to keep themselves warm in winter, and worn over the flimsy gowns fashionable in the early decades of the 19th century. The word stems from the French *douillet*(te), 'soft, downy'.

Drawn
bonnet
English
1840

DRAWN BONNET: a fashion of the mid-19th century from about 1835 onwards for a bonnet made like a calash (see CALASH) with silk-covered cane hoops, the material gathered in between.

Dress
protector
1930

DRESS PROTECTOR (in America, DRESS SHIELD): a double, crescent-shaped piece of material sewn into the armhole of a dress or blouse to protect it from under-arm perspiration. Made of chamois leather there were in use from the 1840s but were later replaced by shields of cotton, silk or rayon seamed together with a rubber inset. These continued in use until about 1930 when the development and marketing of anti-perspirants began to render them superfluous.

Drum
ruffles
French
1610

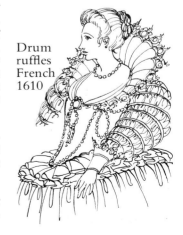

DRUM RUFFLE: a circular piece of ruffled material worn at the waist on top of the horizontal section of a wheel or drum farthingale (see FARTHINGALE).

DUFFLE COAT: a warm, short coat, with or without hood, fastened in front with wood toggles.

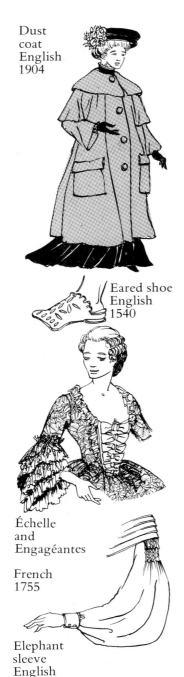

Dust
coat
English
1904

Eared shoe
English
1540

Échelle
and
Engagéantes

French
1755

Elephant
sleeve
English
1835

The style derives from that worn by the Royal Navy as protection from the cold during the Second World War. After the war surplus naval duffel coats were sold off cheaply and so became popular with young people. The original coats were off-white but later duffle coats were made in all colours. The name comes from duffel, the heavy woollen material which has been used since the 17th century for making warm coats and cloaks and is named after its Belgian town of origin, Duffel.

DUNDREARIES:  see BURNSIDES.

DUNGAREES:  workmen's overalls now usually made of denim but originally of a material called dungaree (a corruption of the Hindi word *dungrī*) which was an Indian calico of coarse quality.

DUST COAT, DUSTER:  a long, lightweight coat or cloak worn by both sexes as protection from the summer dust. Particularly of use in the years 1896–1910 for travelling in the open motor car (see MOTORING DRESS). The term 'duster' is in use today for a woman's unlined summer coat or a housecoat.

DUVILLIER WIG:  a particularly long, curled periwig of about 1700 named after a well-known French *perruquier* (wigmaker) of the time.

# E

EARED (HORNED) SHOE:  a style of extremely square-toed shoes worn in the years 1535–50 where the corners of the toes extended sideways to resemble ears or horns.

ÉCHELLE:  a ladies' fashion of the later years of the 17th century and of part of the 18th where a row of ribbon bows, diminishing in size from bosom to waist, decorated the centre front of the bodice stomacher. From the French *échelle*, 'ladder'.

ELEPHANT SLEEVE:  a full sleeve for day dresses of the 1830s where the fullness dropped from the shoulder downwards towards the fitting wristband in the shape of an elephant's ear.

**EMPRESS PETTICOAT:** an elaborate evening petticoat of the later 1860s which was gored and fitted at the waist and hips but spread out below this into knee-high flounces and a train.

**ENGAGÉANTS (ENGAGÉANTES):** two tiers of ruffles made from silk, lawn and lace which depended from the gown sleeve on the forearm. The fashion lasted for about 100 years from the late 1680s on.

**ENGLISH QUEUE:** see CATOGAN.

**EN TOUT CAS:** from the French expression meaning to serve all eventualities, this was a 19th-century umbrella/parasol. It was sufficiently elegant to shade one daintily from the sun, yet robust enough to withstand a summer shower.

**ESCLAVAGE:** a term applied to a bracelet or necklace made up from several rows of gold chains or beads. Named after the French word for slavery, this type of jewellery was designed to represent the fetters of slaves and was a particular fashion of the 18th century.

**ESCOFFION:** a term used to describe a coif of gold thread or coloured silk worn by ladies in the 16th century; from the Italian *scuffia*, 'cap'.

**ESPADRILLE:** traditional footwear of the inhabitants of the Pyrenees, both Spanish and French, in the form of a rope-soled canvas shoe laced round the ankle. The espadrille has become popular in modern times as beach and boat wear.

**ETON COLLAR:** a starched white broad collar turned down over the coat. Derived from the Eton College uniform but also worn extensively by boys in Britain and the USA with other types of suit.

**ETON CROP:** a ladies' hairstyle of the 1920s where the hair was cut very short and shaped to resemble the men's hairstyle of the time.

**ETON SUIT:** a school uniform adopted by Eton College which standardised by the mid-19th century and gradually established a pattern for boys' dress in general. The suit consisted of a short, black broadcloth, open jacket with trousers which were usually grey. The shirt was white with an Eton collar (see ETON COLLAR) and the costume was com-

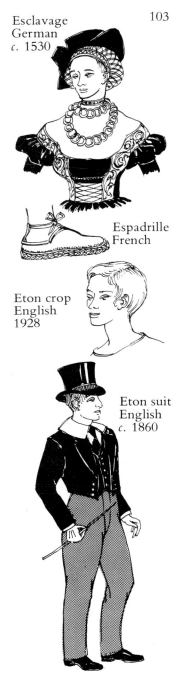

Esclavage
German
c. 1530

Espadrille
French

Eton crop
English
1928

Eton suit
English
c. 1860

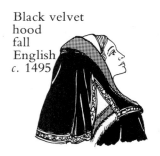

Black velvet
hood
fall
English
*c.* 1495

pleted by a black tie and waistcoat. Until the mid-century a peaked cap was worn, then a round hat, and finally the characteristic Eton top hat.

ETUI: a French word for a case or box. Tiny cases or bags, attached to the lower edge of the bodice or hung from the waist-belt, were worn by ladies from the 17th century onwards to carry on their person various necessities such as sewing and toilet articles. The etui was very fashionable in the 18th century especially to contain scent.

# F

Ribbon and
lace fall
at knee
Italian
1630

FAJA: Spanish word for sash. The broad pleated or folded sash has traditionally been an important item in Spanish dress. In peasant costume it protected the lumbar region from taking chill after becoming over-heated when working in the fields. For the fiesta or as part of the bullfighter's attire it can be brightly coloured and richly ornamented.

Lace
falling
band
Swedish
1644

FALL: a term for any pendant part or decoration in costume. The word is most often applied to a cascade of silk or lace, ruffles or ribbon loops. It is also used for the back drapery of the 16th-century ladies' hood and, in more modern times, for a switch of false hair (see HAIR-PIECE).

The word FALLS is given to the broad, buttoned flap which provided the front opening to breeches, pantaloons and trousers of the 18th and early 19th centuries.

FALLING BAND: a soft, unstiffened, large collar draped over the shoulders of a man's doublet or a woman's gown, fashionable especially in the first half of the 17th century. These collars, which were separate items, were made of white lace or lace-edged cambric or silk and were tied at the throat by band strings which ended in tiny tassels or crochet-covered balls (see BAND).

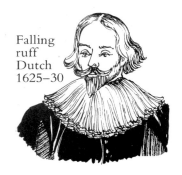

Falling
ruff
Dutch
1625–30

FALLING RUFF: in the second and third decades of the 17th century an unstarched ruff was fashionable. Gathered into the usual form this unstiffened ruff drooped gently in folds over the shoulders (see RUFF).

FALSIES (BUST FORMS): in the 1930s moulded pads of foam rubber worn inside a brassière to amplify the shape of an inadequate bosom.

FANCHON: lace or silk ruffles falling from the sides or back of a day cap or bonnet worn in the mid-19th century.

FARTHINGALE: a skirt with a framework of pliant, wooden, circular hoops inserted in it horizontally at regular intervals between waist and ankle to maintain a desired shape. The farthingale which was the prototype of such skirts in Western Europe (see CRINOLINE, HOOP) originated in Spain as the *vertugado*. This was a bell-shaped skirt introduced in Castile about 1470. It was made of a heavy, richly patterned material and the hoops (*verdugos*), inserted between the gown fabric and its lining, were intentionally visible (see ARO, VERTUGADO).

In the 16th century the fashion for the framework skirt spread first to France, where it was popularised by Eleanor of Austria about 1530, from there to England where it was taken up by 1535, and finally to the other countries of western Europe. The skirt was known by different names in various countries, all of which derived from *vertugado*. In France it was called *vertugade* or *vertugale* and later *la mode vertugadine*. In England it became the farthingale; later in the century it was referred to as the **Spanish farthingale** to distinguish it from the later French wheel farthingale. The farthingale worn in Spain during the 16th century remained bell-shaped; in France and England it resembled a cone, having straight sides.

During the 16th century, the farthingale also became an undergarment, an underskirt generally made of linen, into which the wicker hoops were inserted; it was tied round the waist by tapes. Further underskirts and the gown itself were worn on top concealing the ribs of the hoops. The gowns were cut from rich materials, especially velvet and brocade, with large motif designs beautifully displayed on a creaseless skirt, the fullness of which was extended by the farthingale and was concentrated in folds at the rear. In England and France the gown skirt was often open in front in an inverted V form to display an equally rich underskirt of different material and pattern. This custom was rare in Spain where the gown skirt was more often closed, its centre front edges being fastened at intervals by jewelled clasps.

As the 16th century progressed the diameter of

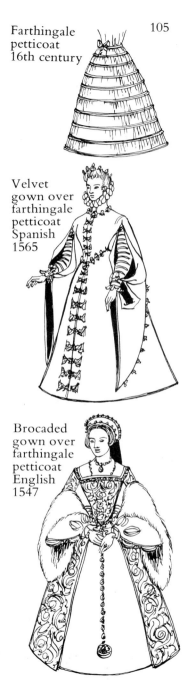

Farthingale petticoat 16th century

Velvet gown over farthingale petticoat Spanish 1565

Brocaded gown over farthingale petticoat English 1547

French or wheel
farthingale
petticoat

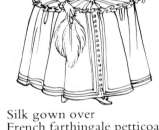

Silk gown over
French farthingale petticoat
English 1610

The Spanish court
farthingale in 1660
(Tontillo)

the farthingale hem became greater. Further layers of underskirts were worn and the shape became fuller (see also BUM ROLL). This was especially so in England, Germany and Flanders while Italy and Spain tended to retain the slimmer line. Towards the end of the century the **wheel** or **drum** form of farthingale was evolved in France, so was often referred to as the **French farthingale**. Made in a similar manner to the Spanish farthingale, the circular hoops were of equal diameter, giving a drum shape. The flat top of the drum was also made of canvas or linen. This had a hole for the waist where it could be drawn up and tied on with tapes. The gowns worn with such farthingales were low-waisted with constricted bodices and very slender waists descending to a narrow point in front. In England a drum ruffle was worn but this was less common in France (see DRUM RUFFLE). Gown skirts were shorter, displaying the feet and having no train. The wheel farthingale remained fashionable until the 1620s.

Spain, where the farthingale had first appeared, was the last country to abandon the style. The bell-shaped version had been worn throughout this long period and continued well into the 17th century becoming only slightly wider as time passed. By 1645 it entered its last phase which resembled an immense panier or hoop skirt of 18th-century type of design. This was fairly flat at back and front but extended at the sides at hip-level. Mid-century portraits by Velasquez show this skirt, known as a TONTILLO, which was inflicted even upon the children of aristocratic families. The fashion did not finally die out until the late 17th century.

FASHION DOLL: large mannequin dolls were dressed in Paris in the latest fashions and sent out each month, especially during the 17th and 18th centuries, to the capitals of Europe as well as America. They acted as ambassadors of French fashion, replaced only by the establishment of the fashion journal.

FASHION JOURNAL: these publications appeared in the second half of the 18th century. They were magazines which presented news and **fashion plate** illustrations to inform men and women of what was being worn by leaders of fashion and what was likely to become the mode. **Costume plates** had been produced since the 17th century. These were coloured engravings made by artists, which illustrated what fashionable people

were wearing at a given date in their individual country. They were, therefore, a record of what was happening, not designs for what might become fashionable. The fashion doll presented French design for the fashionable ladies of Europe to study and adopt if it found favour with them. The fashion journal supplemented and extended this information though the dolls were still being made and sent out until well into the 19th century.

Though in the mid-18th century the French were the supreme arbiters of ladies' fashions and the fashion dolls were sent out from Paris, it was initially the English who chiefly promoted the idea of fashion journals, entering the field with such publications as *The Lady's Magazine* (1770). The 19th century was the heyday of the fashion journal, at first mostly of French and English origin, e.g. *La Belle Assemblée*, *Le Bon Ton*, *The Ladies' Cabinet*, as well as the famous *Gallery of Fashion*, first published in 1794 by von Heideloff. In the second half of the century other countries entered the field also, publishing in several languages. Typical of these were Germany's *Die Modenwelt* and Austria's *Weiner Mode*. Journals which later became world-famous were launched by America at this time, *Harper's Bazaar* and *Vogue*, for instance.

FAUSSE MONTRE: in the last decade of the 18th century and the early 19th, men wore a pair of fob watches hanging below the waistcoat over the breeches, pantaloons or trousers. Generally, one of these was a genuine watch, the other a dummy.

FAVOURITES: a 17th-century term for curls or ringlets hanging loose at the temples.

FEDORA: a man's soft felt hat with a curled brim, the crown creased lengthwise from front to back. Chiefly an American term, it derives from a heroine in a French play of 1883. In England a similar hat was the Homburg (SEE HOMBURG HAT).

FERRONIÈRE: a narrow, metal, jewelled band or chain worn by ladies round the head with a jewel set in the centre of the forehead. Fashionable in Renaissance Europe, especially in Italy and France, the name derived from the painting *La Belle Ferronière* thought to have been by Leonardo da Vinci. The mode was reintroduced in the 1830s.

FICHU: a term used especially in the 19th century for a piece of thin material, often triangular-

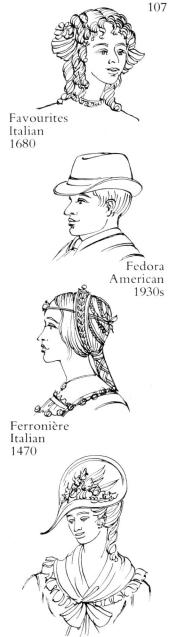

Favourites
Italian
1680

Fedora
American
1930s

Ferronière
Italian
1470

Fichu, German 1770

Finistrella
sleeve
French
1500

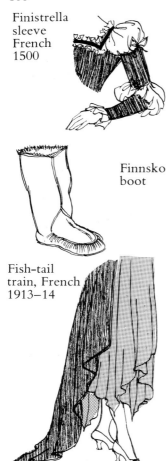

Finnsko
boot

Fish-tail
train, French
1913–14

Lace
fontange
German
1693

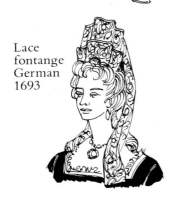

shaped, draped loosely round a lady's neck and shoulders. Different materials and colours were in use and many different names were applied to specific designs of fichu (see also BUFFONT).

FINISTRELLA:    a design of sleeve in Renaissance Italy. This was a fitted long sleeve made in two or three parts, the sections being laced together with points and displaying the full, white undershirt or chemise between.

FINNSKO (FINNESKO) BOOT: a design worn in Norway and Lapland for use in Arctic regions, made of birch-tanned reindeer skin with the fur turned outside.

FISH-TAIL TRAIN:    a narrow train fashionable with evening and formal gowns in the years 1910–14. Also known as a MERMAID'S TAIL.

FITCHET:    a vertical slit or placket hole in a tunic or gown. A medieval term which was often applied to such a slit at hip level in the surcoat, which enabled the wearer to pass his or her hand through to the belt and purse which were worn round the tunic beneath.

FLY FRINGE:    a silk cord fringe of tufts and tassels used especially as dress trimming in the 18th and 19th centuries.

FLY FRONT CLOSURE:    a closure where button and zip fastenings are concealed by an overlap of the material extended over them. Introduced in the late 18th century but used primarily in the 19th and 20th centuries, mainly in men's wear for trousers, breeches and coats.

FONTANGE:    a white lawn or linen cap decorated with ribbons and lace lappets, the crown surmounted by tiers of fluted lace and lawn ruffles which were held in place by a silk-covered wire framework called a COMMODE. This headdress, which was fashionable from the 1680s until about 1710, was named after Mlle de Fontanges, mistress of Louis XIV. It was called a *bonnet à la fontanges* and the superstructure of lace and ribbons was made taller as time passed, the fashion reaching its zenith about 1700 after which, having been subjected to so much ridicule, it subsided to become a lace-crowned cap of moderate proportions.

FOUNDATION GARMENT: see CORSE-LETTE.

FOUR-IN-HAND: a necktie of the years 1890–1914 named after the drivers of these vehicles. The narrow tie was knotted in front and hung down with wider ends.

FRENCH HEEL: a high, elegant heel curving into a narrow base, fashionable in the second half of the 18th century.

FRENCH HOOD: a hood or bonnet worn over a coif (see COIF), fashionable from about 1530 in England until the 1590s, though worn earlier in France where the fashion originated. This head-dress was based on a stiff metal frame. It was set back on the head to display the hair in front and generally had two frontlets called biliments separated by satin or velvet bands (see BILIMENT). The front biliment curved round on each side to cover the ears, the rear one was longer and shaped like a horseshoe. In the 1550s, especially in England, the hood was flattened on top to give a different form. A velvet curtain then hung down the back of the neck in folds or as a tube which could be brought forward to shade the face (see BONGRACE). The hood was held in place by a band under the chin.

FRENCH KNICKERS: a style of open knickers introduced 1925/6 with flared legs, generally lace-trimmed.

FRENCH POCKET: a horizontal slit pocket introduced in the second half of the 17th century into the French style of man's coat (see JUST-AUCORPS).

FROCK COAT: a style of masculine tail coat worn from the late 18th century until the early years of the 20th, changing according to the current mode in the details of collar, revers, sleeves, button-ing and general line. The coat was characterised during the 19th century, especially from 1850 onwards, by being seamed at the waist and having knee-length full skirts which hung straight in front and were level all round. At first single-breasted, in formal use in the second half of the century it was more generally double-breasted.

FROGS: a cord and button fastening (see BRAN-DENBURGS).

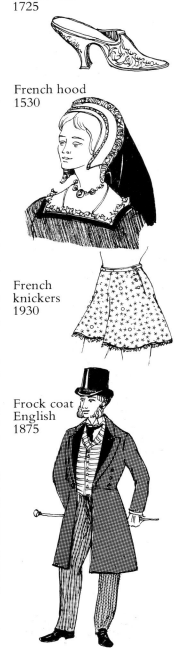

French heel 1725

French hood 1530

French knickers 1930

Frock coat English 1875

Embroidered frontlet
Flemish
1530

Black
velvet
frontlet
Flemish
1480

Full-bottomed wig
French
1695

**FRONTLET:** a decorative band worn round the forehead or the edge of a hood or cap (see BILIMENT). The word, which refers to anything worn on or round the forehead, was also applied to the loop of velvet or gold attached to the cap worn under the elaborate, later-15th-century head-dresses and visible on the forehead below these head-dresses. Again, it could refer to the band of material which, coated with cream, was bound round the forehead at night in bed to prevent wrinkles forming.

**FULL-BOTTOMED WIG:** the style fashionable for men from the 1660s until the early years of the 18th century. This was very large and framed the face with a mass of curls and ringlets which cascaded in a curtain down the back almost to the waist and lay on the shoulders in front. In the 1690s the style had a centre parting and rose to a peak on each side of this. The full-bottomed wig was made in natural hair shades from blond to black according to personal choice; it was usually unpowdered. The best-quality wigs were very costly; they were made from human hair and became a status symbol for the well-to-do. In England, Samuel Pepys tells us of fears that, owing to shortage of supply during the Plague of 1665, it was rumoured that plague victims' hair was being used for wig manufacture. Wigs have survived in formal and ceremonial dress particularly in the legal profession.

**FULLY FASHIONED:** a term applied to a knitted fabric where the edges of the flat material are shaped by reducing or augmenting the number of stitches. In use especially for tights, stockings, socks, jumpers and underwear.

**FUNNEL SLEEVE:** see PAGODA SLEEVE.

# G

**GABARDINE:** a coat or cloak of which a number of variations have appeared in Europe over the centuries. Introduced from the east by way of Venice during the Middle Ages, when it was a long coat with wide sleeves which could be drawn in at the waist by a sash or belt. The name derived from

the Arabic *gaba*. Worn unbelted it continued in use during the 16th and 17th centuries as an outdoor, loose coat for the poorer members of the community. A similar garment, but more in the form of a loose cassock, was the Spanish *gabardina*; the name gabardine was also given to a medieval Jewish cloak.

In the 20th century gabardine (gaberdine) is a cotton or rayon fabric which has been waterproofed before weaving. The name is also applied to rainwear made from the material.

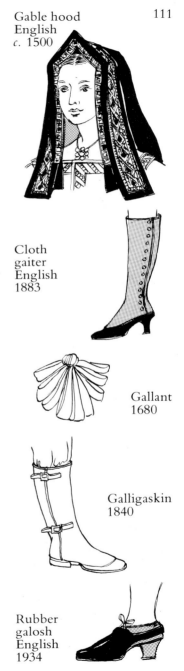

Cloth
gaiter
English
1883

Gallant
1680

Galligaskin
1840

Rubber
galosh
English
1934

**GABLE HOOD, GABLE HEAD-DRESS:** also known as the ENGLISH HOOD as it was a particularly English style during the years 1500–40, the head-dress was worn over a coif. Like the later French hood (see FRENCH HOOD) the gable design was attached to a metal decorative frontlet to keep the form which, in this case, resembled a gable or pyramid. A fall of dark material, usually velvet, hung down behind and decorative lappets lay on the shoulders in front. In the early years the hair was visible on the forehead under the pointed gable, but from the 1520s this hair was encased in striped silk fabric. At the same time one or both lappets were turned up and pinned.

**GAITER:** a covering for the ankle and lower leg worn for extra warmth from the late 18th century until the early 20th. Gaiters could be made of cloth, leather or elasticated fabric; they were generally buttoned up the outside of the leg and fastened under the instep of the boot or shoe.

**GALLANT (GALANT):** the ribbon loops and rosettes which decorated various parts of the costume of both sexes during the 17th century.

**GALLIGASKIN:** in the 16th and the early 17th centuries wide, often padded, masculine breeches. In the 19th century, leather leggings or long gaiters strapped round the leg or foot.

**GALLOWSES (GALLUSES):** traditional English names for braces.

**GALOSH (GOLOSH):** a word with many variations in spelling—most commonly, galoche, galloshios, goloshoes—for an outer covering to footwear worn since the days of ancient Rome to protect elegant shoes from the mud and dirt of the streets. In early times the galosh was a wooden shoe

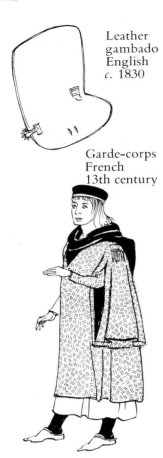

Leather
gambado
English
c. 1830

Garde-corps
French
13th century

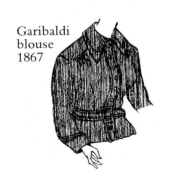

Garibaldi
blouse
1867

or patten (see PATTEN) fastened to the foot by leather straps. By the 17th century it was in general use in Europe and America and had become a leather overshoe with a wooden sole buckled on over the normal footwear. In more modern times the galosh is of rubber-covered canvas or, more recently, of plastic with a rubber sole. In the USA galoshes are termed RUBBERS.

GAMASHES: long cloth leggings buttoned or laced to the leg, worn during the 17th century to protect the leather boots or fine shoes and hose from mud and wet while riding or walking.

GAMBADO: a protection for the leg while riding a horse. The gambado was made of heavy leather, usually black, and resembled a half section of a very wide boot. It was attached to the saddle and harness.

GAMBESON: a padded, quilted body garment worn by soldiers under armour or shirt of mail in the early Middle Ages. In the 14th century it was adopted into civil dress and later evolved into the doublet (see DOUBLET)

GARDE-CORPS: an unbelted, loose overtunic worn by both sexes in the 13th and early 14th centuries. It was threequarter- or ankle-length and had wide sleeves which were often worn as hanging sleeves: that is, they were slit in front at elbow-level so that the arm could pass through the opening while the rest of the sleeve hung down behind the arm. The garde-corps was a winter-wear garment, often lined with fur and with a hood which could be pulled up as required.

GARIBALDI BLOUSE: a popular mode for ladies in the 1860s inspired by and based upon the famous *camicia rossa* of the Italian patriot Giuseppe Garibaldi and his army. Extensively worn in Europe and America the fashion blouse was made of red wool trimmed with black braid; it was a tailored style (shirtwaist in the USA) with a small turned-down collar, a front buttoning and long sleeves gathered into wristbands or cuffs.

GARNACHE: an ankle-length overtunic or robe worn for extra warmth during the 13th century with wide elbow-length sleeves, resembling a cape, cut in one with the garment. A version seen in the first half of the 14th century had two tongue-

shaped tabs or lapels on each side of the neck opening; this is often referred to as a HOUSSE.

GARTER: a band or sash buckled or tied round the leg above or below the knee to hold the stockings in place. Worn by both sexes from the Middle Ages onwards. In some periods such as the 16th and 17th centuries, these were particularly decorative with ribbon loops and bows or long sashes with fringed ends. In the late 19th century elasticated hosiery supports, called SUSPENDERS in England but still GARTERS in the USA, were introduced for men's socks and women's stockings.

GAUGE: in costume this standard measure is used particularly in reference to hose. The gauge is the number of stitches in a given measured section of fabric; the higher the gauge number the stronger the fabric.

GAUGING (GAGING): a series of close parallel lines of running stitches sewn in a garment to make the material between set in gathers; a means of decoration widely used in mid-19th century bonnets and dresses.

GENEVA HAT: a high-crowned hat worn especially by Puritans in the late 16th and early 17th centuries. Named after the Swiss city because of the style adopted by the Calvinists there.

GHILLIE SHOE: originally a Scottish dancing shoe style but now adopted for fashion shoes. Characterised by the design of cross-lacing which passes through loops of leather which may extend from vamp to ankle.

GIBSON GIRL: the ideal American woman of the early years of the 20th century immortalised by the artist Charles Dana Gibson. Also known as the Shirtwaist Girl, she was shown wearing a tailored white linen bouse with Ascot tie, a dark, tailored skirt with small, belted waist and a jaunty hat perched on a pompadour coiffure.

GIBUS: a collapsible black silk top hat invented by a Parisian hatter named Gibus and patented in 1837. The lining concealed a spring and the hat could be collapsed to a flat form and be carried under the arm for evening wear (see OPERA HAT).

GIGOT SLEEVE: French term for leg-of-

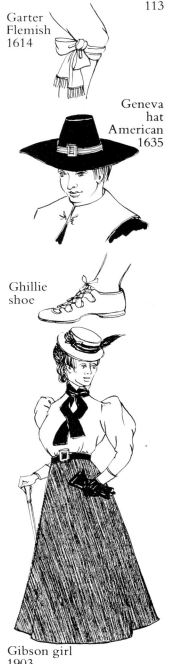

Garter
Flemish
1614

Geneva
hat
American
1635

Ghillie
shoe

Gibson girl
1903

mutton sleeve (see LEG-OF-MUTTON SLEEVE).

Silver decorated leather
gipser, Swiss, *c.* 1400

GILET:   French word for waistcoat. The term is sometimes used in English referring, in modern dress, to a sleeveless blouse or bodice front worn under a jacket or dress.

GIPON (JUPON):   a padded, quilted body undergarment of the 14th century (see DOUBLET, GAMBESON).

GIPSER (GIPCIÈRE):   a purse or pouch suspended from the girdle. A medieval term.

Gipsy hat with veil
English 1808

GIPSY BONNET, GIPSY HAT:   a flat style, with or without veil. The hat was generally of straw and was fashionable in the early decades of the 19th century. It was held on by a scarf or ribbons tied round it under the chin. The bonnet was the mode in the 1870s; this was small, was similarly attached and was decorated by feathers and lace.

GOFFERING   (GAUFFERING):   from   the French *gaufrer*, 'to crimp or flute'. Through the ages the material of articles of dress has been crimped or folded by various means. The commonest method was by **goffering tongs.** Resembling metal curling tongs, these set the folds of the 16th-century ruff (see RUFF) after starching. A **tally iron** (the word is a corruption of Italy) was then used to smooth the fabric. Often erroneously termed a goffering iron, this comprises a cigar-shaped barrel(s) on a stand. A heated metal rod was placed in the holder and the ruff fabric drawn over the barrel. Later devices for finishing the ruffled edges of garments include a **goffering stack and board** and a **crimping machine**.

Metal goffering tongs

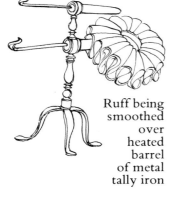

Ruff being smoothed over heated barrel of metal tally iron

GOLILLA:   a support of stiffened material or card faced with silk worn under the Spanish white collar, the valona. A style of band favoured by Philip IV of Spain, and especially fashionable there and to a lesser degree in the rest of Europe (see VALONA).

GORE:   a triangular piece of material inserted into a garment to make it fit snugly to part of the body, e.g. the waist, while flaring out with extra fullness elsewhere. A gored skirt is made in panels which are shaped to be narrow at the top and wider towards the hem. A device in use from the later 14th century, the name deriving from the old High German word for spearhead: a triangular shape.

GORGET: an item of dress which covers the throat. Used to describe some of the medieval head-coverings which were draped round the head and throat, for example, a wimple (see WIMPLE). Originally a piece of armour to protect the throat.

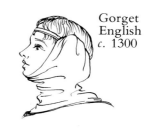

Gorget
English
c. 1300

G-STRING (GEE STRING): a term of obscure origin used by 19th-century writers to describe the breech-clout worn by North American prairie Indians which consisted of a string tied round the waist with a single strip of cloth depending from it and pulled tight between the legs from front to back. The French introduced the BIKINI as beach attire in 1947. This consisted of a bra and briefs. From this derived the scantier attire for which the modern American term 'G-string' has been coined.

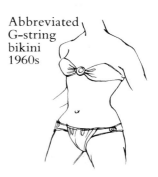

Abbreviated G-string bikini 1960s

GUÊPIÈRE: a corset introduced by Marcel Rochas in 1947 to produce a tiny waist. Known in England as a WASPIE (from the French *guêpe*, 'wasp'), in America also as a WAIST-CINCHER, this was an abbreviated corset, some 5 inches (12·7 cm) deep, of firm material with elastic inserts, bones and back lacing, to confine the waist only; admirably suited to Dior's New Look of the same year (see NEW LOOK).

North American Indian G-string breech-clout

GUERNSEY (GANSEY), JERSEY: from the 1580s the Channel Islands exported their knitted garments, chiefly stockings and waistcoats, to England and France. Due to the high reputation of their knitwear the terms jersey and guernsey became synonymous with all knitted garments. From the 17th century these terms have been more specifically applied to jerseys made for the island fishermen by their wives.

GUSSET: a triangular piece of material let into a garment to strengthen it and give ease of movement. Originally the word was applied to a piece of flexible material inserted between the joints of two sections of mail in a suit of armour.

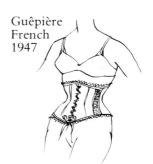

Guêpière French 1947

# H

HABIT: from early times the term denoted clothing or dress in general. By the Middle Ages it

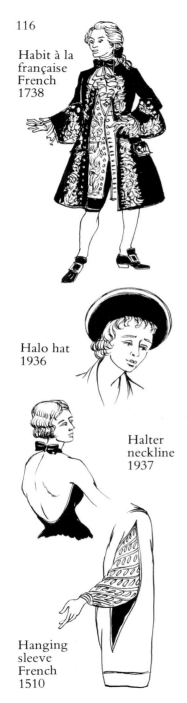

Habit à la française French 1738

Halo hat 1936

Halter neckline 1937

Hanging sleeve French 1510

referred to the attire of a specific profession or rank. It is in this sense that the word is still used in, for instance, a religious habit or in riding dress. The French phrase *habit à la française* was in general use in Europe for the fashionable man's suit of the 18th century which comprised coat, waistcoat and breeches, though, towards the end of the century, the word 'habit' tended to refer to the coat only.

HAIR-PIECE: a modern term for extra, false hair added to and blended with a natural coiffure style and distinct from a wig which is a complete false hair-cover. Other names have been in use over the ages, notably FALL, SWITCH, TRANSFOR-MATION, WIGLET.

HALO HAT: a style especially fashionable in the 1930s which was worn on the back of the head and had a deep upturned brim.

HALTER NECKLINE: a style introduced in the 1930s and intermittently fashionable since. The neckline is high in front at the throat and is usually finished or tied at the nape of the neck leaving shoulders and back bare. At first worn for sunbathing, its popularity spread to evening and day wear.

HANGING SLEEVE: a medieval and Renaissance fashion worn especially between 1450 and 1540. The sleeve was very long and wide; it was slit in front at elbow-level and the arm was passed through the slit leaving the tubular sleeve to hang behind the arm, sometimes nearly to the ground. In the later 16th and early 17th centuries the hanging sleeve became vestigial and was merely a streamer of material attached to the back of the armhole of the doublet, jerkin or gown.

HAREM SKIRT: a full, ankle-length, divided skirt based upon Turkish or Persian trousers which was introduced about 1910 but re-appeared as an evening mode in the 1930s.

HARLOT: a 14th-century term for masculine hose which had by then been joined to become 'tights'.

HAUTE COUTURE: in French the word *couture* means sewing, a *couturier* is a male tailor or dressmaker and a *couturière* a feminine one. An *haute couture* concern is a design and dressmaking establishment. There is, however, in modern parlance a

specific connotation to the term. In haute couture, models are created by a designer, they bear his or her name and are protected by copyright from indiscriminate reproduction. The august body in Paris responsible for maintaining standards in the profession, the *Chambre Syndicale de la Couture*, defines haute couture as 'any undertaking whose most important activity consists in creating models with the object of selling them to a professional clientèle which thereby acquires the right to reproduce them'.

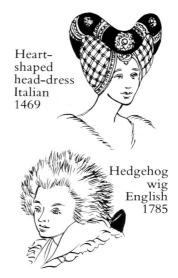

Heart-shaped head-dress Italian 1469

**HEART-SHAPED HEAD-DRESS:** a medieval feminine head-dress worn especially in the years 1430–60 which consisted of a velvet or silk-covered padded roll or turban worn over a jewelled caul and, often, with a veil. The roll was decorated with embroidery and jewels and was designed to dip in the centre front and back and rise at the sides to display and accommodate the caul (see CAUL).

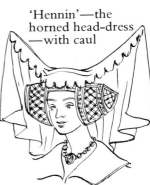

Hedgehog wig English 1785

**HEDGEHOG WIG:** the last phase in the 18th-century fashion for wigs. A style of the 1780s wherein the hair was cut raggedly all over so that the ends stuck out like hedgehog spines. The back hair was tied in a black silk bow or bag.

'Hennin'—the horned head-dress —with caul

**HENNIN:** a term of insult and abuse (the specific meaning is unknown) levelled at the extravagant wired and veiled head-dresses worn in the early years of the 15th century, which rose in two horns, one on each side, above the head, suggestive of the Devil. The term is often incorrectly applied to the steeple head-dress of the second half of the 15th century.

English 1415

**HESSIAN BOOT:** a military style made of black, polished leather, worn by the troops of Hesse in Germany. Introduced into European fashion in the 1790s, the Hessian boot reached to the knee in front, where it was finished with a tassel, but was cut lower at the back. It continued in fashion well into the 19th century.

**HEUKE (HUIK):** a cloak which covered the head and enveloped much of the body, worn during the 16th and early 17th centuries in parts of Europe. The traditional Arab *haik (hayk)* was the prototype of the design. This had been in use since early times in North Africa and was introduced to Spain by the Moors. In Granada it was seen and illustrated in 1529 by Christoph Weiditz, also in

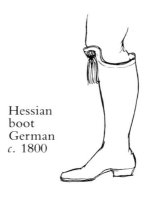

Hessian boot German c. 1800

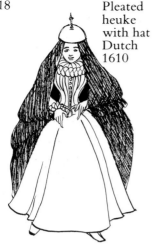

Pleated
heuke
with hat
Dutch
1610

Flanders in 1532 (see *Das Trachtenbuch des Christoph Weiditz von seiner reisen nach Spanien und den Niederlanden 1529–32*, Berlin, 1927).

From Spain the wearing of this type of cloak spread to northern Europe where it was worn in various forms for over a century. It became a characteristic article of dress especially in Flanders and northern Germany, where it was known as a *heuke* or *huik*. Fynes Moryson in his travels in Europe in the 1590s describes this 'hoyke or veil' (see *An Itinerary Containing His Ten Yeeres Travell through the Twelve Dominions of Germany, Bohmerland, Sweitzerland, Netherland, Denmarke, Poland, Italy, Turky, France, England, Scotland and Ireland*, Glasgow University Press, 1907). There were a number of variations on the design of the heuke. In the **hooded heuke** metal or whalebone strips were inserted in the top so that the material projected in front of the head like a canopy. The **peaked heuke** had a flat or curved piece of wood projecting forward over the forehead like a duck's bill; the cloak was then pulled closely to the face and neck. Towards the end of the 16th century and up until about 1630 a common version was to wear a round hat with a spike on top over the folds of the cloak material in order to keep these in place.

**HEUZE (HOUSEAUX):** tall, thick-soled riding boots often reaching to mid-thigh, buckled or strapped to the leg and worn from the 9th to the 15th century.

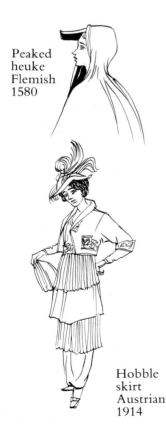

Peaked
heuke
Flemish
1580

**HIGHLOWS:** leather calf- or ankle-length boots laced up the front and worn under the pantaloons and trousers in the years 1820–90.

**HIPSTERS (HIPSTER PANTS in the USA):** a slim, hip-hugging style of trousers introduced in the 1960s, extending only to the hips, where the 'waistband' was, and secured there by a belt.

**HOBBLE SKIRT:** an inconvenient design introduced a year or so before the First World War which was so narrow at the ankle that it was (as the name indicates) difficult to walk. In the early versions a wide band encircled the skirt below the knees but soon this was abandoned as ridiculous and the material was cut to drape and taper towards the ankle.

Hobble
skirt
Austrian
1914

**HOMBURG HAT:** the aristocrat of felt hats for men, introduced in the 1870s and called after the

German town of that name. The crown was dented lengthwise from front to back and the brim edges were braid-trimmed and slightly upturned. The style was popularised by the then Prince of Wales.

HOMESPUN: originally material loosely woven by hand at home. Such fabric is now machine-made in imitation of the rural craft.

HOOP: the hoop petticoat was the second instance in the history of European costume of such a framework being worn under the gown skirt to produce a very different silhouette from the one which Nature intended (see CRINOLINE, FARTHINGALE). The hoop (in France referred to as a *panier*, 'basket') was the 18th-century fashion.

For much of the 17th century women had enjoyed wearing clothes which followed an elegant, feminine yet fairly natural line. Corsets had not been excessively restrictive and only petticoats helped the set of the gown skirt. In the last decade of the century wider, fuller skirts were being worn, supported by more layers of petticoats, sometimes very heavy and stiffened (see CRIARDES), and hip-pads were attached to the corset or stays. Soon the hoop petticoat was introduced, first in England and then, by 1718, in France. The hoop of the early 18th century was circular in section giving a dome or cupola form. Often side-paniers were worn; these were basket forms consisting of whalebone or cane bands inserted into a petticoat of rich material to maintain the shape, and they were tied on with tapes round the waist. Alternatively the full-length hoop petticoat supported the weight of the heavy layers of draped material on top. This had circular whalebone or cane hoops inserted into the petticoat skirt at intervals between waist and ankle in a similar manner to the earlier farthingale but with a different, wider and more rounded form.

The hoop was fashionable for much of the 18th century but its shape changed as time passed. The rounded form lent a lilting, gently-flowing movement to the skirt as the lady walked. Soon, however, the circular section was altered to an elliptical one, flatter at the front and back, wider at the sides. By mid-century it extended up to six feet (1·8 metres) in width and had become a problem when negotiating a doorway (this had to be done sideways) or sitting down in a chair; to enter a sedan was impossible. So, the collapsible hoop was invented. There were several designs of this, some with hoops inserted in material and some just bands

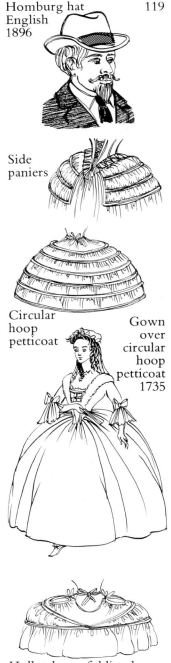

Homburg hat English 1896

Side paniers

Circular hoop petticoat

Gown over circular hoop petticoat 1735

Holland non-folding hoop

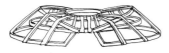

Whalebone and tape
folding hoop

Gown over
such a hoop
German
1750

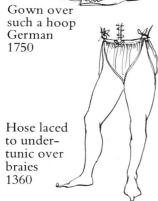

Hose laced
to under-
tunic over
braies
1360

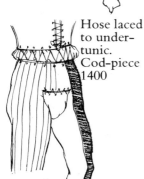

Hose laced
to under-
tunic.
Cod-piece
1400

of cane or whalebone covered in fabric and con-
nected together only by tapes. All versions were
tied on at the waist and were articulated so that
when a lady wished to pass through a doorway, she
lifted the skirt upwards by placing her elbows
under the hoops. Then slits were put into the gown
skirt to enable her to slip her hands inside to raise
the paniers. In the 1770s small pocket hoops were
fashionable under the polonaise gowns of the time
(see *ROBE à la polonaise*). By the 1780s the
emphasis was more at the back and a pad was tied
on to support this; this was termed a BUM or
RUMP (in France, a *cul postiche*) (see BUSTLE).

HOSE:   leg coverings in the form of socks, stock-
ings or 'tights'. In the early Middle Ages stockings
were pulled up to the knee over the undergarment,
the braies (see BRAIES). As time passed the hose
became longer and the braies shorter so that, by
1360, the two legs of the hose had reached the
crotch on the inner side and extended to the hips on
the outer, where they were kept up by being laced
to the lower edge of the undertunic (see AGLET,
POINTS). By 1375–80 the two legs were united to
become 'tights', extending nearly to waist-level
where they were laced to the undertunic all round
the body. The cod-piece was then laced on in front
(see COD-PIECE).
   During this time hose were generally cut to fit
the leg from cloth, velvet or silk. They were cut and
seamed in four shaped, vertical sections (see also
PARTI-COLOURING) and, in winter, could be fur-
lined. During the 15th century fashionable hose
were snugly fitting, displaying the well-turned
masculine leg to advantage. The foot portion was
often soled or elegant shoes could be worn; pattens
were strapped on for outdoor wear (see PATTEN).
By the 16th century hose were often divided into
two parts, upper and lower (see CANIONS, NETHER-
STOCKS, TRUNK HOSE). Women wore hose during
these centuries but these were generally stockings,
not socks or 'tights'.
   Fashionable hose in the 14th and 15th centuries
were cut and shaped from material as described, but
hand-knitted socks and stockings had been made in
Europe from the late 14th century onwards. Before
the 16th century these were worn by less fashion-
able, ordinary citizens. Silk knitted stockings were
introduced from Spain in the 16th century; they
were costly, only imported for the nobility, and
were not made in England until later in the century.
It was an Englishman, the Rev. William Lee, who

invented in 1589 a stocking frame to knit worsted stockings by machine but, although Queen Elizabeth I came to see his machine in operation and was greatly interested in it, she refused to grant him a patent of monopoly because she feared the wide-scale unemployment of the hand-knitters which would result. In the early 17th century, after a further rebuff by James I, Lee went to France and set up his frames there under the patronage of Henry IV, making silk and worsted hose.

HOT PANTS:  very short shorts fashionable for the young in the early 1970s. Often worn with matching braces and high boots.

HOUPPELANDE:  a loose, full overgown worn by men and women from about 1375 until the later 15th century but predominantly in fashion up to about 1445. Until about 1415–20 the houppelande was usually ground-length and had a high collar reaching up to the ears. It was fitting on the shoulders but then fell in folds over the body where it was normally belted at the waist. Sleeves were very wide and edges were dagged (see DAGGES). Some designs were buttoned up the centre front, others were closed but often had a skirt slit at the sides to above the knee.

   After about 1420 the houppelande varied in length from mid-calf to ankle. The fullness was more often carefully arranged in vertical soft pleats and both sleeve and neckline followed current modes. Fur was widely used as lining and trimming. Throughout its years as a fashionable garment the houppelande was always made of rich fabrics, patterned with decorative motifs, and was equally richly ornamented and lined.

HOUSSE:  see GARNACHE.

HUSSAR BOOT:  a military boot adopted in the early 19th century for civilian wear. A leather boot, knee-length at the back but extending higher to just over the knee in front.

HUSSAR JACKET:  a Hungarian military uniform jacket adapted in the 19th century for ladies' wear. Like the original it was waist-length, the front entirely decorated with braid and brandenburgs (see BRANDENBURGS).

Hussar
jacket
English
1805

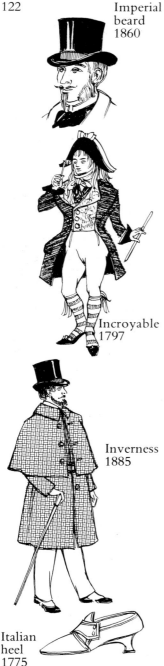

Imperial beard 1860

Incroyable 1797

Inverness 1885

Italian heel 1775

# I

**IMPERIAL BEARD:** a style of the mid-19th century where a narrow tuft of beard below the lower lip was accompanied by a moustache.

**INCROYABLE:** a dandy of the Directoire period in France (1795–9) which followed the Revolution. The Incroyable assumed an extravagant, exaggerated form of the current mode. His coat and waistcoat had very large revers and both cravat and collar extended high enough to conceal partially chin and cheeks. His hair was raggedly cut and his bicorne hat was large and worn at a jaunty angle. His breeches and stockings were excessively tight-fitting. See also MERVEILLEUSE.

**INDESCRIBABLES:** see UNMENTIONABLES.

**INDIAN GOWN:** see BANYAN.

**INDIENNES:** painted and printed cottons imported into western Europe and America during the 17th and 18th centuries, especially those from the Indian sub-continent. By the 18th century, the more costly painted ones had become so popular that supplies were restricted. Prized more highly by elegant society, they were used especially for dressing-gowns and negligées, so that the word was also applied to the garment.

**INDISPENSABLE:** see RETICULE.

**INVERNESS:** a heavy travelling overcoat or cape named after the Scottish city and worn by men in the second half of the 19th century. Usually made of tweed or worsted in check or plaid pattern, it was belted and had a collar and elbow-length cape. In some designs the cape was detachable or was sewn to the coat, in others the sleeves were omitted, the cape being regarded as adequate cover.

**INVERTED PLEATS:** box pleats in reverse so that the folds face each other (see BOX PLEAT).

**ITALIAN HEEL:** a ladies' style of the 1770s and 1780s for a curved heel of medium height set far back under the quarter.

# J

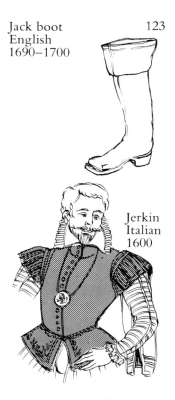

**JABOT:** a fall or made-up cravat of lace, silk or lawn. In the 17th century it was used to conceal the closure of a man's shirt, in the 19th it decorated a lady's blouse.

**JACK BOOT:** made of **jack** leather (which was hardened by being coated with boiling pitch), a style worn for riding and military use in the 17th and 18th centuries. At first a heavy boot with square toes, deep square heels, and a funnel top to cover the knee; though later it might be cut lower at the back to make knee-bending easier. In the 18th century a lighter-weight version was available.

Jerkin
Italian
1600

**JEANS:** blue jeans have become the unisex uniform for younger members of society, first in America, then Britain and Europe, in the post-war years. The style derives from Levi Strauss' denim work pants of the 1850s (see LEVIS) but the name comes from the material, jean, a strong, twilled cotton cloth which originated in Genoa and has been in common use since the 18th century for work and leisure clothes, for men, women and children. Made in various colours but most often blue.

**JERKIN:** a garment worn in the later 16th and early 17th centuries over the doublet (see DOUBLET) and almost identical in style to it though, generally, of different colour and material; often sleeveless, finished at the shoulder by a padded roll or tabs (see PICADIL). In some designs a hanging sleeve was attached behind the arm.

**JERSEY:** see GUERNSEY.

**JODHPURS:** riding trousers which originated in India and were named after a city in the north-west of the country. In the western world in the 20th century jodhpurs are worn by both sexes. They are cut full at the hips and are tight-fitting from knee to ankle, finishing in a cuff and instep strap.

**JOSEPH:** an 18th-century riding coat or cloak with cape worn by women which was usually of green material and was buttoned down the front.

Jodhpurs

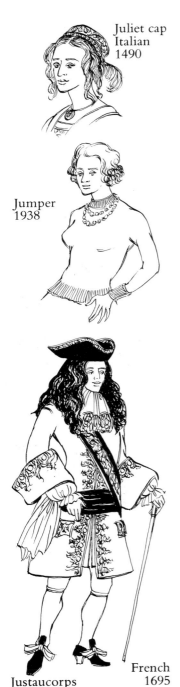

Juliet cap
Italian
1490

Jumper
1938

Justaucorps

French
1695

**JULIET CAP:** a jewelled mesh or embroidered cap worn in the late Middle Ages and early Renaissance especially in Italy. The cap might be made from velvet, silk or lawn, and embroidered with coloured silks or gold or silver thread ornamented with beads or jewels. A modern evening cap based on the Italian Renaissance design is also so named after Shakespeare's Juliet.

**JUMPER:** in England a knitted jersey or sweater. In America an overdress worn on top of a blouse or sweater (see PINAFORE DRESS). Also in America, in the late 19th and early 20th centuries, JUMPER(S) means a toddler's playsuit (see ROMPERS).

**JUMPSUIT:** American term for all-in-one work or play overalls (see BOILER SUIT).

**JUSTAUCORPS:** it was in the second half of the 17th century that a fitted coat began to replace the tunic or doublet as the masculine body garment and this, together with the waistcoat and breeches, formed the basis of a man's suit. The justaucorps came from France about 1665–70. The word derives from *juste*, (in this sense) 'close-fitting' and *au corps*, 'to the body' (see CARACO). The early designs were not too fitting but hung fairly loose to the knees with front edges turned back but, by 1680, the knee-length, fitted, waisted coat had evolved. Although buttons and buttonholes, decoratively embroidered and braided, extended the full length of the coat, generally only the waist buttons were fastened. There was no collar since the full-bottomed periwig cascaded over the shoulders and down the back. The long sleeves ended in very large, turned-back, decoratively-embroidered, buttoned cuffs. Towards 1700 the justaucorps became more waisted and the skirts flared out fully. Fabrics were rich as was also the ornamentation. In the 18th century the justaucorps developed into a suit with the *habit à la française* (see HABIT).

# K

**KAFTAN:** see CAFTAN.

KEVENHÜLLER HAT: a tricorne hat, favoured especially in mid-18th century, with a high cock in the centre front. Known also as the ANDROSMANE (and, colloquially, as the kevenhüller cock), the style was named after the Austrian general Ludwig Andreas von Khevenhül-ler (see also COCK, TRICORNE).

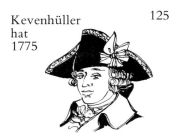

Kevenhüller hat 1775

KICK PLEAT: short inverted pleats inserted in the hem (at sides or centre back) of a fitting skirt to give greater freedom in walking.

KILMARNOCK CAP: a round, woollen, woven or knitted, traditionally Scottish cap named after the town in Strathclyde. Similar to the tam-o'-shanter, the Kilmarnock was flat and generally decorated by a pompon on top (see TAM O'-SHANTER).

Kilmarnock cap

KILT: a knee-length, wrap-over, pleated skirt generally made of tartan cloth. The modern Scottish kilt has evolved from the 17th-century **belted plaid**, a rectangle of woollen material measuring about 6 yards by 2 (5·5 metres by 1·8), part of which was folded by the wearer to form a pleated skirt, fastened at the waist with a leather belt; the remainder of the fabric was then draped round the upper part of the body. The plaid was unbelted at night to serve as a blanket. The present-day kilt derives from the lower part of this plaid which, unsewn and known as the **little kilt**, had been worn in this manner since about 1730. The word 'kilt' is believed to come from the Danish *kilte*, 'to gird or tuck up' (see PLAID).

Belted plaid c. 1660

Tartan pattern omitted to show draping more clearly

KIMONO SLEEVE: a Japanese style where the wide sleeve is usually cut in one with the garment.

KIRBIGRIP: see BOBBY PIN.

KIRTLE: a word which has been used to mean different garments at different times and which derives from more than one linguistic source. In Europe the earliest use of the word stems from the Old Norse *kyrtill* and the Anglo-Saxon *cyrtel* and refers to a man's knee-length tunic with sleeves, worn from the early centuries AD until about 1500. Another source of the word is the Danish and Swedish *kjortel* which referred to a ladies' gown, a skirt or a petticoat worn from the 10th century to the 17th. In the early years it seems to have been an undergown or underskirt, and from about 1550 an

Kimono sleeve

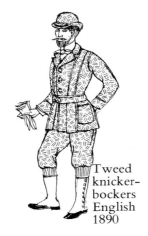

Tweed knicker-bockers English 1890

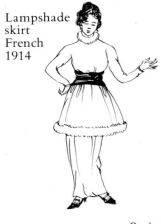

Lampshade skirt French 1914

Swiss Landsknecht 1525

underskirt or petticoat. After the 17th century the word can still be traced, referring to a short coat.

KISSING STRINGS:   an 18th-century term for strings to tie a lady's cap under the chin.

KLOMPEN:   Dutch term for clogs (see CLOGS).

KNEE BREECHES:   normal covering for the man's upper leg from the 1570s until the early 19th century. Fitting or loose breeches closed just below the knee and fastened by a band and buttons, buckle or a sash or ribbon tie.

KNEE HIGHS:   American term for pop socks (see POP SOCKS).

KNICKERBOCKERS:   a full type of breeches fastened below the knee with band and button or buckle. Fashionable for men from the 1860s onwards for casual and sporting attire. The name derives from Washington Irving's *nom de plume* (Diedrich Knickerbocker) for his *History of New York* (1809). The Knickerbockers were a family of Dutch settlers in New Amsterdam (later New York) and Irving's book shows drawings by Cruikshank of Dutchmen wearing 17th-century full breeches with sash ties (see also PLUS FOURS).

# L

LAMPSHADE SKIRT:   a style fashionable for a short time just before the First World War for a hip-length tunic skirt wired to stand out like a lampshade over an ankle-length skirt beneath.

LANDSKNECHT       (LANSQUENET):   the German and French terms for a Swiss or German mercenary soldier. The landsknecht costume was of particular interest in the years 1520–40 because in its flamboyant form at that time it displayed in an extreme manner the current vogue for slashing each garment so that the one beneath, of different colour and fabric, was visible through the cuts.

LAPPET:   pendant streamers, generally a pair,

which were sewn to the back or sides of a ladies' cap, head-dress or bonnet.

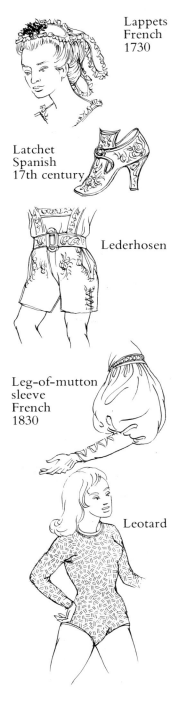

Lappets
French
1730

LATCHET: a traditional form of shoe fastening where the quarters are extended into straps which can be fastened on the instep by a buckle or by ribbon ties.

LEDERHOSEN: a German term for leather breeches or shorts supported by decorative braces; worn in the Alpine regions of Europe.

Latchet
Spanish
17th century

Lederhosen

LEG-OF-MUTTON SLEEVE: a fashion for a ladies' day gown, *à la mode* in the years 1824–36 and re-introduced in the 1890s. Known in France as the *gigot* sleeve, this was very full at the top, then diminished to a tight cuff or wristband. At the zenith of the style, about 1828–33 and around 1895, the sleeve was so full that it required padding and/or whalebone inserted in the seams to maintain the desired shape.

LEOTARD: a long-sleeved, fitting garment worn by dancers, gymnasts and acrobats for exercise practice; designed in the 19th century by Jules Léotard, the French acrobat, for his own needs.

LETTICE RUFF: see CABBAGE RUFF.

Leg-of-mutton
sleeve
French
1830

LEVIS: a term still in use, especially in America, for blue jeans, which derives from Levi Strauss the gold prospector who went to California in 1850. The work pants which he made were so practical and supplied such a basic need that he found he acquired greater wealth from selling them than by panning for gold. His pants were called 'levis' and were made of blue denim reinforced at stress points with copper rivets. The word 'denim' derives from *serge de Nîmes*, a fabric which was originally made in that area of southern France (see also JEANS).

LIDO PYJAMAS: trousers were introduced for beachwear in the late 1920s, known by 1930, when part of an outfit, as lido or beach pyjamas.

LINGERIE: a term introduced in the early years of the 20th century to describe elegant feminine underwear.

Leotard

LIRIPIPE: a streamer or tail, often padded, which hung from the medieval hood. The hood of the early Middle Ages was finished in a small point on

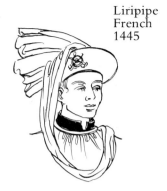

Liripipe
French
1445

top and it was this peak which lengthened into the liripipe during the 14th century. By the following century it extended 5 or 6 feet (about 1½ metres) in length so that it had to be held in one hand or be wound round the head-covering. Sometimes the complete hood was slung over the shoulder to hang down the back while the liripipe was secured in one hand. Men's hats too had dependent liripipes as did feminine head-dresses.

LIVERY: in the early Middle Ages 'livery' referred to the clothes, food or payment in kind made to family retainers. The meaning gradually altered to define a specific attire worn as a uniform by which a servitor might be recognised as being in a particular noble's employment.

Loafer
American

LOAFER: a Norwegian moccasin style of leather shoe introduced to the USA in the 1940s which quickly became popular with men, women and children because of its ease and comfort. The loafer, as it came to be called from the trade name, has a low heel and a moccasin apron front. It is a slip-on shoe, without fastening.

Loo mask
German
1635

LONG HOOD: an outdoor hood worn by ladies in the 18th century. Designed in the same style as the pug hood (see PUG HOOD) but with two long streamers which could be tied under the chin, then swathed round the throat.

LOO MASK: a half mask worn by ladies during the 16th to 18th centuries for riding and in the street to protect the skin and the eyes. Covering only the upper part of the face these were called *loup* masks after the wolf because children were frightened by them. In England and America this was anglicised to loo.

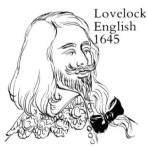

Lovelock
English
1645

LOUIS HEEL: see FRENCH HEEL.

LOVELOCK: a style of the first half of the 17th century when men grew their own hair very long. A lovelock was one longer than the rest, dressed forward to fall over the front of the shoulder where it could be tied in a ribbon bow.

LUNULA: a flat, crescent-shaped, metal necklace, originating in Bronze Age Scotland and Ireland.

Gold lunula
Scotland

# M

MACARONIS: in 1764 a group of young Englishmen, back from the Grand Tour, founded the Macaroni Club in London. By the 1770s the Macaronis had adopted an exaggerated, dandified form of the current mode. It was characterised by a short, tight-fitting coat worn open to display skin-tight breeches and waistcoat, both elegantly striped and multi-coloured. They affected dainty footwear and tall wigs surmounted by tiny tricorne hats.

MACKINTOSH: in 1823 the Scottish chemist Charles Macintosh took out a patent for his water-proof fabric. This somewhat odorous material was produced by cementing together two thicknesses of rubber by means of naphtha. The word 'mackin-tosh' (a small alteration in spelling) came to mean any cloth waterproofed by a coating of rubber, also any garment made from such a material.

MAGYAR SLEEVE: a sleeve cut in one with the garment, of Hungarian peasant origin (see KIMONO SLEEVE).

MAHOITRES: pads placed in the top of the sleeves of men's body garments to broaden the shoulder line in the later Middle Ages.

MAILLOT: a French word used to denote a close-fitting knitted or woven body garment such as a swimming costume, football jersey or tights. The French also use it for a baby's first long-clothes.

MAJOR WIG: a style of the second half of the 18th century which had a double queue composed of two corkscrew curls hanging below the ribbon bow. Also called a BRIGADIER.

MAMELUKE SLEEVE: a fashionable design for ladies' dresses and jackets during the French First Empire (1799–1815), named from Napoleon's conquest in Egypt. Reminiscent of the earlier vir-ago style, this long sleeve was designed in a series of diminishing puffs finishing at the wrist with a frill (see VIRAGO SLEEVE).

MANDARIN COLLAR: of Asiatic origin, a

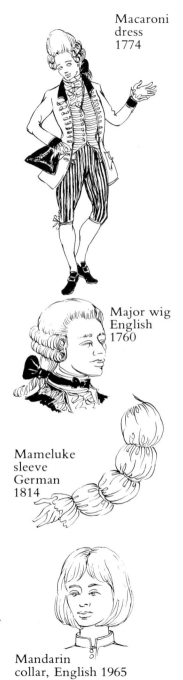

Macaroni dress 1774

Major wig English 1760

Mameluke sleeve German 1814

Mandarin collar, English 1965

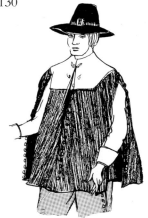

Mandilion
Puritan
colonist
New England
1630s

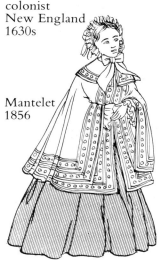

Mantelet
1856

Mantilla
Spanish 1647

standing collar about 1½ inches (35 mm) high with a small gap in front where the garment is buttoned across.

MANDILION:   derived from a tabard-like, hip-length, loose overgarment worn by the ordinary man of the later Middle Ages (see TABARD), the mandilion was a fashionable garment in the second half of the 16th century. Still loose and hip-length it had become a jacket, generally worn buttoned at the neck and slung across the body, its sleeves hanging loose. In the 17th century the mandilion was longer and fuller. It was adopted by the Puritans who took it to New England as a masculine garment. The Colonists' mandilion was usually lined with cotton and fastened with hooks and eyes.

MANIKIN:   a tailor's or dressmaker's lay figure used for the fitting, designing and displaying of new garments. The term spelt in the French manner, MANNEQUIN, is now in general use for the display of new designs on a live model. Mme Marie Worth, once a sales girl who became the wife of the first haute couturier in Paris, Charles Frederick Worth, helped her husband in his early days in the 1850s by displaying his creations, and made history as the first live mannequin.

MANTELET:   diminutive of mantle: a short mantle or cape (see MANTLE). In the 18th and 19th centuries worn by women particularly with hoop and crinoline gowns. In the years 1835–60 there was considerable variety in designs of mantelet which could be of differing lengths and were made from many types of material and trimming.

MANTILLA:   diminutive of the Spanish *manton*, a veil or shawl made to wrap round the body, and *manta*, 'a blanket'. The Spanish mantilla covers the head and shoulders. Traditionally made from black or white lace, silk or cashmere.

MANTLE:   a basic medieval outer garment which was a simple, long, voluminous cloak which could be fastened at shoulder or throat with cords or a brooch. In the later Middle Ages, it became a ceremonial cloak made of rich materials.

MANTUA:   from about 1650–1750 a loose gown with unboned bodice and long skirt open in front to display a petticoat underskirt. The term is believed to derive from the Italian city of Mantua.

**MARCEL WAVE:** a means of making deep waves in the hair which lasted a day or two by the use of heated scissor irons. This method was introduced in western Europe in the later 19th century; it was named after Marcel, the Paris hairdresser who had invented it.

**MARLBOROUGH BUCKET BOOT:** a heavy leather boot of the years 1670–1720 with a high heel, square toes and a deep, wide funnel top covering the knee.

**MARLOTTE:** French term for an overgown or surcote worn by ladies in the 16th and early 17th centuries. Similar to the Spanish *ropa* and Dutch *vlieger*, the garment had a high neckline rising under the ruff and could be worn open or fastened at the throat; it had short puff sleeves or was finished at the shoulder with a slashed roll. The marlotte hung open in folds to ground, or three-quarter, level (see ROPA, VLIEGER).

**MARQUISE:** a dainty, tilting parasol of the 19th century.

**MARTINGALE:** a belt or strap to hold fullness of material in place. Originally the term was applied to a strap one end of which was attached to a horse's girth and the other to his noseband to prevent him from rearing or throwing his head back. In modern dress the term applies, for example, to the half-belt buttoned to the back of a coat.

**MARY STUART CAP, MARY STUART BONNET:** a style of cap with wired edge dipping in the centre front and rising upwards at the sides, worn by Mary, Queen of Scots, and fashionable in western Europe in the years 1560–80. The cap became modish again in the 1750s and the style was revived as a bonnet in the 1820s.

**MASHER:** a dandy of the later 19th century; also known as a PICCADILLY JOHNNY (see also BEAU).

**MAXI SKIRT:** the ankle-length level worn for day and evening dresses, skirts and coats in the late 1960s and early 1970s particularly in fashions for the young.

**MEDICI COLLAR:** a delicate lace and lawn, upstanding collar framing the head and worn with

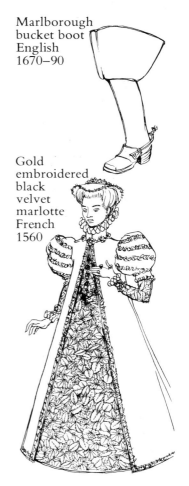

Marlborough bucket boot English 1670–90

Gold embroidered black velvet marlotte French 1560

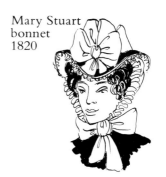

Mary Stuart bonnet 1820

Merveilleuse
1796

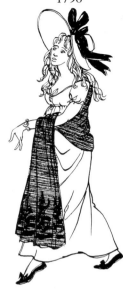

Middy blouse
American
1914

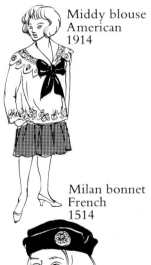

Milan bonnet
French
1514

décolleté gowns of the later 18th century. The name Medici was given to the style after Marie de' Medici who wore the 16th-century collet monté (see COLLET MONTÉ).

MELON: French term for a bowler hat (see BOWLER).

MELON SLEEVE: see BALLOON SLEEVE.

MERVEILLEUSE: the feminine equivalent of the 'Incroyable', the dandy of the French Directoire period. Merveilleuses affected very long and full dresses, bare legs with sandals and an exaggerated bonnet design perched on dishevelled long locks (see INCROYABLE).

MIDDY BLOUSE: the sailor suit had been a fashion for boys in Britain since before 1850. It spread to Europe and America and was later adopted for girls. Middy suits were based on the naval dress of the country concerned, and the middy blouse of the years 1910–30, so popular in America for young and teenage girls, was closely modelled on that of a midshipman in the US Navy. The blouse was made of white cotton with a blue and white sailor's collar. A square black silk kerchief was then draped round the neck under the collar and tied in front. As time passed, variations were introduced in colour, material and trimming and the blouse followed the fashionable line.

MILAN BONNET: a cap or hat generally made of black or dark velvet worn by men from about 1495 to 1545. It was a soft type of head-covering and, for many years, had a brim turned up nearly all round. This was slit and cut at intervals, the edges being fastened by gold points with jewelled aglets as well as being decorated by large brooches or pins. Because so many fine bonnets of this type were made there, it was often called a Milan bonnet though, in England, it was also termed the TUDOR BONNET.

MILLINER: the original meaning of the term was a person who traded in articles of apparel, especially bonnets (see MILAN BONNET), which had been made in the city state or duchy of Milan. The word derives from milaner, myllaner, 'an inhabitant of Milan'. It was later that the term 'milliner' came to be applied more selectively to a designer of ladies' hats and bonnets.

MINI-SKIRT: the mid-thigh skirt length, which dates from 1965, was launched by designers such as Mary Quant in London and André Courrèges in Paris. The mini-skirt stayed in fashion. A symbol of youth, it created a revolution in clothes for the young where skirts rose even higher to MICRO length and affected the rest of fashion to such an extent that even the middle-aged were buying knee-length dresses. As with the crinoline in the previous century, the feminine public liked the mini-skirt so much they were reluctant to let it die. Despite strong efforts by high fashion to alter the length, even into the 1970s girls clung on to it for summer wear in spite of the attractions offered by MIDI lengths.

MITTEN: there are two distinct types of mitten. One is where the hand is completely covered, the fingers in one part and the thumb in a separate stall. From the Middle Ages onwards such mittens were in use in rural communities so that people could keep warm while in the open air. This type of mitten is very popular everywhere today as a fashionable hand-covering because it is easy to make and keeps the hands warmer than gloves.

The other type of mitten, often abbreviated to MITT, was introduced in the later 17th century. It is a glove but with the fingers and thumb cut off just beyond the first row of knuckles, leaving the digits free. Such mittens were often purely decorative and were worn indoors (though heavier mittens of this design were worn by various trades). The fashion mitten was made of net or lace, generally black and embroidered in colour. In the years 1830–50 wrist-length mittens were usual for day wear but were elbow-length in the evening.

MOB CAP: a characteristically English design of the 18th and early 19th centuries worn by women indoors, or out-of-doors under a hat. Made of cambric or muslin, usually white, trimmed with ribbon and lace, the mob cap had a full, puffed crown and a flounced edge. Until about 1750 it had side lappets and could be tied under the chin (see KISSING STRINGS), but later was unfastened. The mob cap varied in size according to the coiffure styles of the time; in the 1770s it was exceptionally large.

MOCCASIN: the traditional North American Indian shoe. It is made in one piece of soft leather (without a heel) and encloses the sole, back and

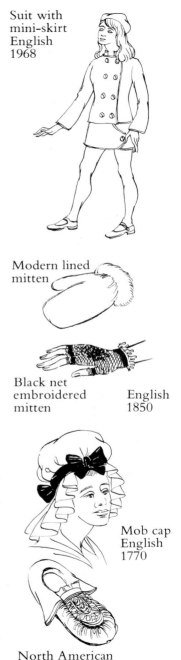

Suit with mini-skirt English 1968

Modern lined mitten

Black net embroidered mitten

English 1850

Mob cap English 1770

North American Indian moccasin

Monk shoe

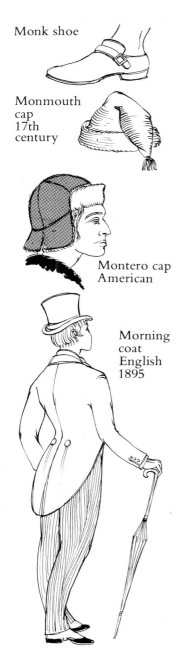

Monmouth cap
17th century

Montero cap
American

Morning coat
English 1895

sides of the foot; it is seamed to a U-shaped inset piece of leather on the instep (see also BROGUE, CARBATINE). Such Indian moccasins were decorated by bead embroidery, dyed porcupine quills and tinkling bells on the fold-over cuff at back and sides and on the apron front on top. The moccasin has become popular in modern dress for indoor and bedroom slippers, for children's footwear and, in America particularly, is in use by woodsmen.

MODESTY PIECE: in the 18th and 19th centuries, when a décolleté gown was worn, the cleavage was delicately concealed by a made-up frill of lace and ribbon pinned to the top of the corset.

MONK SHOE: a plain-fronted, low-heeled shoe with a strap and buckle fastening on the outer side of the instep.

MONMOUTH CAP: a round, flat, soft cap made of knitted wool named after the town of Monmouth in South Wales where it was chiefly made. The Monmouth cap was worn in England and Wales mainly by workmen, sailors and soldiers from the 16th to the 19th centuries but was best known in the 17th, when it had a hanging crown like a stocking cap. At that time this version was also an especially popular head-covering with the Colonists of North America because of its warmth and comfort.

MONTERO CAP: a man's cap worn from the 17th century onwards for travelling, hunting and riding. A style widely in use in the American Colonies, it had a round crown with side and rear flaps, usually of fur, which could be turned down to protect the ears and neck from cold and sun.

MORNING COAT: the 19th-century tail coat which was earlier the Newmarket coat and became the cutaway coat of the 1850s (see CUTAWAY COAT, NEWMARKET COAT).

It was in the 1870s that this type of tail coat became the morning coat and began to replace the frock coat as formal wear (see FROCK COAT). In grey cloth, accompanied by grey striped trousers, it continued to be worn for formal occasions during the 20th century and, even now, is to be seen at weddings and race meetings. The morning coat is single-breasted; it is cut away in a curved line from the third (bottom) button in front towards rounded tails at the rear.

**MORNING GOWN:** a long, loose coat made of rich material and held round the body or girdled with a sash, worn by men for indoor relaxation in the 18th and early 19th centuries. Of similar style and function to the banyan (see BANYAN).

**MOTORING DRESS:** form of protective clothing necessary for riding in the open motor car of the early 20th century. In the late 19th century in Britain, before the lifting of the 'red flag' restriction, cars proceeded so slowly that a special attire was not thought to be necessary but, after 1900, as motoring developed as a sport and means of transport especially in America, where protective clothing was termed AUTOMOBILE TOGS, cars travelled faster and protection was needed against wind, cold and dust from unsurfaced roads.

For such protection men wore a cloth peak cap and goggles, long fur or fur-lined overcoats in winter and storm coats or dust coats in summer. Rugs and foot muffs were added as necessary. Women wore similar fur or dust coats, also goggles with hoods or men's caps, but most tied chiffon veils around the large fashionable hats of the day, maintaining elegance if not vision. Some of these veils were specially designed for motoring and could be adjusted, while travelling, to close over, covering the head and face completely. So that the dust did not show too much, it was recommended by the manufacturers that veils and dust coats should be grey or fawn (see DUST COAT).

**MOURNING BARBE:** a covering for the throat worn especially by widows from the 14th century until nearly the end of the 16th. The barbe was a piece of white linen, pleated vertically, which was pinned to the hair on either side of the face and descended in front to the breasts. It was worn with and partly covered by a hood or veil in the fashion of the day. The barbe, which derived from the 13th-century barbette (see BARBETTE) partly covered the chin for ladies of rank but left it exposed in other instances. In the later 16th century the barbe hung from under the large circular ruff as a bib. The barbe survives today in the head-dress of a nun.

**MOURNING WEEPER:** a garment or piece of material hanging down and indicating the wearer's grief by drooping lines and folds. Weepers took different forms over the centuries. In the Middle Ages, for instance, hoods and veils which were the

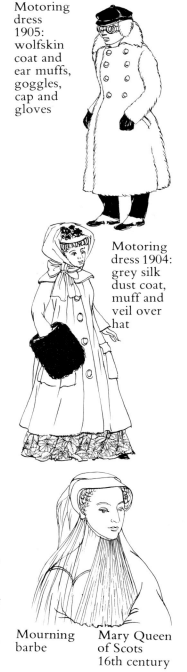

Motoring dress 1905: wolfskin coat and ear muffs, goggles, cap and gloves

Motoring dress 1904: grey silk dust coat, muff and veil over hat

Mourning barbe

Mary Queen of Scots 16th century

Mourning
weeper
14th century

Mousquetaire
1630s

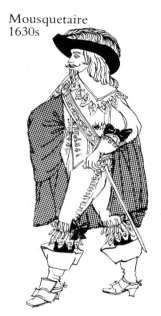

Canadian
mukluk

Silk mule
Spanish
18th century

customary wear hung in deep draped folds partly obscuring the face; in the 16th and 17th centuries ladies wore trains at the front of their gowns as well as at the back and these had to be held or pinned up to make walking possible. Later, until well into the 19th century, draperies or streamers of black crape softly floated from hats, belts, sleeves and cuffs to indicate sadness.

MOUSQUETAIRE: during the 19th century a number of articles of dress were given the name 'mousquetaire'; there was, for instance, a mousquetaire collar, cuff, glove, hat and sleeve. These articles were modelled, approximately, upon the 17th-century attire of the *mousquetaires* (musketeers) of France who, under Louis XIV, were noblemen and dandies.

MUFFETEES: small wrist muffs, one for each hand, made of fur or wool, worn by men and women in the 18th and 19th centuries to keep the wrists and part of the hands warm. The word was also applied to pairs of tiny muffs resembling mittens without thumb stalls which enclosed the whole hand.

MUKLUK: a boot worn in Arctic regions made of sealskin, moose or walrus hide with the flesh side outwards and the hair turned inside. Generally a calf-length boot with Indian moccasin front (see MOCCASIN).

MULE: a slipper with no back or quarter. Before the later 16th century mules were heel-less (see BABOUCHE); after this they were designed in the current fashion of heel and vamp.

MUSCADIN: name scornfully applied by Parisians in 1793 during the years of the French Revolution to royalist elegants. This was because such dandies were partial to pastilles perfumed with musk which were called muscadins: *moscardino* is Italian for fop.

# N

NAPKIN CAP: see NIGHT-CAP.

NAPOLEON BOOT: a hunting boot of the 1860s named after the French Emperor Napoleon III. A high, black leather boot pulled on over the trousers, covering the knee in front but cut away at the back to allow the leg to bend.

NECKCLOTH: general term which referred to the many different designs of scarf, stock or cravat worn by men round their necks with or without a collar from the 1660s to the later 19th century (see CRAVAT, STOCK).

NECKED BONNET: a design of the first half of the 16th century when the upturned brim of the man's soft velvet cap or bonnet was pulled down to protect the back of the neck (see MILAN BONNET).

NEGLIGÉ, NEGLIGÉE: a term used in the 18th and 19th centuries for the informal attire of both sexes worn for indoor relaxation: from the French *negligé*, 'loose, undress'. 'Negligé' referred to the banyans, dressing-gowns, morning gowns, etc., of both sexes but, as the 18th century progressed, 'negligée' was more generally applied to the feminine styles trimmed with lace and ruffles.

NEGLIGÉ CAP: a man's cap worn indoors during the 17th and 18th centuries. Be-wigged men usually shaved their heads or cut their own hair close for comfort under the wig; at home they wished to relax, so took off their heavy wigs and wore a cap to avoid taking a chill. The negligé cap was made of a rich material; it had a soft, full crown gathered or pleated into a band.

NETHERSTOCKS: the lower part of masculine hose in the 16th century. This was the section which covered the lower leg and was pulled up over the canions at knee-level (see CANIONS).

NEW LOOK: after the Second World War several designers were experimenting with ideas for a more feminine line after the long years of utility and uniform-based clothes. It was Christian Dior who, launching his first collection in February 1947, staked his reputation on what he believed to be the desire of women at the time: to be feminine and elegant once more. This collection he presented as 'Corolle'. Corolla is a botanical term meaning the delicate ring of petals opening within the centre of a flower. In America the Press dubbed it 'New Look' and so it has remained ever since.

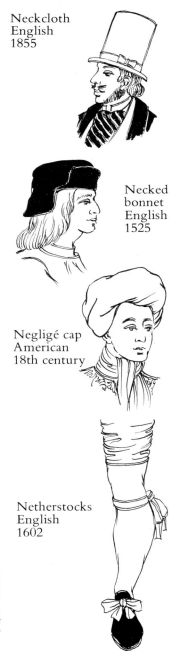

Neckcloth
English
1855

Necked
bonnet
English
1525

Negligé cap
American
18th century

Netherstocks
English
1602

Dior's New
Look

The basis of Dior's New Look was a figure with small waist, sloping shoulders, a full bosom and a long, swinging skirt; it was the essence of femininity. The silhouette was applied to all garments: coats, skirts, dresses and suits. Shoes were high-heeled, hats elegant and also feminine. It was a revolution in dress because it was impossible to adapt war-time clothes to this line; there was just not enough material. So, by 1948/9 everyone had capitulated and established a new wardrobe.

NEWMARKET COAT:   a tail coat of the years 1837–50 which had rounded, short tails. The coat was often worn open or with only the top button fastened; the front was then cut away to curve towards the tails (see CUTAWAY COAT, MORNING COAT).

NIGHT-CAP:   this term was used for the washable white cap worn by both sexes in bed; from the Middle Ages onwards.
    Men's night-caps had a point and a tassel in stocking-cap shape, women's were tied under the chin and were ornamented with ribbons and flounced edges.
    The term was also applied to an indoor cap for informal wear by both sexes. Men used it especially to cover their heads when they had removed their wigs; this was also known as a NAPKIN CAP (see also NEGLIGÉ CAP).

Newmarket
coat
1849

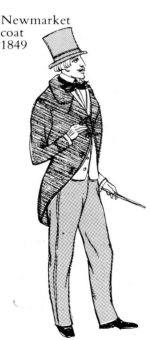

NIGHT-CHEMISE, NIGHT-SHIFT, NIGHT-SHIRT:   these were all garments intended to be worn in bed and date from the later 16th century onwards; before this people slept naked or wore their day shirts or chemises. Nightwear after this was based on the designs for daywear.
    Until the early 20th century men wore a night-shirt (this could also be called a BED-SHIRT), which was a loose garment made of white linen or cotton reaching to the knees or ankles. It had long sleeves and a round neckline, with or without a collar. Women wore a similar garment called a night-shift, also known as a NIGHT-CHEMISE or NIGHT-SMOCK.
    In the 19th century a garment especially designed for wear in bed was introduced for ladies; this was the NIGHTDRESS which was very full and long and had a high neckline with frilled collar. Sleeves were long and full, descending to fitting wristbands. The nightdress was generously decorated with tucks, embroidery and lace.

NITHSDALE CLOAK: a long hooded, riding cloak named after the Countess of Nithsdale whose husband, a Jacobite, was helped to escape from the Tower of London in 1716 by wearing her cloak.

NONE-SO-PRETTYS: an American Colonial term applied to fancy, ornamental tapes used for decorating clothes in the 18th century in the USA.

NORFOLK JACKET: a development in 1880 from the Norfolk shirt which preceded it by a decade. Named after the then Duke of Norfolk, the jacket was popular for country and sporting wear, made in tweed, often in a check pattern. It was characterised by a belt of self-material and by vertical box pleats front and back; it also had patch pockets on the hips, usually of bellows style (see BELLOWS POCKET). The Norfolk jacket was often worn by men as a suit with knickerbockers and this type of outfit was soon widely adopted for boys' wear. Ladies wore the Norfolk jacket with a skirt, especially in the 1890s when the jacket had leg-of-mutton sleeves (see LEG-OF-MUTTON SLEEVE).

NORWICH SHAWL: a popular style from the early 19th century when shawls were especially fashionable. The Norwich shawl was square; it was made with a wool weft and silk warp.

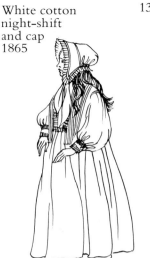

White cotton night-shift and cap 1865

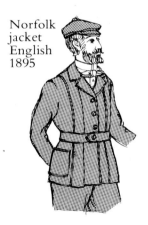

Norfolk jacket English 1895

# O

OCTAGON TIE: a man's scarf necktie worn from the 1860s and similar in style to the Ascot (see ASCOT TIE).

OFF-THE-PEG: see READY-MADE CLOTHES.

OILSKINS: oilskin is a cotton material which has been made waterproof by a treatment with oil and gum and is used chiefly for sailors' and fishermen's protective wear: these are called oilskins. In America the term used is SLICKERS.

OPEN RUFF: a style of ruff fashionable in the late 16th and early 17th centuries. Worn with a décolleté gown, the large ruff extended round the sides and back of this neckline leaving the front

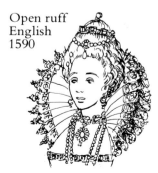

Open ruff English 1590

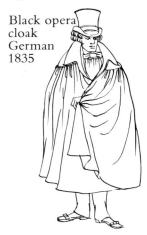

Black opera
cloak
German
1835

open and the rear, behind the head, supported by a wire framework or pasteboard (see REBATO, RUFF, SUPPORTASSE).

OPERA CLOAK: fashionable for men's evening wear in the 19th century, particularly in the years 1835–60. Such cloaks were generally black, of velvet or cloth and often with a coloured silk lining. The cloak was collared, full and fastened at the throat by cords or buttons.

OPERA HAT: a collapsible hat for evening wear (see CHAPEAU BRAS, GIBUS).

ORPHREY: a medieval term describing bands of gold and rich embroidery sewn to the costly garments of royalty and the nobility, also ecclesiastical vestments. The word derives from *auriphrygium*, 'gold' + 'Phrygian'; this is because Phrygia was famed in ancient times for its gold embroideries.

OXFORD BAGS: a masculine fashion of the 1920s (from 1925 on) for very wide trousers up to 24 inches (60 cm) at the turn-up.

OXFORD SHOE: a traditional design of closed shoe with tie front.

Oxford
bags
English
1926

# P

Oxford shoe
English

PAGODA SLEEVE: a feminine style of the middle years of the 18th century also known as a FUNNEL SLEEVE. The gown sleeve was fitting to the elbow where it was then finished by one or more tiers of flounces and, generally, a ribbon bow. Below this fell the engagéantes (see ENGAGÉANTES).

PAILLETTES: spangles or sequins; tiny circular sparkling discs of metal or mother-of-pearl, the former finished in gold, silver, copper or colours, sewn to evening or fancy dresses as decoration.

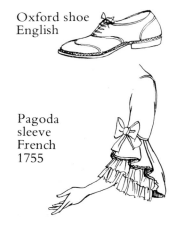

Pagoda
sleeve
French
1755

PAISLEY SHAWL: shawls were manufactured in Paisley during much of the 19th century but the years 1830–70 were those when the characteristic 'Paisley pattern' was mainly used. These shawls were based on Indian and Kashmir originals which

had been imported for some time and had been very fashionable since the 1780s. The motif which regularly occurred in these was the so-called 'pine cone' which is cone-shaped but with the tip turned over. Shawls depicting this motif had been made in Edinburgh from the early 19th century where it was to be seen in wide borders and in corner designs; the theme was later developed in Paisley.

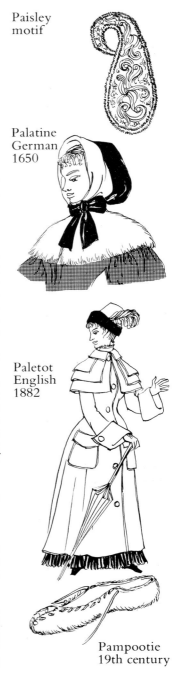

Paisley motif

PAJAMA:   see PYJAMAS.

PALATINE:   a fur shoulder cape named in 1676 after the Princess Palatine who wore a fur round her neck and shoulders during the cold winter. Re-introduced in the early 19th century when it could be made in various materials and had pendant ends in front.

Palatine German 1650

PALETOT:   an outdoor garment, coat or cloak, worn by both sexes during the 19th century. This French word was variously applied to differing styles of coats, in particular between the 1830s and 1890s. The term is thought to derive from paltock (see PALTOCK) and was used in France for several different, non-fashionable outer garments for men and women in the early 19th century before appearing in the 1830s as a man's short greatcoat which, by mid-century, had a longer, flared skirt seamed at the waist to a fitting body.

 The woman's paletot could be a threequarter-length cloak with shoulder cape from the 1840s onwards but, more typically, became a fashionable long coat from 1860 to the end of the century. This followed the modish line, over a bustle or princess cut, but was nearly always a stylish, waisted, fitting coat with long sleeves, collar and, often, tiers of shoulder capes.

Paletot English 1882

PALTOCK (PALTOK):   a short coat with sleeves worn by men in the 14th and 15th centuries. Predecessor to the doublet (see DOUBLET).

PAMPOOTIE:   one of the simplest types of shoe construction, traditional to the Isles of Aran off the west coast of Ireland; made of rawhide in moccasin pattern (see BROGUE, CARBATINE, MOCCASIN).

PANES:   a fashion of the 16th and early 17th centuries whereby a sleeve or trunk hose was slashed vertically into strips of material an inch (25 mm) or more in width. These strips were then decoratively embroidered with gold, silver or coloured silk

Pampootie 19th century

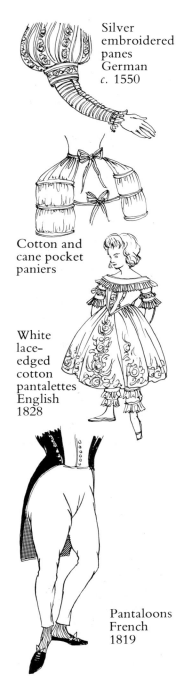

Silver embroidered panes German c. 1550

Cotton and cane pocket paniers

White lace-edged cotton pantalettes English 1828

Pantaloons French 1819

thread and the undersleeve or hose, of different colour and material, was displayed between the panes (see TRUNK HOSE).

PANIER (PANNIER): *panier*, 'basket' is the French term for the side and pocket hoops worn by women during the 18th century. *Panier anglais* referred to the earlier English style of hoop petticoat (see HOOP). The word 'pannier', based on the French term, was used in England in the 19th century in reference to the bustle gowns of the years 1868–75.

PANTALETTES: diminutive of pantaloons (see PANTALOONS). A term used in the early 19th century to refer to women's drawers, visible below the dress hem from about 1790–1820; after that, when they were no longer visible, the word 'drawers' became more usual. Also used for those worn by children, reaching to the ankle and displayed below the skirt hem until mid-century. Pantalettes usually referred to the leglets decorated with lace and frilled edges; these were separate legs of linen, cotton or muslin attached to a waistband.

PANTALOON(S): a word applied at various periods in the history of costume to describe a covering for masculine legs. In the 16th century the term was applied in a theatrical context to the long, fitting trousers or hose worn with slippers by a foolish, enfeebled, elderly man. Such a character was the Venetian Pantalone in Italian comedy and Shakespeare more than once uses the term, e.g. in *As You Like It* when he refers, in the sixth age of man, to 'The leane and slipper'd Pantaloone'.

By the second half of the 17th century pantaloons were a type of breeches and, after this, the word lapsed until, about 1790, fitting trousers began to replace the 18th-century knee-breeches. These trousers were called pantaloons; they were leg-hugging tights which, at first, ended just below the calf but gradually lengthened until, by 1817–18, they reached to the ankles where they were fastened by buttons or buckle. By 1820 they were longer and were strapped under the instep of the footwear. Pantaloons became looser trousers by mid-century.

The word 'pantaloons' was also given, from the early 19th century, to feminine drawers which were first termed TROWSERS. These drawers were worn by children in the first instance, later by adults.

PANTOFFLE: an overshoe without back quarter which was slipped on over other footwear. Worn from about 1490–1650 but especially in the 16th century (see MULE).

Pantoffle
German
1535

PANTS: in England, a term for underwear (UNDERPANTS). In America, pants are trousers.

PANTS STOCKINGS: American term for pop socks (see POP SOCKS).

PANTS SUIT: American term for trouser suit.

PANTY HOSE: American term for modern tights.

PAPILLOTE: a hair curl-paper of the 18th century. The word derives from the French *papilloter*, 'to flicker or blink' which, in turn, is believed to have come from *papillon*, 'butterfly'.

PARASOL: see UMBRELLA.

PARDESSUS: a French word meaning that which is over, or above, and a term used especially in the 19th century. From about 1840 it referred to a man's fitted, formal overcoat but it was also used for much of the century indiscriminately to describe many different outer garments worn by women.

PARKA: see ANORAK.

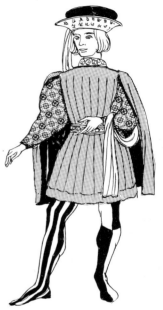

Parti-coloured hose in black and gold, Italian 1450

PARTI-COLOURING: a method of decoration where one half or quarter of a garment was made in one colour and pattern and the other or others in a different one. A fashion of the Middle Ages in Europe, especially of the 14th and 15th centuries. Garments worn by either sex could be parti-coloured, from ladies' gowns to men's tunics, hoods and cloaks, but it was masculine hose which were most often treated in this way. The hose was divided vertically down centre back and front and often quartered at the knee also and this lent accent and distinction to a well-turned leg (see also COUNTERCHANGE).

PARTLET: a separate fill-in for covering the neck, chest and shoulders to wear with a gown with a low, wide décolletage. Such detachable insets have been worn in different periods of costume (see CHEMISETTE) but the most decorative and distinc-

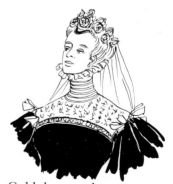

Gold decorated
white silk partlet
Austrian 1575

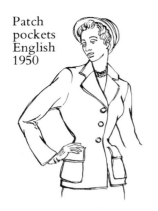

Patch
pockets
English
1950

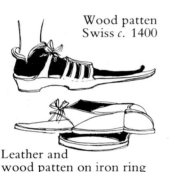

Wood patten
Swiss *c.* 1400

Leather and
wood patten on iron ring
English 18th century

Pea jacket
English
1864

tive partlets were fashionable in the second half of the 16th century when they were made of sheer fabrics richly and beautifully jewelled and embroidered. Many were accompanied by a dainty ruff, others by a high collar or jewelled neckband.

PARURE: a matching set of items of jewellery such as a necklace, earrings, bracelet, finger ring and brooch.

PASSEMENTERIE: an ornamental trimming for garments, made of braid or cording decorated with appliqué and metal embroidery, beads, fringe, tassels and lace.

PASTE: a process for making artificial gemstones was developed in the 18th century. The imitation material was produced from a hard compound of glass which also contained potash and white oxide of lead and displayed such brilliance that paste, or strass, jewellery, as it was termed, became valued in its own right.

PATCH POCKET: one sewn to the exterior of a garment.

PATTEN: an overshoe made of wood or leather fastened to the foot by straps and worn to raise the footwear above the dirt and mud of the road. Pattens of varied design were in use from the Middle Ages onwards in Europe and, later, in the American Colonies. They were particularly necessary with the fashion in the 14th and 15th centuries for soled hose when they were generally of wood and shaped with blocks under the heel and ball of the foot and attached by leather straps. When it became the mode to have extended long toes to the hose, pattens were extended also to accommodate them. By the 17th century pattens were more often designed to blend with the shoe which was raised above ground level by a metal ring attached to a wedge under the arch (see also CLOGS).

PEA JACKET: a heavy, short coat made of woollen material, also known as a PILOT JACKET, worn by sailors and adopted for civilian use in the second half of the 19th century, when it could be a normal-length jacket or a hip-length overcoat.

PEARLIES: London Cockney street traders, mostly costermongers, who decorate their own clothes by sewing pearl buttons on them in

geometric, symbolic or floral patterns. Coster-mongers were apple sellers in the Middle Ages who sold their wares in the street. The term derives from costard, the name of a large apple, and monger, a dealer or trader.

The tradition of decorating a costermonger's garments with pearl buttons represents the poor man's jewellery. It began in the early 19th century with the sewing of these buttons on to their best clothing in imitation of diamond-studded costume. Pearl buttons were used because, at that time, oysters, from which the mother-of-pearl was obtained, were very cheap. It was Henry Croft who initiated the full pearled costume which, since it may contain as many as 80,000 buttons, can weigh up to 60 pounds (over 27 kilos). Croft was a road-sweeper interested in raising money for charity. He sewed buttons on to his own clothes in order to attract attention and so benefit the causes in which he was interested.

The tradition of pearly royalty comes from the older coster royalty and the right to wear pearly suits is an inherited one. Suits are passed down from generation to generation. In modern times there have been problems because pearl buttons are now difficult to obtain but assistance was recently offered to help to supply the needs of the pearlies by the Japanese oyster pearl industry.

**PEASANT BLOUSE:** a design traditional for centuries in central and eastern Europe introduced to the west as a fashionable blouse in the 1930s and revived at intervals since. The blouse is made of a white sheer fabric such as voile or silk and is cut very full and with full long sleeves. It is stitched with smocking at the waist, wrists and neck and is embroidered in geometrical and floral designs. The stitching is done in coloured silks, cottons or wools.

**PEASECOD-BELLY:** an unusual fashion of the years 1580–1600 for masculine doublets padded in front to overhang the belt at the waist like a paunch. The term 'peasecod' is derisory, likening the shape to a pea-pod. The suggestion put forward is that the fashion imitated the shape of the military cuirass made in this manner to deflect bullets.

**PEDAL PUSHERS:** an American term for modern feminine loose trousers of mid-calf length.

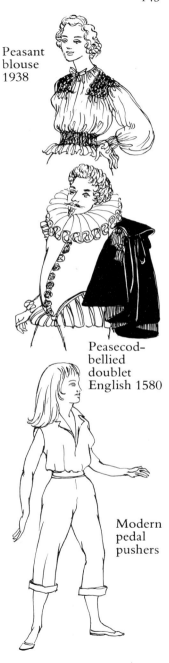

145

Peasant blouse 1938

Peasecod-bellied doublet English 1580

Modern pedal pushers

Peep-toe
shoe
1950

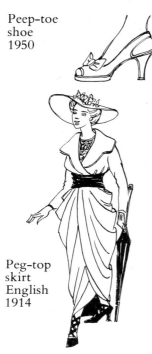

Peg-top
skirt
English
1914

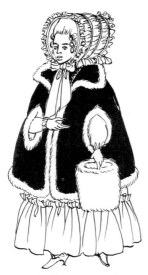

Pelisse, French 1778

PEEP-TOE SHOE: one cut away in front to show part of the toes. Popular in the early 1950s.

PEG-TOP SKIRT: a style seen in the years 1912–19 and revived in evening wear of the 1960s, of an ankle-length skirt cut very full and draped at the hips but diminishing to be narrow at the hem.

PEG-TOP TROUSERS: a similar theme to the skirt in that the trousers were cut to be full at the hips, pleated and eased into the waistband, but diminishing to be narrow at the ankle; a style to be seen between 1825 and 1840.

PEIGNOIR: in modern France, a dressing-gown but in the 18th century, a negligé gown made of thin fabric, generally fastened at the neck, worn in the bedroom or for informal relaxation at home. The literal meaning is 'combing-gown' as the word derives from the French *peigner*, 'to comb'.

PÈLERINE: in the Middle Ages a pilgrim's cloak, from the French *pèlerin*, 'pilgrim'. In the 18th century and, especially, the 19th, a cape worn by women which had long pendant ends in front.

PELISSE: a fur, fur-lined or trimmed cloak, coat or mantle, the word derived from the old French *pelice* and the Italian *pelliccia*, 'fur', 'fur coat'. The pelisse was introduced as a feminine coat or cloak in the 18th century, worn for warmth in winter over hooped gowns. It varied in length from hip to ankle, was most often made of velvet, silk or satin and had a fur lining and trimming. Most designs had a large collar or shoulder cape, sometimes a hood, and there were slits for the arms to pass through in order to hold the fashionable large muffs.
  The 18th-century pelisse had been a revival of the furred overgown of the Middle Ages, the PELISSON. It continued to be worn until about 1840, the style changing with current fashion so that, for example, in the first few years of the 19th century it was a fur-lined mantle draped round the body; by 1812–15 it had become a high-waisted, long coat; and in the 1830s it reverted to its 1770s style of a full garment with large collar, slits for hands and, perhaps, hanging sleeves.

PENCIL BEARD: one where a narrow tuft of hair is grown near the point of the chin; a 16th-century style.

PENNSYLVANIA HAT: a late 17th-century style, also known as a QUAKER HAT, named after the American Colony. The hat, worn by Quaker men here, was generally made of quality brown or grey beaver; it had a round crown and a wide brim turned up at the sides.

PERIWIG: a wig. In the later Middle Ages the English words, first 'perruke', then 'peruke', were derived from the French *perruque* but meaning a natural head of hair. In the 16th century, if the word were used to indicate a wig, the term was an 'artificial peruke'. Also at that time the English word 'perwyke' was coined to mean a wig and gradually corrupted via perewyke, perewig and perrywig to 'periwig', the term in general use during the 17th century to describe the full-bottomed wig worn by men from about 1660 onwards. Later 'periwig' became simply 'wig'.

Pennsylvania hat
American 1680

Petenlair French 1760

PERMANENT WAVING: introduced about 1906 but few people then had their hair waved in this manner as the process took about 12 hours and cost over £200. In the 1920s it was made cheaper by the use of machine, either by electric dry heat or by steam. The hair was wound on to curlers which were then attached to a machine to be 'cooked', a process which took 3 to 4 hours. The post-war method of cold waving, employing chemicals in lotion form, is more comfortable and faster.

PERUKE: see PERIWIG.

PETENLAIR: a ladies' short jacket designed with the current mode of sack back, worn with a stomacher and petticoat (in this sense, a skirt) in the mid-18th century. Jacket and petticoat were usually of matching material. Before the 19th century the term 'petticoat', as in this case, was also applied to the skirt of a dress.

Peter Pan collar 1960

PETER PAN COLLAR: a flat, round-ended collar about 2 to 3 inches (5 to 7·5 cm) deep, named after Sir James Barrie's Peter Pan. Worn by women and children from the early 20th century on.

PETTICOAT BREECHES: see RHINE-GRAVES.

PHRYGIAN CAP: a style of round cap with a point on top which was allowed to fall forwards. Widely in use from the early Middle Ages in

Phrygian cap Italy 11th century

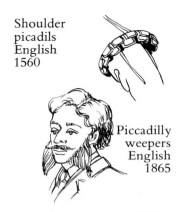

Shoulder
picadils
English
1560

Piccadilly
weepers
English
1865

Pig-tail wig English 1750

Pigeons'
wings
French
1745

Pilgrims'
hat
American
1635

Pill-box
hat
1965

Europe and derived from a design commonly worn throughout ancient Mesopotamia and the classical world. The name, in use from the 18th century onwards, refers to ancient Phrygia in Asia Minor. In more modern times the cap has been identified as a symbol of workers' revolt—the 'cap of liberty'.

PICADIL (PICCADIL, PICKADIL): a fashion of the later 16th and early 17th centuries for a stiffened tabbed or scalloped edge to finish the armhole, waistband or neckline of the doublet or jerkin. It is believed that the word was taken from the name of the house of a Mr Higgins in the parish of St Martin-in-the-Fields, called Pickadilly Hall. Mr Higgins, who lived there in 1622, was a tailor who specialised in garments decorated by 'pickadilles'. London's famous thoroughfare, Piccadilly, was named from the same source.

PICCADILLY JOHNNY: see MASHER.

PICCADILLY WEEPERS: the English name for the fashion for long hair grown on the cheeks by men in the years 1840–70 (see also BURNSIDES).

PICOT: an ornamental edging or finish made of tiny loops of twisted thread.

PIG-TAIL WIG: a manner of dressing the queue of an 18th-century masculine wig in which the plait was encased in or interwoven with black silk. A black silk bow was then tied at the nape and another at the end of the queue.

PIGEON'S WING: a manner of dressing the sides of the 18th-century masculine wig into soft waves or curls on the temples; fashionable especially in the 1730s and 1740s.

PIKED SHOE: see POULAINE.

PILGRIM'S HAT: a Puritan style of black hat worn in the American Colonies by the 17th-century Pilgrim settlers of New England.

PILL-BOX HAT: a small, round, stiffened hat or cap worn generally on the back of the head. This was a characteristic style of the later 16th century in central and western Europe when it was made of rich fabrics, jewelled and embroidered and accompanied by a veil. The mode has been revived more than once in the 20th century.

PINAFORE DRESS:   the term in Britain for a
modern overdress which is sleeveless and has a low
round, V or square neckline, worn over a blouse or
knitted top. In America the pinafore dress is called a
JUMPER.

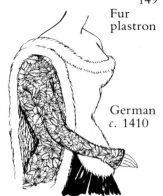

Fur
plastron

German
*c.* 1410

PINNER:   an abbreviation for the 19th-century
pinafore, a bibbed apron worn by children and
working women to protect their dresses, so-called
because originally it was pinned to the bodice.
    The word 'pinner' was also applied in the 17th
and 18th centuries to the pinned-up lappets of an
indoor cap (see LAPPET).

PLACKET:   a slit or opening in a skirt or pet-
ticoat to facilitate putting on the garment.

PLAID:   in Gaelic, *plaide*, 'a blanket'. In Scotland
this large rectangular piece of woollen cloth was, in
the 17th century, pleated and wrapped round the
body by day and used as a blanket by night; this was
the **belted plaid** (see KILT). The plaid was generally
woven in a check or tartan pattern and the word is
also used to refer to this arrangement of stripes and
bands crossing one another at right angles to form a
tartan design.

Platform
sole
1973

Plimsoll
1924

PLASTRON:   originally a steel breastplate in
armour, from the French word *plastron*, 'breast-
plate'. The word is used in civil dress to refer to a
decorative panel in the bodice of a woman's gown,
which is of a different colour and material.

PLATFORM SOLE:   an extra-thick sole built up
with cork, wood or plastic. A characteristic style in
footwear for both sexes in the 1970s.

PLIMSOLLS:   rubber-soled canvas shoes were
being worn on the beach by the 1870s. These were
called sand-shoes but after the Merchant Shipping
Act of 1876, sponsored by Samuel Plimsoll,
required that the loadline should be marked on
ships—the Plimsoll Line—these canvas shoes were
nicknamed plimsolls, a name by which they have
been known ever since. This was because the
manufacturer fastened a strip of rubber all round
the shoe to cover the join between sole and upper.
See also SNEAKERS.

Pluderhosen
Dutch
1580

PLUDERHOSEN:   a German name for a loose,

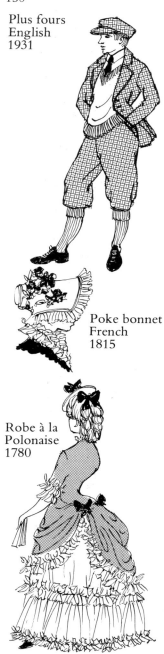

Plus fours
English
1931

Poke bonnet
French
1815

Robe à la
Polonaise
1780

long type of trunk hose or slops worn in the later 16th and early 17th centuries in Switzerland and Germany. In this style the fullness of material hung down between and below the outer panes (see PANES, SLOPS, TRUNK HOSE).

PLUMPERS: small, lightweight balls of cork placed by ladies in their mouths between the late 17th century and the 19th, and held in the cheeks to fill out the sunken cavities caused by age and loss of teeth.

PLUS FOURS: men's tweed or worsted knickerbockers worn with sports jackets in the 1920s and 1930s for playing golf, cycling and walking. This style was fuller than the 19th-century form of knickerbocker and acquired its name because the material which overhung the band at the knee required 4 extra inches (10 cm) in depth.

POCKET-IN-THE-PLEATS: a pocket sewn into the back of the skirt of a man's coat which had its opening hidden under the pleats there. A POCKET-IN-THE-SKIRT was similar but its opening was in the lining of the coat skirt.

POINTS: laces used in the Middle Ages to fasten one garment to another, e.g. the hose to the doublet, or two parts of a sleeve to one another. Points were tipped with decorative metal tags (see AGLET). Later, when garments were fastened by other means, points continued to be used as ornamentation and, in ribbon form with aglet tips, they were fashionable for decorating parts of masculine and feminine dress in the 16th and 17th centuries.

POKE (POKING) BONNET: a term given to 19th-century bonnets in which the brim projected forward over the face.

POLO COLLAR: at the turn of this century, a white, starched, man's shirt collar. In modern dress it is a circular, soft, high collar, without opening, turned down all the way round the neck and widely favoured for shirts and pullovers.

POLONAISE: this term has been applied to a number of garments, especially in the 18th and 19th centuries, and indicates, however tenuously, that the design is of Polish origin. For example, there was the polonaise gown of the years 1770–80 (see ROBE à la polonaise) and, in the 1870s the bustle style

of gown with a similarly draped-up overskirt (but in this style, due to its bustle silhouette, the front of the overskirt was open and the material mainly bunched up behind). Polonaise overcoats were fashionable in the 19th century, chiefly worn by men. In the 1830s there was the style with brandenburgs covering the whole of the chest (see BRANDENBURGS), also a polonaise version of the redingote of these years which had a fur collar and braid trimming (see REDINGOTE).

Polonaise type of overcoat French 1835

POLO SHIRT: the British version is an informal shirt with polo collar, the American one is a summer shirt with round or collared neckline.

POMADE (POMATUM): a perfumed unguent which originally is said to have contained apple and was used for the skin, but later was applied specifically to the hair.

POMANDER: an ornamental hollow sphere of precious metal containing aromatic substances which hung from a lady's girdle or necklace or was carried by elegants on the person to offset infection and unpleasant smells. Pomanders were used and worn during the 16th and early 17th centuries, after which they were replaced by perfume bottles and cases. The name derives from the Old French *pome ambre* and the medieval *pomme d'embre*, both meaning 'apple of amber'. Ambergris was the basis of the perfumed substance inside the sphere.

Gold pomander case 1585

POMPADOUR: several articles of dress and personal adornment were named after the Marquise de Pompadour (1721–64), mistress of Louis XV of France, a number of which have been reintroduced at a later time, notably the 19th century. There was the pompadour coiffure style with the hair brushed up softly from the forehead and the nape which recurred in the late 19th century in a more exaggerated form. There was the pompadour heel which was the characteristic curved slender style of her day (see FRENCH HEEL), which has been revived more than once. Also named after the marquise were a coat, a bodice, an apron and various fabrics.

Pompadour coiffure English 1901

PONCHO: one of the simplest and earliest forms of outer covering which was adopted by primitive peoples as a blanket at night and a garment by day. The poncho is a traditional cloak of the South American Indian; it is a square of

Modern
poncho

Poulaine
Swiss
1385

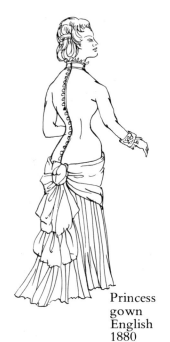

Princess
gown
English
1880

brightly-coloured, striped woollen cloth with a hole in the centre for the head. It hangs down to hip-level, and was intended for both sexes. In recent years the poncho has been adopted by the western fashion world as an outer garment chiefly for children and young people.

POP SOCKS:   Calf- or knee-length nylon stockings for wear with trousers; KNEE HIGHS or PANTS STOCKINGS in America.

POSTICHE:   an imitation of a genuine article. In costume may be applied to a wig or hair-piece.

POULAINE (PULLAYNE): *poulaine* is the usual French term for what, in England, was more commonly referred to as the PIKED (PEAKED) SHOE. This was a fashion for extended toes to the footwear which was taken up early in Poland, spread to Italy, then further westwards. The term CRAKOW was also used for this mode, named after the Polish city. The making of long toes for footwear was a general custom in the 14th and 15th centuries but exaggeratedly lengthened soled hose, pattens and shoes were especially characteristic of the years 1380–1410 and, again, from 1460–80. In several countries sumptuary laws were passed to curb this fashion, particularly in the 15th century, but in Burgundy, France and England these failed and it has been reported that in some instances footwear became so long—up to 24 inches (60 cm)—that the toes had to be reinforced by whalebone or tied up to a knee garter.

POURPOINT:   the chief masculine body garment of the 14th and early 15th centuries after which it was referred to as a doublet (see DOUBLET).

POWDERING JACKET (GOWN, etc.):   a term used in the 18th century for a loose garment to be slipped on over the clothes to protect them while the wig was being powdered.

PRESS STUD:   see SNAP FASTENER.

PRÉTINTAILLES:   decorative cut-out pieces of coloured and varied fabrics which were appliquéd to ladies' gowns to ornament them in the late 17th century.

PRINCESS:   a princess style in a gown or a coat is one where there is no waist seam; bodice and skirt

are made in one and the skirt gored and flared to the hem giving a sleek fit over the waist and hips. The princess gown was introduced in the mid-19th century and was worn with crinoline and bustle styles. A sleeker princess gown was *à la mode* in the late 1870s and, again, in the 1890s. This line has recurred often in 20th-century fashion.

PUG HOOD: also known as a SHORT HOOD, an outdoor ladies' style of the 17th and 18th centuries. The hood was made of a soft material such as velvet or silk and was lined, usually in a different colour. The fullness was provided by folds which radiated from a point in the centre back. The hood was turned back a few inches in front where it framed the face, then was tied by short ribbons at the throat (see also CAPUCHIN, LONG HOOD).

PUMP: a low-cut shoe in court style made of soft leather, heel-less or with a very low heel. First mentioned in the 16th century, pumps became especially fashionable for both sexes in the years 1790–1830. Men wore them indoors and these were generally of black leather with a low heel and low-cut in front where they were finished with a small ribbon bow or a buckle. Ladies' pumps were heel-less and made of plain silk or satin. They were low-cut all round and were generally fastened by ribbons which were crossed over the foot and at the ankle where they were tied.

PURITAN DRESS: the Puritans of the first half of the 17th century did not deliberately design a style of dress of their own, they adapted the current mode into what they considered to be restrained, decent and sober. This applied equally to the Swiss Calvinists, the English Puritans and those who emigrated to the New World. Some Puritans adopted an extreme form of contemporary dress, stripping the fashionable attire of all its fripperies—ribbons, long hair, lace collars and cuffs and feather ornamentation. They wore holland and worsted instead of satin, velvet and lace, their hats were plain black felt with only a ribbon and buckle for trimming and no feathers. Colours were 'sadd', that is, browns, greys, black, purple and white. Hose were woollen, boots and shoes of black leather; band, cuffs and cap were all of plain, white linen. Other Puritans wore a dress almost indistinguishable from that of the Catholic gentlemen of the 1630s, and in between were a variety of compromise costumes.

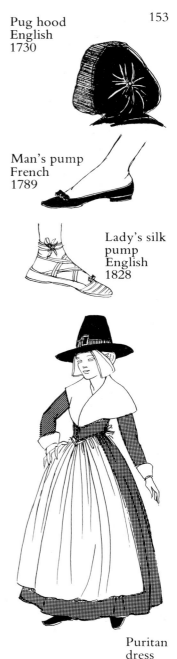

Pug hood
English
1730

Man's pump
French
1789

Lady's silk
pump
English
1828

Puritan
dress
1650

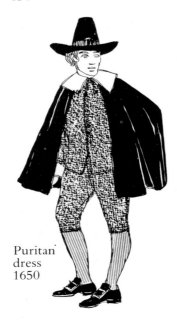

Puritan dress
1650

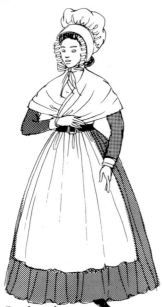

Quaker dress
American, 19th century

In Puritan dress, as in all attire of the period, social status played an important part in choice of clothes. A Puritan might eschew the fripperies and follies of fashion but, if he were of high birth and good family, he would wear clothes made of quality materials, well-cut and finished in the latest (if plainer) fashion. In the New World this was particularly stressed because the New England settlers were establishing a fresh community and it was vital that social status be made clear from the beginning. The colours here were more in shades of brown, from golden to dark, than grey or black. This was largely because warmer clothes were needed and local materials had to be used so tanned skins and hides and furs were in extensive use for garments. Phillymort was a popular shade, a corruption of *feuille morte*.

PYJAMAS: the suit of coloured cotton or silk pyjamas was introduced into England in the 17th century. It was an ephemeral fashion, worn by men of the aristocratic and upper class as an informal house attire. The idea had come from India: it was based upon Indian and Persian designs and the term derived from the ancient Persian and Urdu words *pāē*, 'foot, leg', and *jāmah*, 'clothing, garment'. PAJAMA was the original spelling and this form has persisted in the USA.

It was in the 1880s that pyjamas returned, this time as masculine sleeping attire, and soon ousted the night-shirt. With the early 20th century pyjamas were made for children and before long for women also.

QUAKER DRESS: as with the Puritans, the Quakers in Europe and Colonial America adopted no specific style of dress but followed the current fashion. Unlike the Puritans, however, they published no sumptuary laws to try to discipline those members of the Society of Friends who dressed in too frivolous a manner. Quaker dress was fashionable, well-made and of rich, high-quality materials. Friends were recommended to eschew over-ornamentation, hoops under their gowns, powder on their wigs, and to wear muted colours. Ladies

were asked to wear aprons at all times and a green linen or lawn apron as well as the distinctive bonnet and cap became symbols of Quakerism. On the other hand, according to the current mode of the 17th and 18th centuries, Friends wore wigs, silver shoe-buckles, lace-trimmed linen and cloaks in bright colours, especially red; this style was termed a cardinal (see CARDINAL, PENNSYLVANIA HAT, WAGON BONNET).

QUARTER:  see VAMP.

QUEUE:  the tail of a wig hanging down the back. From the French *queue*, 'tail'. The word was also anglicised to CUE.

QUITASOL:  a parasol made of coloured oiled muslin used in 18th-century America. The Spanish word for parasol.

# R

RAGLAN:  several items of masculine dress were named in the 1850s after Lord Raglan, commanding officer of the British troops in the Crimea. These include an overcoat, a style of boot, a cape and a sleeve. It is the last of these which has proved the most important in costume history because it has been used in coat design ever since. The **raglan sleeve** is not inset; the sleeve seams continue from underarm up to the collar seam so avoiding a shoulder seam. This gives an easy line suited to an outer coat which often has to be put over another tailored coat sleeve.

RAMILLIE (RAMILLIES) WIG:  an 18th-century wig; a military style adopted also for civilian use, which had a long queue, plaited and tied with a black ribbon bow at the nape and at the end. Named after the Duke of Marlborough's victory at the Battle of Ramillies in Belgium in 1706.

RATIONALS:  knickerbockers introduced for women to wear when cycling and for sport in the 1890s (see BLOOMERS).

RAWHIDE:  untanned animal hide, usually sof-

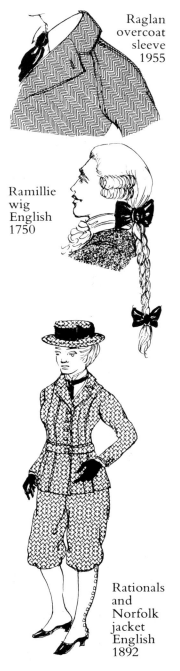

Raglan overcoat sleeve 1955

Ramillie wig English 1750

Rationals and Norfolk jacket English 1892

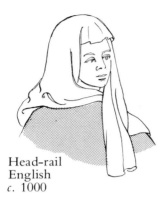

Head-rail
English
*c.* 1000

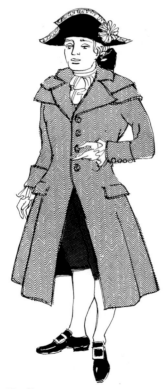

Redingote
French
1775

tened with oil and sometimes varnished to make it moisture-proof. Used mainly by ancient, primitive and simple communities and peoples.

RAYLE (RAIL): a piece of material draped round the neck. A NIGHT-RAIL was a loose wrap or cape worn by women in the bedroom. A HEAD-RAIL was a veil or kerchief worn from Anglo-Saxon times; it was draped round the head, then hung loose or was tucked into the neckline of the gown. The Normans called this a couvrechef but the word 'head-rail' continued in use also (see COUVRECHEF).

RAYONNÉ: a hood which was extensively worn by women in the American Colonies in the second half of the 17th century. Like the English pug hood, it was made of corded silk (generally black) and lined with silk of a contrasting colour; the front edges were turned back to frame the face and the hood was tied under the chin with ribbons. The name derives from the French *rayonner*, 'to radiate', and refers to the radiating folds at the back (see PUG HOOD).

READY-MADE (READY-TO-WEAR) CLOTHES: ready-made suits of poor quality were available for working-class men by the mid-18th century and garments for women by the end of the century when these were advertised in local newspapers. The middle classes were reluctant to buy such ill-fitting garments of inferior material but mantles and cloaks of a higher quality were available by the 1830s. It was then also possible to buy a fashionable dress partly-made. This was cut out, the skirt finished and material supplied for bodice and sleeves, which had to be personally fitted by a dressmaker. It was well into the 1860s before middle-class women, in general, purchased ready-made clothes (in modern parlance off-the-peg) and professional men continued to have their suits made to measure until the mid-20th century.

Mass production of clothes for a wide market had begun to develop in the 1840s but the early vital mass retail outlets were slower to follow. Early department stores had been opened in England: for instance, *Bainbridge's* at Newcastle (well established by 1845) and *Kendal Milne and Faulkner* of Manchester (1836). The famous *Bon Marché* of Paris was established with several departments by 1860 and the big cities of Europe and America were quick to follow suit. In London's West End *Swan and Edgar,*

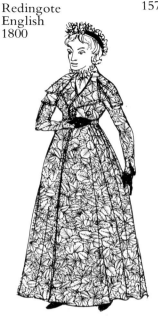

*Dickins and Jones* and *Peter Jones* all expanded in the years 1855–75. In New York, *Macy's* became a department store by 1860; *Stewart's* opened in 1862; *Wanamaker's* of Philadelphia followed in 1876.

REBATO: in the later 16th century a stiffened, wired, white collar worn by women round the sides and back of a décolleté neckline. Before the end of the century this term was more often used for a wired support at the rear of a large collar or ruff, a fashion which continued until after 1625.

REDINGOTE: the French term for a riding-coat and one used to describe an overcoat worn by both sexes during the 18th and 19th centuries, during which time the style varied greatly. The redingote was worn by men from about 1725 for travelling and for riding. For over 50 years it was a heavy, long coat, double-breasted, and had a large collar and revers, also a shoulder cape. By the 1780s the style had changed and gradually the redingote became a fitted, waisted coat with flared skirts. It could be single- or double-breasted; the shoulder cape and large collar had been replaced by a smaller collar, often of fur or silk-faced.

From the 1780s the redingote was introduced for women and over the years this coat also changed in its design and function. The version of the years 1790–1820 was high-waisted, generally double-breasted, and had collar, revers and shoulder cape. The front, from high waist downwards, was open and unfastened. From the 1820s to the 1860s the redingote was made of dress fabrics as it was a gown rather than a coat; it followed the current modes. From about 1875–80 the garment reverted to being an outdoor coat, this time tailored, with a fitting waist, a collar and long, flared skirt.

REEFER JACKET: the name usually given, after 1860, to the pea jacket (see PEA JACKET).

RETICULATED HEAD-DRESS: one which incorporates a net made of silk, jewelled metal threads or a metal mesh. Characteristic of the designs of the 14th and 15th centuries (see CAUL).

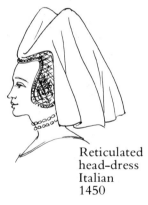

Reticulated
head-dress
Italian
1450

RETICULE (RIDICULE): in the years 1795–1820 the current feminine fashions which decreed a minimum of garments, made of lightweight fabrics, and a slim silhouette, permitted no pockets so ladies needed to carry a reticule. This was a dainty handbag, somewhat inadequate for its purpose,

Reticule
1810

Rhinegraves
German 1653

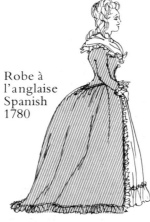

Robe à
l'anglaise
Spanish
1780

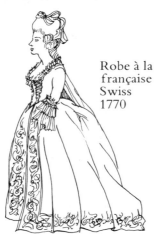

Robe à la
française
Swiss
1770

which was hung over the arm by strap handles and contained a handkerchief, fan, purse and a perfume bottle. These little bags, also referred to wryly as RIDICULE or INDISPENSABLE, were usually circular or oval and were drawn up by cords at the top. They were made of soft fabrics—velvet, silk or satin—and were embroidered and beaded.

RHINEGRAVES (RHINEGRAVE BREE-CHES): a short-lived masculine fashion of the years 1652–75 but especially modish in the 1660s, for very wide breeches made in the form of a knee-length divided skirt or a kilt-like skirt. The shape of the garment was not easy to discern as it was ornamented over much of its surface by ribbon loops and lace ruffles. The front closure was covered by diminishing rows of ribbon loops. Also known as PETTICOAT BREECHES, the garment came from the Rhineland where it was named after the count, Rhinegrafen Karl, who wore it and the fashion spread quickly when Louis XIV adopted it.

ROBE: France had become the undisputed arbiter of feminine fashion by 1700 and, during the 18th century, the French word *robe* was frequently used instead of 'gown' when defining a specific fashion. The principal designs were:

**Robe à l'anglaise:** the English style of gown which became fashionable in Europe from the late 1770s. This was a waisted gown with a fitted bodice, open in front, and a long skirt worn without a hoop. The décolleté neckline was softened by a fichu or wide collar.

**Robe à la française:** this style developed about 1745–50 from the sack gown and continued fashionable until the 1770s when its use was restricted to formal court wear (see SACK GOWN). The bodice front was fitted and open over a decorative stomacher which was often decorated with graduated ribbon bows (see ÉCHELLE, STOMACHER); the neckline was low and square. At the back the fullness was controlled by broad double box pleats on either side of the centre (see WATTEAU PLEATS) and the fabric descended directly to the ground and a train. In front the overgown opened over an underskirt of the same material. Sleeves were in pagoda style with engageantes below (see ENGAGEANTES, PAGODA SLEEVE).

**Robe à la polonaise:** a popular fashion of the late 1770s and the 1780s for an ankle-length, full underskirt worn over paniers, and an overskirt which could be arranged in looped-up drapery by being raised with draw-cords; usually the drapery was arranged in three festoons (see POLONAISE). Sleeves were usually of sabot design (see SABOT SLEEVE). A variation on this gown style was the *robe à la circassienne*, in which the sleeves were short, displaying those of the undergown below.

**Robe battante (Robe volante):** French term for the sack or sack-back dress which preceded the *robe à la française* and which was worn from about 1720 (see SACK GOWN).

ROMAN T BEARD: a fashion of the first half of the 17th century where a narrow, waxed, horizontal moustache was worn above a narrow pointed beard extending down from the lower lip. Also called a HAMMER CUT BEARD.

ROMPERS: a one-piece playsuit for infants with top, sleeves and bloomers all in one. First worn in the later 19th century and established as sensible playwear from the First World War on. In the USA also known as JUMPER(S).

ROPA: a Spanish surcote worn by women in the second half of the 16th century and the early 17th. It was a full-length outer garment with a high collar and generally fastened at the throat. The surcote then fell, unwaisted, to the ground, open in front displaying the gown beneath. Many designs were sleeveless, the shoulder line finished by a padded roll; others had puff or hanging sleeves. The ropa was a rich garment, made of velvet or satin and embroidered, often with gold thread and jewels. It became a popular garment and was adopted in most European countries (see MARLOTTE, VLIEGER).

ROQUELAURE CLOAK: an 18th-century cloak named after the Duke of Roquelaure, fashionable in Europe and the American Colonies where it was often abbreviated to ROQUELO. It was a travelling and riding cloak, knee-length and with a back vent. Made of woollen cloth, it buttoned, or tied, down the front; it had a large collar and, generally, a hood.

ROULEAU(X): a wide, full piping used as a decorative trimming especially on bonnets, hats and skirts.

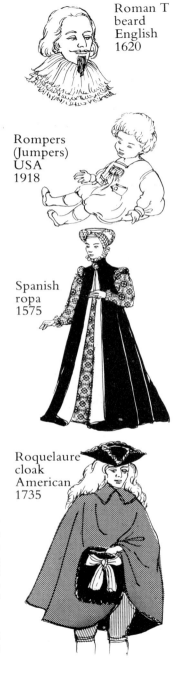

Roman T beard English 1620

Rompers (Jumpers) USA 1918

Spanish ropa 1575

Roquelaure cloak American 1735

Roundlet
Spanish 15th century

Ruching
English 1760

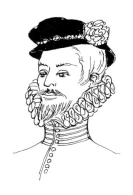

Ruff
English 1763

ROUNDLET: a later term for the bourrelet, the padded roll of the 15th-century chaperon. This was the part of the made-up hood which was set on the head (see BOURRELET, CHAPERON).

RUBBERS: American term for galoshes (see GALOSH).

RUCHE (ROUCHE): a pleated or softened ornamental edging used to decorate garments. The word derives from the French *ruche*, 'beehive' and refers, in this instance, to the structural bands of a straw hive.

RUFF: the 16th-century ruff developed from the neck and wrist finish of the Spanish shirt and chemise of the 1550s. The shirt at that time had a high neckline edged with a ruffle; it was open in front and divided by the chin. At the wrists the ruffles extended all round. In the 1560s these ruffles became ruffs, called bands (see BAND). They were then separate articles of wear, not attached to the shirt, and they were made of fine linen.

After 1565, with the introduction of starch, ruffs became larger, requiring frequent washing and starching, and were then goffered (see GOFFERING). The fashionable ruff gradually increased in size until 1580–5 (see CARTWHEEL RUFF) when it could extend as much as 9 inches (23 cm) on either side of the neck and be made from 18 yards (16·5 metres) of fabric. Such ruffs needed supports at the back and these were made of pasteboard or metal wires (see REBATO, SUPPORTASSE). In some countries ruffs were sometimes lace-edged or made entirely of lace and the edge of such a ruff might be wired to maintain its shape. These ruffs were fashionable in England, France and Italy; in Germany, Poland and the Low Countries ruffs were large but plain. Spanish ruffs tended to remain small and discreet but were beautifully made and often embroidered with black silk or gold and silver thread incorporating tiny jewels. Wrist ruffles were provided in sets with the ruff, the whole being termed a **suit of ruffs**.

The ruff continued to be worn until mid-17th century. For specific designs see CABBAGE RUFF, CARTWHEEL RUFF, FALLING RUFF, OPEN RUFF. The fashion for small ruffs was revived for women at intervals in the 18th and 19th centuries (see BETSIE).

# S

SABOT: French term for a wooden working clog (see CLOGS) as worn in France and Belgium. *Saboter* in French means to make a noise with sabots or to damage wilfully. The word 'sabotage' came into general use after the French railway strike of 1912 when the workers cut the shoes (*sabots*) holding the lines in place.

French wooden sabot

SABOT SLEEVE: a feminine style of the second half of the 18th century, worn especially with the *robe à la polonaise*, fitting to the upper arm and finished by a soft puff of gauze ruffles arranged vertically over the elbow. Revived as a 19th-century puff sleeve.

SACK (SACQUE) GOWN: a French loose gown derived from an informal house dress of the early 18th century. From a low, wide neckline this flared out freely over a large circular hoop petticoat; it was not waisted at first but the fullness of material was gathered into the neckline at the back. From about 1720–5 these gathers became two wide double box pleats (see WATTEAU PLEATS), which were sewn down at the neckband but were allowed to drape freely from here to the ground. From about 1730 the bodice was shaped to the figure in front to below waist level but continued to fall gracefully at the rear. By 1745–50 the sack, or SACK-BACK gown as it was generally termed in English, had evolved into the *robe à la française* (see ROBE *à la française*). In France the sack-back gown was sometimes called the *sacque* but more often the *robe battante* or *robe volante*.

Sabot sleeve
French 1786

SAFARI JACKET, SAFARI SUIT: the safari jacket was originally designed for use in the African bush (BUSH JACKET). Made from a heavy, usually water-repellent material, it had four large patch pockets with buttoned flaps and was belted at the waist. A modern adaptation, the safari suit, with skirt or trousers, is available for holiday wear.

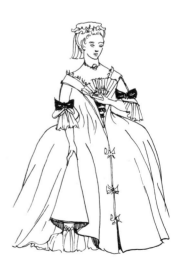

SAFEGUARD: an overskirt of heavy wool or linen worn by women over their gowns from the late 16th until the end of the 17th century when riding, to protect their clothes from mud or dirt in

Sack gown
(Robe volante or battante)
French 1721

Little boy
in sailor
suit
1883

Little girl
in sailor
suit
1910

Sans-culotte
1792

the days before the riding-habit was designed for feminine wear. The safeguard was also known as a WEATHER-SKIRT or FOOT-MANTLE. Adopted in the American Colonies about 1650.

SAILOR SUIT: a popular fashion for boys in the second half of the 19th century. This was triggered off by Winterhalter's portrait of Prince Edward (later Edward VII) in 1846 at the age of five, depicting him wearing a diminutive but accurate version of naval uniform in a white suit with bell-bottom trousers, a sailor collar and neckerchief and sailor hat. The sailor suit achieved immense popularity quickly, especially in England and Germany, both countries with powerful navies, and both with royal families with strong naval links who dressed their children in the new fashion. By the 1860s the vogue for the suit had spread to other countries in Europe and, by the 1880s, it had become almost a uniform for boys and even spread to girls. Sailor suits based upon those worn in the US Navy were adopted with equal enthusiasm by American mothers. There were many variations on sailor suit themes. For younger boys especially the loose sailor blouse was worn with knickerbockers or even shorts, and round caps with ships' names on them provided an alternative to the type with the turned-up brim. Materials varied with the season; in general, winter suits were of navy serge with white drill or cotton blouses and navy caps, in summer the suit was of white drill with straw hat. Middy suits, based on midshipman's uniform, had a short jacket and long trousers. Girls wore sailor blouses with square collars, sailor hats and a pleated skirt of white drill or navy serge. Reefer jackets and sailors' jerseys were incorporated into the outfit in the 1880s (see also MIDDY BLOUSE).

SAMARE (SAMARRE): see CHAMARRE.

SANBENITO: a penitential garment named, because of its similarity of shape, after the scapular, which was a cloak prescribed by St Benedict to be worn by his Order while engaged in manual labour. The sanbenito, marked by the cross of St Andrew in front and rear, was made of yellow or black sackcloth. It was the ritual wear for a confessed and penitent heretic who had been condemned to death by *auto da fé* under the Spanish Inquisition.

SANS-CULOTTE: the literal meaning is 'without breeches' (see CULOTTE). This was the name

given to the French Revolutionaries by the aristocrats, indicating that they wore workers' trousers, not the knee-breeches of fashionable society (see also CARMAGNOLE).

SAYE (SAYON): a sleeveless jacket worn by working people during the Middle Ages.

SCHLAPPE: an elegant feminine Swiss headdress traditional to the Appenzell Canton. It is a white lace or embroidered cap with fan-like wings made of stiffened, pleated, black and white gauze or lace attached to it on either side; ribbons hang down the back.

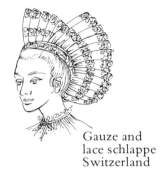

Gauze and lace schlappe Switzerland

SCOGGER: a stocking or sleeve without foot or hand part, made of wool and worn over the footwear to prevent slipping on icy surfaces and over the arm to protect it. Traditional to England and widely used in the American Colonies.

SCORPION'S TAIL: a footwear design also called RAM'S HORN: in the later 11th century the shoe toes were cut and shaped into a likeness of a scorpion's tail or ram's horn, then padded to maintain the shape. These shoes were sometimes referred to by the French name of PIGACHE. The fashion did not last long, only from about 1090–1110, but it represented an early appearance of the medieval pointed footwear which reached a climax in the 14th and 15th centuries (see POULAINE).

Scorpion's tail shoe
English
c. 1110

SCOTTISH BONNET: the traditional design was recorded from the 17th century onwards. It was woven in one piece, made of wool and was most often blue (also termed 'bluebonnet'). The ribbon cockade and feathers denoted allegiance and rank (see KILMARNOCK CAP, TAM-O'-SHANTER).

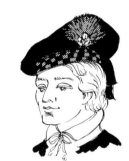

Scottish bonnet
early 19th century

SCRATCH WIG: an 18th-century wig which covered the back of the head only, the natural hair being brushed over it from the front.

SCUFF: a heel-less, back-less bedroom slipper made of soft, fluffy material, often washable nylon.

SCYE: tailoring term for the armhole into which a sleeve is fitted.

SHADOW: in the years 1580–1650, a shade against the sun which could be held in the hand or

Modern scuff

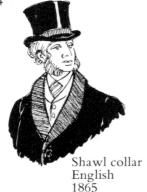

Shawl collar
English
1865

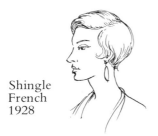

Shingle
French
1928

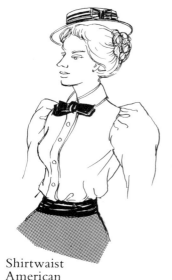

Shirtwaist
American
1898

was worn on the head. Similar to a bongrace but not part of a hood (see BONGRACE). Used in England, also in Colonial America.

SHAWL COLLAR: a turned-down coat or dress collar, continuous with the lapels, so in one line from the back of the neck to the buttoning but without a peak or notch. Also known as a ROLL COLLAR.

SHEPHERDESS HAT: see BERGÈRE HAT.

SHERRYVALLIES: loose pantaloons worn on horseback during the later 18th and the 19th century in America over normal attire to protect this from mud and travel staining. The term is of oriental origin deriving via the Arabic and Persian words (such as *shalwar*) signifying a type of trousers, to the Spanish *zaraguelles* which was then corrupted to sherryvallies.

SHINGLE: a feminine hairstyle of the 1920s when the hair was cut short and shaped to a point at the nape.

SHIRRING: see GAUGING.

SHIRTWAIST: an American term for a blouse fashionable in the years 1890–1910, which was a feminine version of the masculine shirt. The blouse had a masculine-style collar and tie or scarf. The term has continued in use to denote a tailored blouse.
   The SHIRTWAIST DRESS, developed from this, followed a similar design extended to dress length and has become a classic design in the American wardrobe. It is buttoned down the front to waist level where it is belted.

SHOEPACK: a shoe or low boot made of tanned leather in Indian moccasin style without a separate sole (see MOCCASIN). An American term for a design widely in use during the Revolution and derived from an Indian word, *shipak*.

SIDEBURNS: American term for side-whiskers.

SIDELESS SURCOAT (SIDELESS GOWN): a feminine overgown worn during most of the 14th and 15th centuries but especially from about 1350 until 1430. In the early years the garment was sleeveless; it had a round neckline and deep

armholes which extended down to hip-level, show-
ing the long sleeves and torso of the undergown.
The armholes were finished with embroidered or
fur edging. The front of the bodice was also gener-
ally decorated with fur. The skirt was ground-
length and very full.

From the years 1340–50 onwards the sideless
gown was made of a heavy rich fabric, often velvet,
and could be lined with fur. As time passed the
neckline became lower and wider, taking an off-
the-shoulder line, and the armholes larger. The
front bodice fur strip, which had become very nar-
row, was then attached, for support, by a row of
jewelled buttons, to the undergown. The back of
the bodice was much wider and this helped to take
the weight of the heavy skirt, the fullness of which
was gathered into the deep armholes. The hem was
also often decorated with deep fur bands.

SIREN SUIT:   during the Second World War this
one-piece garment, based on the boiler suit of the
previous World War (see BOILER SUIT), gained its
name because it was widely adopted for use by air
raid rescue workers and wardens. It was popular-
ised at this time by Sir Winston Churchill.

SKELETON SUIT:   one of the earliest examples
of an attire designed especially for children. Before
1780 children, after the age of about five years,
wore a miniature version, however unsuitable, of
their parents' clothes; up to the age of five boys and
girls both wore dresses. In the 1780s the skeleton
suit ('skeletons') was introduced for little boys after
they had been 'breeched'. The outfit, which was
much more comfortable than what had been worn
earlier, consisted of ankle-length, fairly loose-
fitting trousers, generally made of cotton materials,
which buttoned on to a soft, frilled shirt or a short,
fitting jacket. The trousers were derived from the
country peasant design and their introduction
antedated fashionable trousers for men by a genera-
tion. The skeleton suit was worn until about 1830.

SKILTS:   full trousers or breeches, up to half a
yard (0·45 metre) wide at the bottom, reaching to
just below the knee. Worn by country people in
America at the time of the Revolution.

SKIMMER:   an American term for a broad-
brimmed, low-crowned, 18th-century hat of
beaver, felt or straw often worn over a cap. Also
known as a SKIMMING-DISH HAT, this was

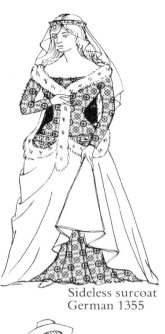

Sideless surcoat
German 1355

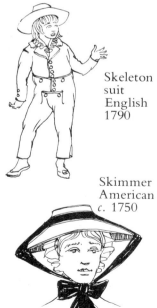

Skeleton
suit
English
1790

Skimmer
American
*c.* 1750

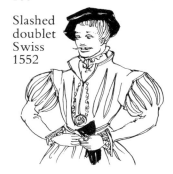

Slashed
doublet
Swiss
1552

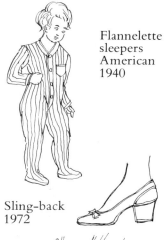

Flannelette
sleepers
American
1940

Sling-back
1972

Slops
Swedish 1609

based on the European bergère and shepherdess rustic styles (see BERGÈRE HAT) and was often tied on under the chin by cords or ribbons. In Philadelphia, in particular, Quaker women wore these hats, made of white beaver. In the early 18th century they were worn on top of a hood, later over a cap.

**SLAMMAKIN (SLAMMERKIN):** loose, unboned 18th-century morning gown in sack-back style and with pagoda sleeves (see SACK GOWN).

**SLASHED GARMENTS:** during the 16th century in particular it became a decorative fashion to cut slits in clothes so that the garment beneath, of different colour and material, could be pulled through these slits. Most items of wear received this treatment: doublets, gowns, hose, hats and footwear. The edges of the slash were embroidered and/or braided and the ends were generally held by points or jewelled clasps. Slashes were made in deliberate patterns especially on doublet and gown.

**SLEEPERS:** an American term for an all-in-one sleeping suit for children which includes feet; the garment has long sleeves and buttons all the way down the centre front.

**SLICKER(S):** an American term for rainproof wear (see OILSKINS).

**SLINGS (SLING-BACKS):** a shoe or sandal with a strap passing round the back of an open heel.

**SLOP (SLOPPE), SLOPS:** slop, in the singular, was used from the 14th to 16th centuries to refer to a variety of garments: a cassock, a jacket, a cloak, a gown, a slipper. In the years 1550–1625 slops, in the plural, were the full trunk hose or ample breeches of the time; one leg of these was a slop. In the 17th century the term 'slops' was also given to a type of sailors' loose breeches made from a poor quality material. This led to the word being associated with any cheap, ready-made garments.

**SLOPPY JOE:** a knitted wool jersey or pullover worn especially in the 1940s and 1950s. It was very long and loose-fitting; it had long sleeves and a round or V neck which displayed the collar of the blouse which was generally worn underneath.

**SLYDER:** a 17th-century New England term for a suit of overalls.

**SMALLCLOTHES:** in the years 1775–1840 a euphemism for breeches.

**SMOCK:** a Saxon term for a woman's chemise, in general use until the 18th century, derived from the old Norse *smokkr* and North Friesian *smok*. The word was also added to the names of other undergarments as, for instance, **smock-petticoat** and **smock-shirt**.

**SMOCK-FROCK:** the agricultural worker's traditional protective smock of the 18th and 19th centuries. A loose overgown, hanging to below the knees, made of homespun linen or cotton and usually gauged (smocked) on the chest and shoulders. It had full, long sleeves and, often, a collar.

**SMOKING-JACKET:** a gentleman's jacket of the second half of the 19th century reserved for use at home in the smoking-room where the gentleman could savour his tobacco without giving offence to the ladies in the drawing-room. The jacket was usually made of velvet, plush or brocade in rich or bright colours and was decorated by brandenburgs and ornamental buttons (see BRANDENBURGS).

**SNAP FASTENER (SNAPPER):** an American term, now in general use in English, for a metal or plastic fastener made in two parts, one male and one female, which are sewn to either side of an opening in a garment. When pressed together, these snap tightly to give a firm closure. The earlier English term was PRESS STUD.

**SNEAKERS:** an American term for canvas shoes with rubber soles in use for sports, boating and seaside wear (see PLIMSOLLS).

**SNOOD:** traditionally a ribbon or fillet for confining the hair, particularly in use by young, unmarried girls in northern England and Scotland. In the 19th century a snood had become a net of wool or silk to contain the long hair; this fashion stemmed from the medieval caul (see CAUL). The snood was revived as a mode of the 1930s when it was often attached to the back of a small hat which was perched on the front or the top of the head.

**SNUGGIES:** an apt American term for the post-war, knee-length, fitting pants worn by women for winter warmth. Made of nylon or

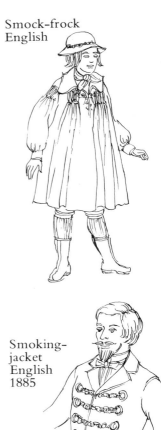

Smock-frock
English

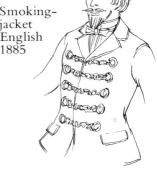

Smoking-jacket
English
1885

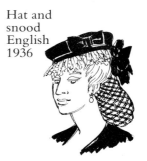

Hat and snood
English
1936

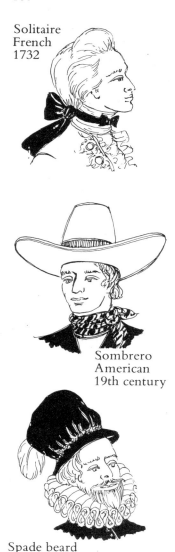

Solitaire
French
1732

Sombrero
American
19th century

Spade beard
Austrian
1600

Spat, English 1900

wool, these are elasticated at waist and knee. Also known as PETTIPANTS.

SOLITAIRE: in the 18th century it was fashionable to pass a broad or narrow black band round the neck on top of the stock (see STOCK) and tie it in front in a bow or tuck the ends into the shirt front. The solitaire was most often adopted with a bag wig (see BAG WIG), in which case, it was attached to it. The term 'solitaire' was also applied in the 19th century to a coloured scarf worn by ladies which was knotted at the throat; and, again, it can refer to a single gemstone set in a ring or brooch.

SOLLERET: originally meaning the section of articulated armour protecting the foot, the term was adopted in the first half of the 16th century for the broad-toed shoes which, when slashed, resembled this piece of armour. The shoe gradually became broader until it developed into the eared style (see EARED SHOE).

SOMBRERO: Spanish word for hat. The word was adopted on the American Continent for the broad-brimmed hat worn by the horsemen of Mexico and the American West where, later, it was also termed the TEN-GALLON HAT.

SOULETTE: a French term used to describe the leather strap which passed under the instep of the 17th-century boot to hold the spur leather in place (see SPUR LEATHER).

SOUTIEN-GORGE: French for brassière.

SPADE BEARD: a style of the later 16th century cut to resemble a curved-sided spade.

SPATS: an abbreviated form of spatterdashes (see SPATTERDASHES), worn chiefly by men from the mid-19th century until the 1930s. Spats were made of cloth, usually in grey, fawn or black; they were ankle-length, buttoned on the outer side, and were strapped under the footwear.

SPATTERDASHES: long leggings of leather, canvas or cloth, worn from the mid-17th century onwards as protection from mud-splashing in riding and walking. Extensively in use in the American Colonies, spatterdashes were buttoned, buckled or laced down the outer side and were sometimes strapped under the footwear.

SPENCER:   describes three different garments:

1. A short, outer coat or jacket without tails worn by men from about 1790–1840. This was generally double-breasted and had collar and revers.

2. A waist-length jacket worn by women from about 1790–1830. Since, for much of this time, the 'waist' level was high, just under the breasts, the jacket was short indeed. It took the same form as the gown bodice so, if serving for outdoor day wear, had long sleeves often with a puff at the top and a high neckline ending in a collar or a ruffle; but if worn for evening attire, the neckline was décolleté and it was sleeveless or had short puff sleeves (see also CANEZOU, HUSSAR JACKET).

3. Between the 1880s and 1920s, a flannel or knitted wool, sleeved or sleeveless garment put on under the jacket or gown for extra warmth. Worn especially by the elderly and infirm.

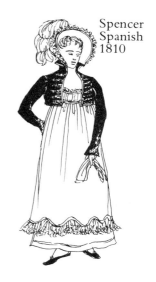

Spencer
Spanish
1810

SPOON BONNET:   a fashion of the 1860s characterised by a brim which rose high in front in a spoon-shaped curve.

SPOON BUSK, (BUSE-EN-POIRE):   a metal busk inserted vertically down the centre front of the corset of the years 1870–90. So-called because of its form which was narrow at the top and widened below the waist into a pear shape.

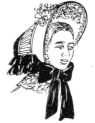

Spoon
bonnet
English
1861

SPORRAN:   a large pouch hung from the belt in front over the kilt in Scottish Highland dress to contain money and personal necessities. In the 17th century the sporran was a plain leather or cloth pouch drawn up by thongs at the top. Metal clasps and mounts were introduced in the 18th century and, in the 19th, large, hairy or furry over-decorated sporrans were often affected. The modern sporran is less ostentatious though many designs have metal mounts and tassel decoration.

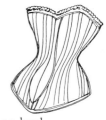

SPUR LEATHER:   decorative leather flaps sometimes, as in the 17th century, of quatrefoil shape, worn over the instep of leather boots to secure the spur to the foot and conceal the metal fittings (see also SOULETTE).

Spoon busk
English
1887

STACKED HEEL:   one built up from thin layers of wood or leather.

STANDING BAND:   a term used in the 16th and 17th centuries to denote an upstanding collar and to

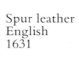

Spur leather
English
1631

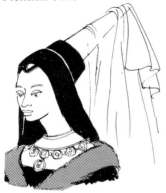

Steeple head–dress
Flemish 1470

differentiate between this and the turned-down collar: the falling band (see BAND).

STARTOP (STARTUP): a peasant's ankle-boot worn over leggings in the 16th and 17th centuries. Adopted in 17th-century New England as a laced-up half boot with wood pegged soles.

STAYBAND: a support for the head of a young baby comprising a headband with bib ends which could be pinned down in front.

STAYHOOK: a small decorative hook pinned or inserted into the front of the bodice or corset from which could be hung a watch or an etui (see ETUI).

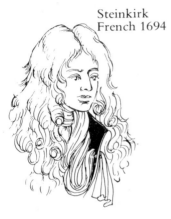

Steinkirk
French 1694

STEEPLE HEAD-DRESS: a ladies' fashion mainly of the years 1450–80, especially favoured in Burgundy, France, the Low Countries and Germany, for a tall, pointed head-dress shaped like a dunce's cap. Probably of oriental or Middle Eastern origin, the cap was made of stiffened velvet, brocade or gold fabric and was worn on top of a fitted coif or skull cap, attached to which was visible on the forehead a black velvet frontlet loop. The hair was pulled back tightly and concealed under the head-dress; any hairs which showed on the temples or at the nape were plucked out. A soft white diaphanous veil was draped over the top of the cap and fell in folds to the ground. Alternatively, a stiffened, wired veil was attached, but this was more usual with the later truncated form of head-dress (see BUTTERFLY HEAD-DRESS).

STEINKIRK (STEENKIRK): a style of long cravat worn especially in the years 1692–1730 where the loosely-twisted ends were tucked into the shirt front or passed through a buttonhole in the coat edge. The name was taken from the battle of Steenkerke in Belgium in 1692.

STEP-INS: in English underwear, a girdle without fastening. In American underwear, bias-cut French knickers of the 1920s and 1930s.

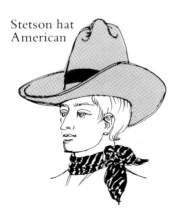

Stetson hat
American

STETSON: the wide-brimmed, high-crowned hat of the American Western cowboy (see also SOMBRERO). It was the Philadelphia hatter John B. Stetson who, visiting the West in the 1860s, designed for himself a hat as protection from the wind and sun. On his return home, he began manu-

facture of this type of hat which he named 'boss of the plains', and which was thenceforth distributed to Western trading posts where its suitability led to its speedy, wide acceptance. Not all cowboy hats are Stetsons but this name is the best-known.

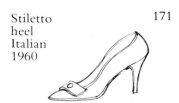

STILETTO BEARD; a narrow, pointed style of the first half of the 17th century.

STILETTO (SPIKE) HEEL: a style introduced from Italy in the 1950s and very fashionable around 1960. A high, slender heel which could be up to 4 inches (100 mm) in height but was only about $\frac{3}{8}$ of an inch (9·5 mm) in diameter at base where it was generally metal-tipped and so highly detrimental to wood-floor surfacing.

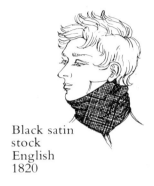

STIRRUP HOSE: long overhose of the 17th century worn on horseback as protection for the costly silk stockings. Serving a similar function to boot hose, stirrup hose were longer; they were laced at the top to the breeches or waist-belt and were strapped under the foot (see BOOT HOSE).

Black satin stock English 1820

STOCK: the style of masculine neckwear which developed from the cravat (see CRAVAT). This took the form of a neckcloth made in a broad band of material—soft or stiffened—wrapped round the neck and fastened with a buckle or tie at the back. The stock became fashionable about 1735 and continued to be so until mid-19th century. It was usually white, though a black solitaire could be worn on top (see SOLITAIRE).

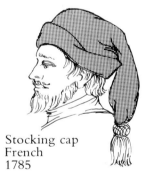

STOCKING CAP: a traditional, working man's head-covering. Usually made of knitted fabric, the cap had a turned-up brim and a long tapering and hanging end generally finished with a tassel or pompon.

Stocking cap French 1785

STOCKING PURSE: a long, knitted purse, similar in shape to a stocking cap and widely used in the 18th century.

STOCKS: the leg part of the 15th and 16th century hose. In the later 16th century this was often divided into two sections, upper and lower stocks, made of different colour and material (see CANIONS, NETHERSTOCKS).

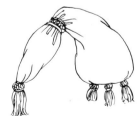

STOMACHER: an ornamental panel made of rich or embroidered material attached to or separ-

Stocking purse English, c. 1810

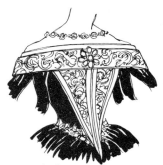

Brocaded stomacher
Italian 1670

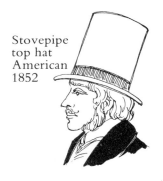

Stovepipe
top hat
American
1852

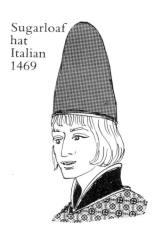

Sugarloaf
hat
Italian
1469

ate from the bodice, inserted into the front of a doublet or gown. Men wore a stiffened, decorative stomacher in a U or V shape inserted into a low-cut doublet in the late 15th and early 16th centuries. The stomacher of rich material, stiffened by inserts of whalebone or metal strips, was characteristic of 16th-century gowns. This was embroidered and jewelled and was of a different material and colour from the remainder of a woman's attire. It was triangular in shape, descending to a point at the waist. The stomacher continued in fashion during the 17th and 18th centuries; from about 1685–1750 it was often decorated up the centre front by a row of graduated ribbon bows (see ÉCHELLE).

STOVEPIPE HAT: a version of the 19th-century top hat worn by men around mid-century. This was very tall and had straight sides; it was also known as a CHIMNEYPOT HAT.

STRAIGHTS: footwear which was symmetrical and could be worn on either foot.

STRASS: see PASTE.

SUGARLOAF HAT: a recurring fashion notably in the 15th and 17th centuries for a tall hat made in the shape of loaf sugar.

SUMPTUARY LAWS: legislation enacted to regulate personal expenditure and to curb excess. Many such laws have been passed since about 1300 in Britain, Europe and, later, in the New World to restrict the wearing and importation of certain articles of dress or materials from which they might be made. Broadly, there were two principal reasons for such legislation. One was to restrict the importation of foreign goods and materials in order to protect the home product. The other was to create and maintain a social structure of which dress was a notable visual expression.

There have been, and still are, many examples of sumptuary legislation for the first of these reasons. Edward III's Act of 1337 and Charles II's of 1666 were two English instances in that these Acts sought to restrict the importation of foreign cloth in order to protect the home woollen trade. In the Middle Ages both England and France restricted the quantity of costly Russian furs coming into their countries in order to protect the home industries which traded in hides and furs. France has traditionally been the country which has been

quick to pass sumptuary laws forbidding the importation of foreign materials in order to protect her own trade, in particular against silks and lace from Italy, whose industries, being established earlier, threatened the French product. Jean Baptiste Colbert's legislation of the 1660s is an instance.

Sumptuary legislation of the second type has been more widespread and varied. This has stemmed from the natural human instincts to ape one's betters, to improve one's status and to dress to prove it—also to dominate others by dictating what might or might not be worn. The system of class status was a strong and well-defined one in the Middle Ages in Europe and sumptuary laws were passed one after the other at frequent intervals to attempt to preserve the privileges and status of royalty and the aristocracy. This legislation enumerated in great detail which fabrics, furs, ornamentation and colours were permitted to be used and worn by various sections of the population and, of these, fur was the subject of a great many laws. Fur was an important material at this time because living conditions, especially in northern Europe, were inhospitable and draughty. People wore clothes lined and trimmed with fur to keep warm in buildings where window glass was rare and costly and heating was by large but inadequate open fires. For instance, in England and France, only royalty and the wealthy aristocracy were permitted to wear such furs as marten (including sable), vair and ermine; and in a descending scale of social eminence came otter, fox, beaver, lamb, goat and wolf.

An early instance of sumptuary legislation in Europe was by the City State of Venice which, in the early 14th century, was the leader of European fashion. It became necessary, in order to protect the city's economy, to limit the natural instinct of its people to express their wealth and status in luxury apparel. A much later instance was the attempt by the Puritans in northern Europe to regulate the attire of their followers by stripping it of all ornamentation to present a sober, plain appearance in garments made from modest fabrics in subdued colours. In Europe this was mainly attempted by persuasion rather than legislation but in New England many laws were passed during the 17th century to restrict the natural exuberance and vanity of the population although Puritan. It should be said that in few cases indeed were sumptuary laws forbidding the wearing of certain materials and garments by specific classes and members of the community ever successful in their aim.

Supportasse 1585

Supportasse or under-propper 1610

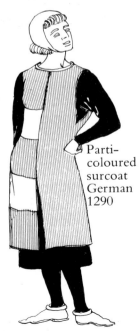

Parti-coloured surcoat German 1290

SUNBURST PLEATING: a modern type of machine pleating, used especially in skirts, where pleats radiate from being narrow at the waist to become wider at the hem.

SUPERTOTUS: also known as a balandrana (see BALANDRANA).

SUPPORTASSE: a back support for the large ruff fashionable in the later 16th century (see RUFF). Also known as an UNDERPROPPER, this could consist of a wire framework, whipped with thread, which was fixed at the back of the neck, or of wire-edged paste-board generally covered with white material.

SURCOAT (SURCOTE): an overtunic or gown worn by both sexes during the Middle Ages. Introduced in the late 12th century as a tabard (see TABARD). By about 1220 this had become a loose, sleeveless garment with large armholes. Men wore it threequarter-length over their bliaud or cote; the feminine version generally reached the ground. Later in the 13th century the surcoat was made with sleeves which were often full and long, of hanging style (see HANGING SLEEVE). A hip-belt was usual with the 14th-century surcoat (see also GARDE-CORPS, SIDELESS SURCOAT).

SURPIED: French term for spur leather (see SPUR LEATHER).

SURTOUT: a French term for an outer coat which, in the 18th century, was long and loose. It generally had shoulder capes and was worn especially for riding in bad weather. By the 19th century it had become more formal and was styled like a frock coat (see FROCK COAT).

SUSPENDERS: sock suspenders were introduced for men in the late 19th century. These consisted of a band of woven elastic worn round the calf supporting a suspender to attach to the sock. Some years earlier, in 1878, elastic suspenders had been affixed to straps or a belt worn over a lady's corset to hold up her stockings. By 1901 these were attached to the corset itself so that this not only did away with the constriction of garters but held the long corset down in position. In the USA such suspenders attached to a corset or girdle are known as DETACHABLE GARTERS; the word 'suspenders' is used to denote braces.

SWADDLING: from very early times until well into the 18th century babies were swaddled, that is, they were bound up by bandaging until they resembled a neat, convenient parcel. As soon as the infant was born a swathe or bandage of about 6 inches (15 cm) in width and some 10 to 12 feet (3 to 3·5 metres) in length was bound tightly round its body over a chemise, beginning at the armpits and moving downwards towards the feet. The baby remained in swaddling bands, looking like an Egyptian mummy, until it was weaned, though, at about four months, the arms were freed. In the Middle Ages the bands were put on in a criss-cross manner. Later, in the 17th century, they were generally wrapped horizontally round the body.

Swaddling was normal custom for all classes of society; indeed, the practice was world wide. Its purpose was to protect the baby from harm and to make it easy to carry. It was also sincerely believed that tight bandaging would encourage the limbs to grow straight and strong. Not until the 18th century did the upper classes limit the swaddling period to about six weeks after birth when the baby was unbound and dressed in long clothes.

SWEATER: American term now widely used in English to describe a knitted blouse, top or jacket (see GUERNSEY). It derives from a heavy woollen jersey or knitted shirt adopted in the 1890s by American sportsmen and worn to make them sweat. The term SWEAT SHIRT was later used for this.

SWEEPERS: from the 1870s until about 1910, pleated or frilled ruffles sewn to the underside of the gown and petticoat hems of the ladies' long skirts to protect them from the dust and dirt of the floor and street; they were also known as DUST RUFFLES. The French term, widely used in Europe and America, was BALAYEUSE.

SWITCH: see HAIR-PIECE.

# T

TABARD: a simple outer garment worn from the early Middle Ages when it was sleeveless and

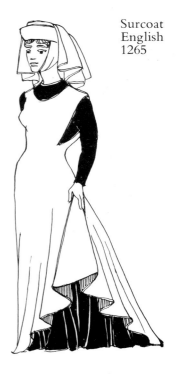

Surcoat
English
1265

Swaddled baby
English *c.* 1600

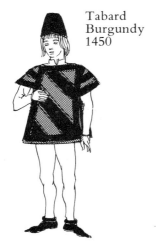

Tabard
Burgundy
1450

hung in a rectangular panel back and front over the tunic or bliaud. In civil dress this evolved in the 13th century into the surcoat (see SURCOAT), but continued in use, in a short-sleeved version, worn by knights over their armour. These tabards were emblazoned with their owner's armorial bearings. The garment has been retained, slightly altered, through the ages as the official dress of the herald or pursuivant when it is emblazoned with the arms of the sovereign. It has been revived as an overgarment in the fashions of the 1970s.

TABARRO: Italian word for tabard, but its more general meaning in contemporary language is a loose cloak. A richly ornamented tabarro, made of costly fabric, was a characteristic part of the 18th-century Venetian carnival and masquerade dress as can be seen vividly depicted in the paintings of Pietro Longhi.

Tablier
English
1872

TABLIER: French word for apron. The term is used especially in costume to describe the tablier gown or skirt which is designed with a front resembling a decorative apron. This was particularly fashionable in the years of the late 1860s and the 1870s when the complex overskirts were often open in front and draped back at each side leaving an ornamental apron motif in the centre front.

TACHE: a mechanism for fastening together two parts of a clasp, buckle, hook and eye etc. From the old French *tache*, 'a nail or fibula'.

TAGLIONI: a 19th-century overcoat named after Filippo Taglioni, Italian maître de ballet. Worn chiefly between 1840 and 1860, this style was knee-length and generally trimmed with braid.

TAIL COAT: the masculine tail coat was essentially a 19th-century design but it evolved from the slim-fitting coats worn in the later 1780s. These at first were cut away in a rounded line in front to narrow, knee-length tails at the back but, by 1790, the traditional tail coat had appeared. It was worn open and cut away straight across at waist level or above in front and descended to tails at the rear. Since 1790 details of this design have changed according to the modes of the day—collar and rever styles, length of tails and level of the horizontal cut across in front but, fundamentally, this same type of coat has survived in the evening dress 'tails' of our own times.

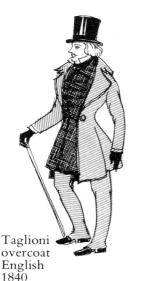

Taglioni
overcoat
English
1840

During the 19th century there were three basic types of tail coat: the **swallow-tail** or **claw-hammer** design just described, the frock coat (see FROCK COAT), and the single-breasted style with rounded tails cut away in a sloping line from the front. At first known as the Newmarket Coat, this developed into the cutaway and, finally, the morning coat (see CUTAWAY COAT, MORNING COAT, NEWMARKET COAT). During the 19th century the swallow-tail design, often merely referred to as a tail coat, was worn as a day coat in town until about 1860, after which it was gradually replaced by the other two styles and, finally, the lounge jacket. It was double-breasted and worn open; its style varied according to the fashion line of the period. Made in varied colours and materials until the 1840s, after which it was usually of dark-coloured cloth. Adopted as an evening tail coat in black in the early years of Queen Victoria's reign, it has continued with only minor changes since, though today it is worn only for very formal occasions.

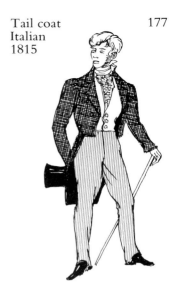

TAM-O'-SHANTER: a round cap of knitted wool worn at a jaunty angle and finished with a wool or feather bobble. Named after the poem by Robert Burns, the tam-o'-shanter was a popular form of head-covering for both sexes during the 19th century and has several times been revived as a feminine fashion in the 20th.

Tam o'shanter
English
1925

TANK TOP: an informal top worn in the 1960s and 1970s, chiefly by the young; often of brightly-coloured cotton, usually sleeveless with large armholes and with a low, scooped neckline. The name derives from the early 20th-century American men's tank suits.

Tank top
modern

TASSET (TASSETTE): a term for the doublet basques of the years 1620–35 (see BASQUE).

TEA GOWN: a fashion of the later 19th century which stemmed from the custom of ladies being entertained to tea in their hostess' boudoir. At first they wore dressing-gowns but these gradually became more feminine and elegant and were designed especially for the purpose so the name 'tea gown' was adopted. It permitted the ladies some relief from the boning of their everyday gowns which had rigid, waisted bodices, for the tea gown was un-boned. It was made of soft, sheer fabrics—silk, satin, lace, chiffon—and was generally styled, in the 1880s, in a high-waisted full design

Tassets
Charles I
1631

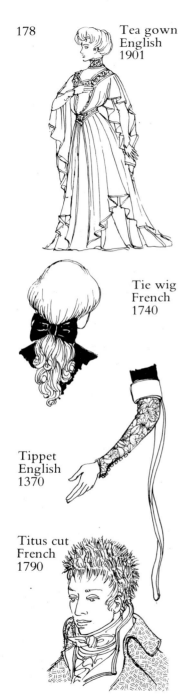

Tea gown
English
1901

Tie wig
French
1740

Tippet
English
1370

Titus cut
French
1790

with long sleeves. By the turn of the century the Edwardian tea gown had become a drawing-room garment, an elaborate creation of chiffon and lace, pleated, ruffled, with trailing draperies at sleeve and skirt, which followed the fashions of the day.

THÉRÈSE:   see CALASH.

TICKET POCKET:   first inserted into a gentleman's overcoat to hold a railway ticket (1859); since the 1890s placed in a lounge jacket just above the right-hand hip-pocket.

TIE AND DYE:   one of the oldest and simplest processes of making a coloured design on textiles and one practised by many primitive peoples. Parts of the fabric are tied up, knotted, stitched up or plaited before dyeing so that the dye cannot penetrate these areas, so producing a pattern when the fabric has been released.

TIE (TYE) WIG:   a style of wig fashionable in the first half of the 18th century where the curls were tied back at the nape by a ribbon bow and allowed to hang loose down the back.

TIPPET:   the pendant streamers which, in the Middle Ages, hung from the elbow-length sleeves of the tunic or gown. The word could also be applied to the liripipe (see LIRIPIPE).
 The word 'tippet' was also used for a ladies' shoulder cape, generally of fur, worn from the 17th century onwards. (See PALATINE.)

TITUS CUT:   in the years 1790–1810 under the influence of the French Revolution, classical hairstyles were fashionable for both sexes. The Roman style of short, carefully dishevelled coiffure was used both for wigs and natural hair. It went under the name of TITUS, and also BRUTUS.

TOG:   a noun used from the 16th century onwards in the singular and plural (TOGS) as a colloquial term for clothes in general or, specifically, a coat or outer garment. Widely used in the 19th century when the past participle of the verb to tog (TOGGED) indicated that the wearer was clothed, hatted or booted.

TOILET:   a wrapper or piece of material placed round the shoulders while the hair was being dressed.

TOP BOOT: a style worn from the 1780s of a soft, black leather boot reaching to just below the knee and turned down with a deep cuff which displayed the lighter, brown lining.

TOP HAT: colloquially known as a 'topper', the top hat was the chief style of head-covering for men during the 19th century. A high-crowned hat, it varied a little in shape over the years from the tall, straight-sided 'stovepipe' or 'chimneypot' (see STOVEPIPE HAT) of the mid-century to a lower, curved-sided version which was later fashionable. The small brim was often rolled at the sides, though a flat brim was more usual in the 1840s and 1850s. In the early decades of the century the hat was known as a BEAVER because it was generally made of beaver in grey, fawn, brown or white. By the 1840s it was of polished beaver with a silk finish and the most usual colour for the rest of the century was black, though grey could be worn in the day-time. After 1860 the top hat was retained more and more for formal wear as the bowler, the boater, the homburg and other styles were introduced (see BOATER, BOWLER, HOMBURG, TRILBY).

TORC (TORQUE): a twisted metal (usually precious) necklace or bracelet characteristic of the workmanship of early Gaul and Britain.

TOUPEE (TOUPET): in the 18th century the part of a wig brushed back from the forehead. Before about 1730 the wig had been dressed with curls or waves on either side of a central parting. In modern times, it is a switch or pad of false hair to cover a bald patch.

TOURNURE: see BUSTLE.

TRANSFORMATION: see HAIR-PIECE.

TRENCH COAT: a classic style of rainproof coat worn by both sexes, though most usually by men, which has a collar and revers and is belted. Based on that worn by officers in the trench warfare of the First World War when it had buttoned epaulets.

TREWS: fitted long trousers worn in Scotland and Ireland (TRUIS) since the 16th century. Trews continued to be worn, becoming an alternative to the kilt from the 18th century, accompanied by a shoulder plaid (see KILT, PLAID).

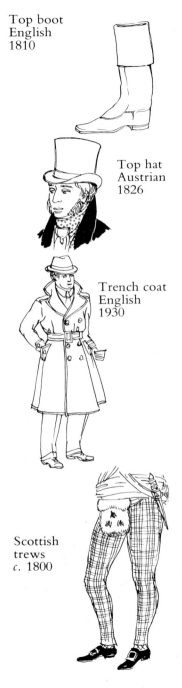

Top boot
English
1810

Top hat
Austrian
1826

Trench coat
English
1930

Scottish
trews
c. 1800

Tricorne
Italian
1740

Trilby
English
1900

Trunk
hose
Portuguese
1573

Tunic dress
English
1808

**TRICORNE:** the three-cornered hat with round crown and turned-up brim worn by men for much of the 18th century; it was also known as a cocked hat (see COCK). The tricorne was usually black and edged with gold braid or white ostrich tips (see also KEVENHÜLLER HAT).

**TRILBY:** a soft felt hat in homburg style worn in England for much of the 20th century, named in 1895 from a dramatised version of George du Maurier's novel *Trilby* (see HOMBURG HAT).

**TROUSSES (TRUSSES):** close-fitting breeches or hose worn in the 17th century to cover the buttocks and upper thigh.

**TRUNK HOSE:** the usual masculine covering in the years *c.* 1540–50 to *c.* 1610–15 from the waist to the upper thigh. Trunk hose could be loose or padded and varied in length from the most abbreviated possible to about mid-thigh. They were fitted with a waistband and thighbands, the full material blousing out between; they were generally covered by panes (see PANES).

**T-SHIRT (TEE-SHIRT):** a popular abbreviation for the modern T-shaped sports shirt of machine-knitted white or coloured cotton. Originally made with short sleeves cut in one with the garment and a round or V collarless neckline.

**TUCKER:** from the 17th to 19th centuries a yoke of embroidered fabric or lace, often frilled, inserted as a fill-in to a low-necked bodice.

**TUDOR BONNET:** see MILAN BONNET.

**TUNIC DRESS:** overdresses or tunic dresses have recurred from time to time in ladies' fashions. Threequarter-length tunic dresses were popular in the years 1790–1815 because the thin fabrics and limited number of garments worn at the time proved most unsuitable in the climate of northern Europe and in the colder parts of North America. The gowns were usually made of white or light-coloured thin fabrics and the tunic dress provided a contrast both in colour—which was often bright and strong—and in fabric—which was heavier, probably satin, velvet or thin wool. Tunic dresses were also to be seen for a short time in the volatile modes of the years 1910–1916, when there was a considerable variety in two- and three-tiered skirts.

TURBAN: a head-covering of Moslem origin, the name derived from the Persian *dulbānd*, which became 'tulband' and then 'turban'. It was introduced to fashionable European dress in the 15th century when it was adopted first in Venice and Austria, then spread westwards to the rest of Italy, Switzerland, France, Flanders and, finally, England. Padded or softly loose it was accompanied by a veil and, often, by a liripipe also (see LIRIPIPE). The turban has returned to fashion on more than one occasion since the early 16th century, notably from 1790–1815 and again in the 1920s.

Turban
Flemish
*c.* 1480

TURTLE NECKLINE: a knitted sweater or jersey neckline finished in a wide collar rolled down like a tube and fastened down all round.

Turtle
neckline
modern

TUXEDO: American term for a man's evening dress dinner jacket, so-called because it was first introduced in the millionaire district of Tuxedo Park, New York, for small dinner parties.

TWIN SET: an English fashion of the 1930s and 1940s for a matching set of jersey and cardigan.

TYROLEAN HAT: a 1930s ladies' fashion based on the coloured felt hats of the Austrian Tyrol, which were worn with brim turned up at one side and with feather and cord trimming.

Tyrolean
hat
English
1936

# U

Ulster
German
1882

UGLY: colloquial term for a shade attached as an extra brim to the front of a bonnet in the middle years of the 19th century in order to give protection from sunlight. The shade consisted of silk-covered, hooped canes which, like a calash, could be folded back when not needed (see CALASH).

ULSTER: a long, loose, bad-weather overcoat generally with half or whole belt and a shoulder cape, worn by both sexes from the 1870s onwards. The Ulster overcoat, later abbreviated to Ulster, was introduced in Belfast in 1867 when it was made of Irish frieze.

182

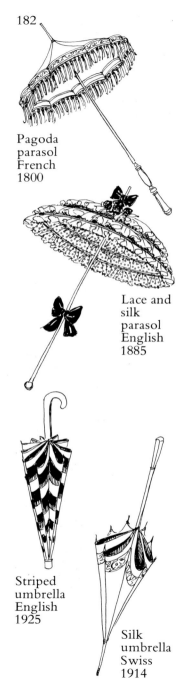

Pagoda
parasol
French
1800

Lace and
silk
parasol
English
1885

Striped
umbrella
English
1925

Silk
umbrella
Swiss
1914

UMBRELLA: in varied design, large and small, the umbrella has been used as protection from rain and sun since antiquity. The name derives from the Latin *umbraculum*, 'a shady place', and umbrellas were used chiefly as a shield from the sun in ancient Rome.

In more recent times the use of the umbrella was revived in Italy in the late 16th century when it was usually made of leather. Soon lighter fabrics replaced this and the umbrella was adopted by both sexes for protection from sun or rain; its use spread to the rest of Europe and, later, North America. By the 18th century the umbrella had become an article of fashion for women; its use by men was considered to be effeminate. Two types of design now evolved. The French term PARASOL was adopted for the sunshade (see also QUITASOL), which was dainty and elegant, generally rigidly constructed and shaped as a dome or the top of a pagoda. The umbrella, made in stronger material for protection from the rain, was larger and plainer and could be opened and closed. In France it was a *parapluie*, in England it continued to be called an umbrella after the Italian *umbrello* which had derived from the Latin *umbraculum*.

Throughout the 19th century the parasol was an important item of feminine fashion. Pagoda shapes were usual in the earlier years; later designs were varied and often were very small. The tilting parasol with hinged stick was popular from 1795 (see also EN TOUT CAS, MARQUISE). The umbrella continued in use. From the 1880s the slender, long-handled design was tightly rolled and used as a 'walking model'. The colloquial term GAMP originated in the 1840s from Charles Dickens' character Mrs Gamp. By the mid-19th century it was deemed suitable for men to carry umbrellas. These were long-handled and large and were tightly rolled.

UNDERPINNINGS: late 19th-century euphemism for corsetry.

UNDERPROPPER: see SUPPORTASSE.

UNION SUIT: American term for combinations (see COMBINATIONS).

UNISEX: clothes of the 1960s and 1970s which are designed so that almost identical garments can be worn by the young of both sexes.

**UNMENTIONABLES, UNWHISPER-ABLES:** 19th-century euphemisms for a man's trousers or breeches.

**UPLIFT BRA:** a brassière designed to delineate, hold and raise the breasts. A style which began just before 1930 but which attained its apogee in the characteristic 'sweater girl' image of the 1950s. A circular stitching of the cups was used to create and support the high, pointed breast line.

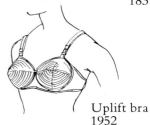

Uplift bra
1952

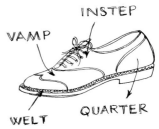

**VALONA:** a plain, white collar of starched material favoured by Philip IV of Spain and fashionable in that country between 1620 and 1650. It was supported on a golilla (see GOLILLA).

Valona
Philip IV of Spain 1625

**VAMP:** the front portion of the upper of a shoe or boot. The back portion is the QUARTER and the part on top of the foot where, in a laced shoe, the lace holes are set, is the INSTEP.

**VAMPAY (VAMP):** an American term for an ankle-length woollen, often knitted, stocking or hose worn on top of a full-length stocking, especially in Colonial America.

**VANDYKE:** Anglicised spelling of the name of the Flemish painter Sir Anthony Van Dyck and applied, in later ages, to a number of garments and decorative features of the period shown in his paintings. Most often mentioned are **Vandyke beard**, meaning the small, pointed style fashionable in the time of Charles I, or **Vandyke collar**, referring to the contemporaneous lace or lace-edged falling band (see FALLING BAND). The term was also used to denote the scalloped border of the collar.

**VELDTSCHOEN:** a veldtshoe was of South-African origin, made of rawhide and so that the edges of the upper were turned outwards to make a flange which was then stitched to the sole. A modern veldtshoe may be welted, in which case the lining is welted to the insole and the flanged upper is stitched to welt and sole.

Vandyke beard
Charles I of
England
1631

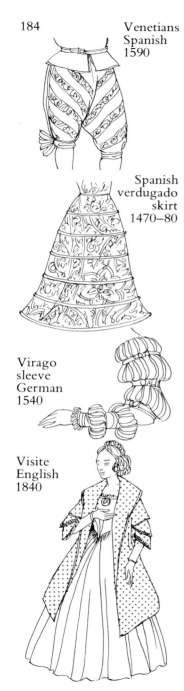

Venetians
Spanish
1590

Spanish
verdugado
skirt
1470–80

Virago
sleeve
German
1540

Visite
English
1840

**VENETIANS:** full, padded knee-breeches fashionable for men between about 1570 and 1620. Sometimes called VENETIAN SLOPS (see SLOPS), the garment was fastened just below the knee with a garter or fringed sash. Venetians were full at the hips and diminished towards the knee.

**VERTUGADO:** the Spanish framework skirt of rich, heavy fabric into which circular hoops of pliant wood (*verdugos*) were inserted horizontally at intervals (see ARO). The vertugado was introduced in Castile about 1470 and the fashion spread during the 16th century all over Europe (see FARTHINGALE).

**VEST (VESTE):** forerunner of the waistcoat, the vest(e) was worn under the 17th-century justaucorps; it was a little shorter and had long, fitting sleeves. Sometimes it was worn indoors without the justaucorps on top. During the first half of the 18th century the vest continued to be similar in style to the coat (now the *habit à la française*) but about 6 inches (15 cm) shorter. It was made of a rich brocaded or embroidered material. After this the vest developed into a sleeveless waistcoat.

Since the mid-19th century the term 'vest' has been used in England to denote an undervest. In the USA it has been retained to mean waistcoat and the undervest is usually referred to as an undershirt.

**VEST SUIT:** an American term to describe a ladies' outfit consisting of a waistcoat and skirt (worn with blouse or jersey) or waistcoat and trousers.

**VIRAGO SLEEVE:** a full, padded and slashed style of the years 1530–1640 which was banded at intervals down the arm, leaving the material to puff out between the tight bands.

**VISITE:** a general term for a ladies' cape or mantle worn between about 1840 and 1890. Sometimes the garment was sleeveless and only covered the shoulders and back; alternative styles had part sleeves and long hanging ends as in a pèlerine (see PÈLERINE).

**VLIEGER:** the Dutch version of the 16th-century *ropa* which was generally worn open; it had a shoulder roll or puff sleeves.

# W

**WAGON BONNET:** a style worn by some American Quakers in the late 18th and early 19th centuries, particularly in Philadelphia. The wagon bonnet, so-called because it was said to resemble the top of the Jersey covered wagon, was generally made of black silk. The top was gathered and the ends reinforced to maintain the shape. A cape of the same material was attached, which was formed in three points, one to cover each shoulder and one to fall down the back.

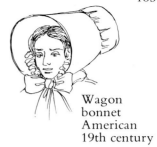

Wagon bonnet American 19th century

**WASPIE:** see GUÊPIÈRE.

**WATTEAU PLEATS:** a name often given to the deep box pleats which were set to fall from the back of the neckline of the gowns of the mid-18th century (see ROBE à la française). The term appears to be a misnomer because the gown styles worn by the ladies depicted by the painter Watteau were not of this type and were mainly fashions from the early years of the century.

**WEDGE SOLE:** a design in which a wedge-shaped piece of cork, wood or plastic is inserted under the arch of a shoe in order to make heel and sole in one solid piece and flat on the ground. Especially modish in the 1940s.

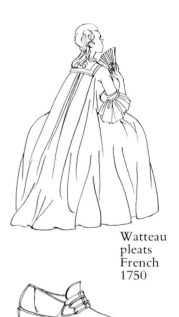

Watteau pleats French 1750

**WELLINGTON BOOT:** a style in leather named after the Duke, introduced in the early 19th century, which was knee-high and generally cut straight across the top. A shorter version was also worn under the trousers during much of the 19th century. The waterproof rubberised version in half- or full-length came into common use after 1900.

Wedge sole English 1945

**WHISK:** a starched and /or wired collar, often of lace or lace-edged, fashionable for both sexes in the late 16th and early 17th centuries, which framed the back of the head but also extended round to the throat. A larger, more decorative version of Philip IV's flat valona (see VALONA).

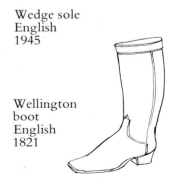

Wellington boot English 1821

**WIDE-AWAKE HAT:** a style with a round, low crown and a broad brim, generally made of soft felt

Widow's peak French 1572

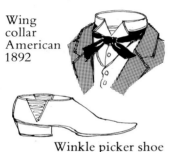

Wimple and veil German 1310

Wing collar American 1892

Winkle picker shoe English 1955

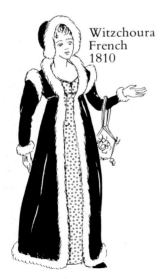

Witzchoura French 1810

or beaver, worn especially in the late 18th century and during the 19th. It was suggested then that the early designs were so-called because the material had no nap.

WIDOW'S PEAK: a widow's mourning head-dress with a peak dipping over the forehead. Originally this was a flap projecting forwards from a hood or head-dress but later it was indicated merely by a dip in the centre front (see ATTIFET). In the 18th and 19th centuries the peak became a triangle of material placed on the forehead under a veil.

WIDOW'S WEEDS: the word 'weed' was used from the 9th century to denote any raiment or garment but from the 16th century on it referred more specifically to the mourning attire of a widow.

WIMPLE (GUIMPLE, GWIMPLE): a medieval covering for women consisting of a piece of material which was fastened to the hair on the crown or at the sides of the head above the ears and which was then draped to conceal the neck and throat. The lower edge was often tucked into the gown neckline. The wimple, which was usually made of white linen, was generally accompanied by a veil or couvrechef (see COUVRECHEF, GORGET). It was worn until the late 14th century and survives in nuns' dress.

WINDBREAKER, WINDCHEATER: American and British terms in general use in the 1930s for a jacket made of heavy or impermeable material, often lined, worn outdoors to resist the wind. In modern dress this has been largely replaced by the quilted anorak made of synthetic materials.

WING COLLAR: a stiffened shirt or blouse standing collar with pointed turned-down corners fashionable especially in the 1890s and early years of the 20th century. Worn with men's formal evening dress since that time.

WINKLE PICKER: a term given to a style of shoe, particularly those worn by men, fashionable in the 1950s, which had excessively pointed toes.

WITZCHOURA (WITCHOURA): a term derived from the Polish wolfskin coat called the wilczura which became fashionable in the west about 1808 as a long, warm coat to wear over the thin dresses of the time and continued so until the 1830s. Styled as an overcoat or as a mantle, the witzchoura

was fur-trimmed and fur-lined. It was nearly ground-length and had a collar and, often, a shoulder cape as well; some designs were hooded.

WRAPAROUND SKIRT: a 20th-century leisure and beach style where the material is wrapped round the body and fastened at the waist with a good overlap but generally left open for much or all of its length.

WRAPPER: in women's dress, an informal house or negligée gown worn from the 18th century onwards. In men's attire, an overcoat of the mid-19th century which was short and wrapped round the body, then buttoned or held in place by the hand. Designs varied but most had deep shawl collars.

WRAPRASCAL: a long, loose, heavy overcoat of the 18th and early 19th centuries similar to the surtout (see SURTOUT).

# Y

YOKE: a fitted portion of a garment, usually on the shoulders or the hips, which supports the fabric of the remainder of the dress, coat, skirt, which is often much fuller and is gathered, pleated or shaped into it. The yoke is often of double thickness and sometimes of a different material and decoration from the rest of the garment.

# Z

ZAMARRA: see CHAMARRE.

ZIMARRA: an Italian Renaissance robe similar to the chamarre (see CHAMARRE). Also used for a cassock worn by Roman Catholic priests.

ZOCCOLO: Italian word for a clog or wooden shoe. The term was applied in particular to the

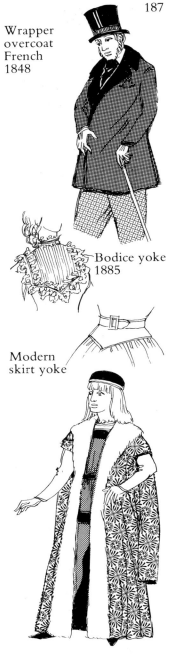

Wrapper overcoat French 1848

Bodice yoke 1885

Modern skirt yoke

Zimarra 1495

188

Venetian
zoccolo
16th century

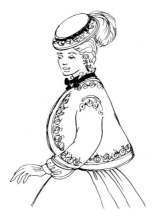

Zouave jacket
English 1865

exceptionally high chopines with wooden supports worn in 16th-century Venice (see CHOPINE).

ZOUAVE JACKET: a feminine fashion of the 1860s of a collar-less, bolero style with rounded corners named after the uniform jacket of the Zouave regiment in Algeria.

# Acknowledgments

The drawings which I have made for this book have been derived from original material in museums and galleries in Britain, Europe and America. My on-the-spot research in these countries in the form of notes and sketches has been carried out over a period of thirty years. It is not possible in the space available in this book to acknowledge the source of each drawing *in situ* but I should like to express my deep gratitude for the generous and ready help which I have received everywhere from the directors and staff of these institutions, the chief of which are listed here:

The Victoria and Albert Museum and Library, the British Museum, the Museum of London, the National Gallery and the National Portrait Gallery, all in London; the Central Museum (Shoe Museum), Northampton; the Lace Museum, Nottingham; the Gallery of English Costume, Manchester; the Museum of Costume, Bath; the Welsh Folk Museum, Cardiff; the Royal Scottish Museum, the National Museum of Antiquities, the Scottish National Gallery and the Scottish National Portrait Gallery, all in Edinburgh; Musée du Costume de la Ville de Paris and the Centre d'Enseignement et de Documentation du Costume, both in Paris; Kostuummuseum, the Hague, Netherlands; Openluchtmuseum, Arnhem; Centraal Museum, Utrecht; Bayerische Nationalmuseum, Munich; Historisches Museum, Frankfurt-am-Main; Rocamora Museum, Barcelona; Museo del Pueblo Español, Madrid; Nordiska Museet, Stockholm; National Museum, Copenhagen; Rosenborg Palace, Copenhagen; Musées Royaux d'Art et d'Histoire, Brussels; Musée Royal des Beaux Arts, Antwerp; the Musée du Louvre, Paris; the Museo del Prado, Madrid; the Rijksmuseum, Amsterdam; the Historisches Museum, Basle; the Metropolitan Museum of Art in New York and the Boston Museum of Fine Arts, both in the USA. *Doreen Yarwood*

# SOURCES OF INFORMATION

## Selected Museum and Gallery List
## ——North America, Britain and Western Europe

There are many museums housing and displaying costumes, textiles and accessories which date from about AD 1600 onwards, though the bulk of such collections are from the 18th, 19th and 20th centuries. Articles made from leather, such as footwear and bags, can be seen from earlier periods than this. For information regarding the dress worn between AD 1000 and the 17th century, the student will need to consult a variety of sources, many of which may be found in the great galleries of painting and sculpture and the principal museums and churches in the towns and cities. Detailed and helpful knowledge can be gained from a study of paintings, drawings and engravings, sculpture and relief carvings, stained glass, mosaics, illuminated manuscripts, embroidered textiles, effigies, brasses and jewellery of the appropriate date.

A selection of the more important sources for all this material is listed here.

## AUSTRIA
VIENNA      Paintings and drawings from the Middle Ages onwards in the *Kunsthistorisches Museum*, galleries of the *Upper and Lower Belvedere* and the *Historisches Museum der Stadt Wien*.
Costume collection at the *Hetzendorf Schloss*—mainly 19th century.

## BELGIUM
ANTWERP      Paintings and sculpture in the *Musée Royal des Beaux Arts*.
BRUGES      Paintings and sculpture in the *Musée Groenige*.
BRUSSELS      Paintings and sculpture in the *Musées Royaux des Beaux Arts*.

## DENMARK
COPENHAGEN      Chief costume collections in the *Nationalmuseet*. General collection 1690 onwards but also costumes from 14th-century Greenland and the remarkable Bronze Age peat-bog finds.
Danish royal family costume collection in the *Rosenborg Palace* (1600–1940).

## FRANCE
BAYEUX      In the town museum (*Musée Tapisserie de la Reine Mathilde*) is displayed the famous Bayeux tapestry illustrating the clothes worn at the time of the Norman Conquest.

| | |
|---|---|
| PARIS | *Musée du Louvre*—paintings, sculpture, jewellery.<br>Paintings and tapestries at the *Musée de Cluny* and the *Musée des Arts Decoratifs*.<br>Paintings of 19th-century dress in the *Petit Palais*.<br>Costume collections and reference library and study centre at, respectively, the *Musée du Costume de la Ville de Paris* and the *Centre d'Enseignement et de Documentation du Costume*. |
| VERSAILLES | *Musée National du Château de Versailles*—paintings and tapestries. |

## GERMANY

| | |
|---|---|
| FRANKFURT-<br>AM-MAIN | *Historisches Museum*—large collection of costumes 1750 onwards. |
| MUNICH | Paintings in the *Alte Pinakothek*.<br>Costumes, paintings, sculpture and carving in the *Bayerisches Nationalmuseum*. |

## GREAT BRITAIN

| | |
|---|---|
| BATH | *Museum of Costume*, Assembly Rooms—remarkable costume collection 1610 onwards. *Costume and Fashion Research Centre* at No. 4, The Circus: for reference and study. |
| CARDIFF | Welsh costume at *National Museum of Wales, Welsh Folk Museum, St Fagan's*. |
| EDINBURGH | *Royal Scottish Museum*—European costumes 17th to 20th century, also textiles.<br>*National Museum of Antiquities*—mainly Scottish dress, accessories and jewellery from very early times.<br>*National Gallery of Scotland* and *National Portrait Gallery of Scotland*—paintings and portraits, especially Scottish Highland dress. |
| LONDON | The *Victoria and Albert Museum*—a very large costume collection. Display in Costume Court from 1580 onwards, also fashion dolls and fashion plates. Portrait miniatures, textiles, stained glass, sculpture and carvings. The library. Children's section at the *Bethnal Green Museum of Childhood*.<br>The *British Museum*—jewellery, illuminated manuscripts. The British Library.<br>The *Museum of London*—costume and accessories collection from 1575.<br>*National Gallery* and *National Portrait Gallery*—paintings. |
| MANCHESTER | *Gallery of English Costume* at Platt Hall. Good costume collection especially 18th century onwards. |
| NORTHAMPTON | *Central Museum and Art Gallery*—specialist museum of footwear. Fine collection from Roman times onwards. |

## HOLLAND

| | |
|---|---|
| AMSTERDAM | *Rijksmuseum*—paintings, tapestries, carved wood sculpture. Costume collection 18th century onwards. |

| | |
|---|---|
| THE HAGUE | *Kostuummuseum*—comprehensive, large collection of costumes and accessories, mainly 18th century onwards.<br>The *Mauritshuis*—paintings and portraits. |
| UTRECHT | *Centraal Museum*—costume collection 1760 onwards. |

## ITALY
| | |
|---|---|
| FLORENCE | *Uffizi Gallery* —paintings and sculpture from the Middle Ages onwards. |
| MILAN | *Pinacoteca di Brera.* |
| NAPLES | *Musei e Gallerie Nazionali di Capodimonte.* |
| ROME | *Musei e Gallerie di Pittura di Vaticano.* |
| VENICE | *Galleria dell'Accademia* and *Ca' Rezzonico.* |

## NORTH AMERICA
| | |
|---|---|
| BOSTON | *Museum of Fine Arts*—good costume collection and paintings. |
| LOS ANGELES | *County Museum*—costume collection. |
| NEW YORK | *Metropolitan Museum of Art*—fine collection of costumes and paintings. Includes *Costume Institute* and *Museum Collection of the Traphagen School of Fashion.*<br>*Brooklyn Museum*—costume collection. |
| TORONTO<br>(Canada) | *Royal Ontario Museum*—costume collection. |
| WASHINGTON | *National Museum of History and Technology.*<br>*Smithsonian Institution*—costume collection. |

## SPAIN
| | |
|---|---|
| BARCELONA | *Museo de Indumentaria*—excellent Rocamora collection of costumes from 17th century onwards.<br>*Museo de Arte de Cataluña*—paintings. |
| MADRID | *Museo de Pueblo Español*—costume collection.<br>*Museo del Prado*—paintings.<br>*Museo Arqueologico Nacional*—sculpture, mosaics, paintings—Medieval and Renaissance. |

## SWEDEN
| | |
|---|---|
| GÖTEBORG | (Gothenburg) *Historiska Museet*—large costume collection 18th century onwards. |
| STOCKHOLM | *Nordiska Museet*—large costume collection 1600–1960. |

## SWITZERLAND
| | |
|---|---|
| BASLE | *Historisches Museum*—paintings and drawings. |
| BERNE | *Bernisches Historisches Museum*—18th and 19th century costume. Tapestries and painted glass.<br>*Kunstmuseum*—paintings. |
| SCHÖNENWERD | *Schumuseum*—footwear through the ages. |
| ZÜRICH | *Schweizerisches Landesmuseum*—costume and jewellery collection. Medieval and 18th and 19th century. |

# Selected Book List

Boucher, F., *A History of Costume in the West*, Thames & Hudson, 1967

Bradfield, N., *Historical Costumes of England 1066–1968*, Harrap, 1970
   *also*          *Costume in Detail 1730–1930*, Harrap, 1968

Bruhn, W., & Tilke, M., *A Pictorial History of Costume*, Zwemmer, 1955

Cunnington, C. W., & Cunnington, P., *Handbook of English Costume (4 vols),*
  *Medieval to 19th Century*, Faber, 1973

Davenport, M., *The Book of Costume*, Crown Publishers, New York, 1968

Dunbar, J. Telfer, *History of Highland Dress*, Batsford, 1979

Earle, A. M., *Two Centuries of Costume in America 1620–1820* (2 vols), Arno,
  1976

*Encyclopaedia of Textiles*, editors of *American Fabrics Magazine*, Prentice-Hall
  (USA), 1972

Ewing, E., *History of Twentieth-Century Fashion*, Batsford, 1975
   *also*       *History of Children's Costume*, Batsford, 1977
   *also*       *Dress and Undress*, Batsford, 1978

Houston, M. G., *Medieval Costume in England and France*, Black, 1965

Kelly, F. M., & Schwabe, R., *Historic Costume*, Putnam, New York, 1976

Kidwell, C. B., & Christman, M. C., *Suiting Everyone*, Smithsonian Institution
  (USA), 1974

Kohler, C., & Sichart, E. von, *A History of Costume*, Dover paperback reprint,
  1963

Laver, J., *A Concise History of Costume*, Thames & Hudson, 1977

McClellan, E., *History of American Costume 1607–1870*, Tudor (USA), 1969

Moore, D. L., *Fashion through Fashion Plates 1771–1970*, Ward Lock, 1971

Schoeffler, O. E., & Gale, W., *Esquire's Encyclopaedia of 20th Century Men's
  Fashions*, McGraw-Hill (USA), 1973

Selbie, R., *The Anatomy of Costume*, Mills & Boon, 1977

Waugh, N., *Corsets and Crinolines*, Batsford, 1970

Wilcox, R. T., *Five Centuries of American Costume*, Black, 1966

Yarwood, D., *English Costume*, Batsford, 1979
   *also*       *European Costume*, Batsford, 1975
   *also*       *Outline of English Costume*, Batsford, 1977
   *also*       *The Encyclopaedia of World Costume*, Batsford, 1978